THE BEGINNER'S
PHOTOGRAPHY GUIDE

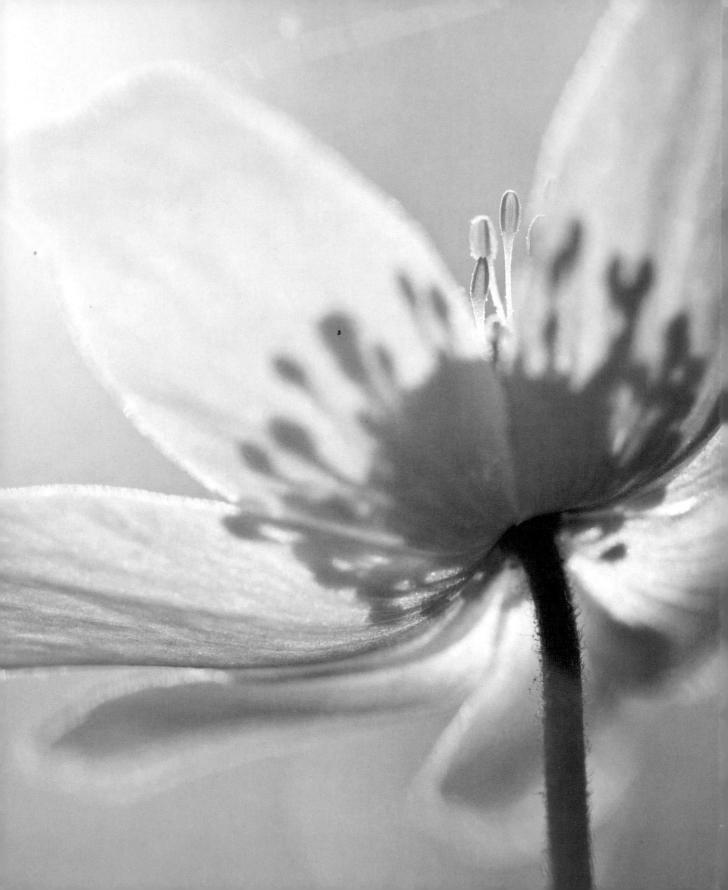

THE BEGINNER'S PHOTOGRAPHY GUIDE

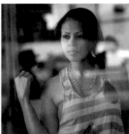
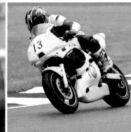

LONDON, NEW YORK, MUNICH,
MELBOURNE, DELHI

Senior Editor Nicky Munro
Project Art Editor Joanne Clark
Editor Hannah Bowen
Designer Simon Murrell
US Editors Kate Johnsen, Allison Singer
Jacket Designer Natasha Rees
Jacket Editor Manisha Majithia
Jacket Design Development Manager Sophia MTT
Producer, Pre-production Rebekah Parsons-King
Managing Editor Stephanie Farrow
Senior Managing Art Editor Lee Griffiths

Written by Chris Gatcum

First American Edition, 2013
Published in the United States by DK Publishing,
345 Hudson Street, New York, New York 10014

6 8 10 9 7
013–186986–May/2013

Published in Great Britain by
Dorling Kindersley Limited.

A catalog record for this book is available from
the Library of Congress.
ISBN 978-1-4654-0845-7

DK books are available at special discounts when
purchased in bulk for sales promotions, premiums,
fundraising, or educational use. For details, contact
DK Publishing Special Markets, 345 Hudson Street,
New York, New York 10014 or specialsales@dk.com

Printed and bound by Hung Hing

Discover more at **www.dk.com**

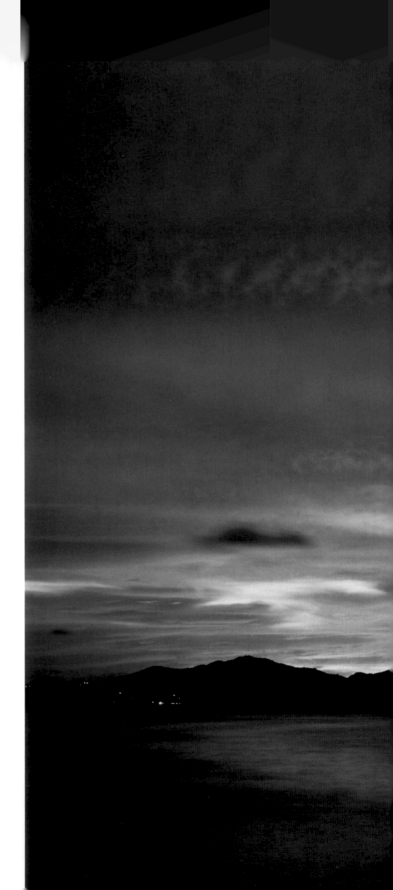

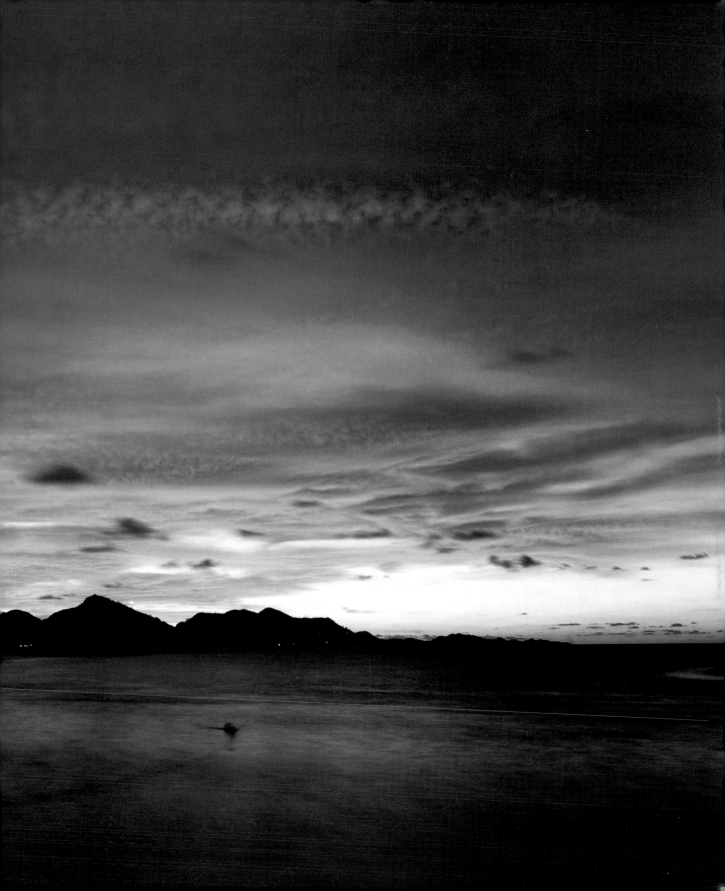

CONTENTS

INTRODUCTION

The aim of this book is simple: to provide you with a solid foundation in digital photography. It cuts through the jargon and complicated technicalities that can make the subject unnecessarily intimidating, and shows you how to get the most out of your camera. It's not surprising that so many photographers feel daunted by all the buttons, dials, and menus found on modern digital cameras—and it's all too easy to switch to Auto and leave everything to the camera. But once you learn how satisfying it is to make the creative decisions yourself, and see how taking control can make such a huge difference to your pictures, you'll never look back. And it's really not as difficult as it might appear. Of course, it does take a little commitment and you won't be able to master every technique without some practice, but the results are more than worth the effort. Your camera is an amazing piece of technology that's capable of transforming your pictures from average snapshots to something altogether more impressive. This book will completely demystify the world of digital photography for you, and will set you on the path to becoming not just a good photographer, but a great one.

ABOUT
THIS BOOK

Each chapter of the book is full of practical hands-on tutorials that will help you get the best from your camera. Canon and Nikon dSLRs are used throughout, but even if your camera make or model is different, you'll find that most dSLRs (and many CSCs) have very similar functions and controls.

CAMERA SETTINGS KEY

The following icons are used throughout the book to show you precisely what settings were used for each of the final images.

SHOOTING MODES

P Program mode

A Aperture Priority mode

S Shutter Priority mode

M Manual mode

METERING MODES

 Multi-area

 Center-weighted

 Spot

 Partial

EXPOSURE

 Aperture setting

 Shutter speed

 ISO setting

WHITE BALANCE

 Auto

 Daylight

 Cloudy

 Shade

 Tungsten

 Fluorescent

 Flash

 Custom

WHAT'S ON THE PAGES?

INTRODUCING |

At the start of every chapter you'll find "Introducing" pages that will give you an overview of the particular subject covered. You won't be overloaded with technical information, but will learn all you need to gain the confidence and know-how to get started.

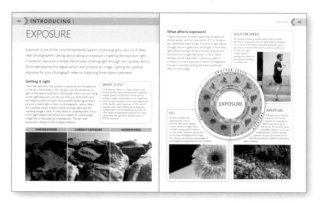

THINGS YOU'LL SEE

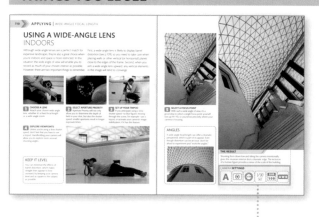

CAMERA **SETTINGS**

Camera settings Wherever you're shown how to apply a technique, you'll also see the final result, along with the settings used to get there (see also Key, left).

 # EXPLAINING |

If you see "Explaining" at the top of a page, you'll get a specific look at one aspect of photography. It could be an explanation of focal length, or the theory behind the color of light (and why you might need to know about it). The concepts are presented clearly and simply throughout.

 # APPLYING |

The "Applying" pages provide you with illustrated tutorials on how to put all the theory into practice. The step-by-step instructions are so simple and straightforward that you really can't go wrong. You'll also find suggestions on how to apply the techniques to different subjects and situations.

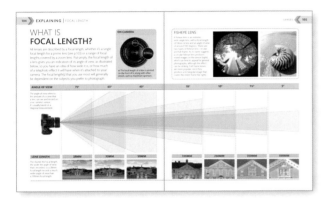

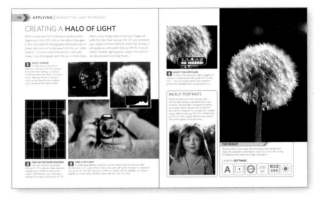

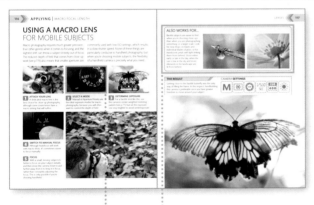

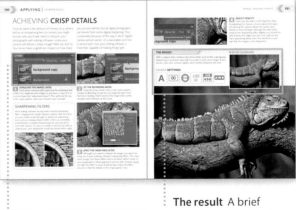

Boxes Handy tip boxes provide inspirational advice to expand your knowledge of the subject in question.

The result A brief overview of the final image explains how it was created and which techniques were used.

Close-up camera details The tutorials show you which buttons and dials you should be looking for on your camera. Most dSLRs (and many CSCs) have similar options, often in exactly the same place.

Screenshots Image editing can turn a good shot into a great one. Adobe's Photoshop Elements has been used throughout, but most editing software has a comparable range of features.

EQUIPMENT

EQUIPMENT

Your choice of camera is likely to come down to two things: the type of photography you want to do, and your budget. The camera isn't necessarily the end of your purchases, however. There are a lot of accessories available that aim to enhance your photography in some way, but lenses, tripods, and flashes are designed to expand your camera's capabilities and are often considered must-have items.

The essentials

Whether you want a camera that's light, foolproof, and requires minimal input, or one that allows you to take full creative control, this chapter will help you choose the ideal camera for you. The panel below gives a brief overview of the options available, and lists the pros and cons of each camera type. If you're serious about photography, then a camera with interchangeable lenses is definitely the most versatile option.

CAMERAPHONE	BASIC COMPACT	ADVANCED COMPACT
Has a fixed lens and minimal control over exposures, but with the advantage that you'll have it on hand at all times.	A modest zoom range and primarily automatic controls makes this an ideal point-and-shoot camera.	Provides manual control, and in some cases Raw file capture, with the convenience of a portable size.
FUNCTIONALITY	**FUNCTIONALITY**	**FUNCTIONALITY**
■ Fixed lens ■ Few manual controls ■ Easy to share images, either via email or text message, or by uploading to social networking sites ■ Small, discreet, and pocketable	■ Zoom lens covering wide to telephoto focal lengths ■ Automatic/semi-automatic shooting modes ■ JPEG only ■ Small and pocketable	■ Zoom lens covering wide to telephoto focal lengths ■ Automatic and manual shooting modes ■ Range of creative controls ■ Raw and JPEG capture ■ Small and pocketable

EXTRAS

If you choose to invest in a dSLR or CSC, then there's a wide range of lenses, flash units, and other accessories that can help you take your photography to another level. And regardless of which type of camera you choose, a camera case and memory card are essential extras. This chapter will show you what's available so you can decide what you need.

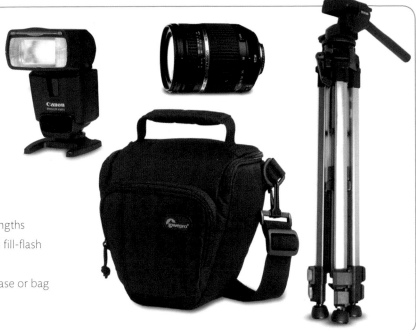

PRIMARY CONSIDERATIONS:

- Lenses to expand your range of focal lengths
- An external flash for low-light shots and fill-flash
- A tripod
- A comfortable and accessible camera case or bag
- Spare battery and memory card(s)

BRIDGE/SUPERZOOM

Combines dSLR styling and features (including manual control) with a wide-ranging zoom lens.

FUNCTIONALITY

- All-encompassing zoom lens covering wide to super-telephoto focal lengths
- Non-interchangeable lens
- Small, compact-camera sized
- Automatic and manual shooting modes
- Full range of creative controls
- dSLR-style handling

CSC

A full range of automatic, manual, and creative controls, plus interchangeable lenses, all in a small camera body.

FUNCTIONALITY

- Interchangeable lenses
- High quality dSLR-sized sensor
- Fully automatic to fully manual control
- Full range of creative controls
- Raw and JPEG capture
- Electronic viewfinder
- Compact and dSLR-style camera bodies available

DSLR

A tried-and-tested design and the favored camera of countless enthusiasts and professional photographers.

FUNCTIONALITY

- Wide range of lenses and accessories
- Full-frame and sub-full-frame sensor sizes available
- Full manual control over all aspects of your photography
- Raw and JPEG image capture
- Optical through-the-lens viewfinder
- Ergonomic design

ANATOMY OF A DSLR

Single lens reflex (SLR) cameras have been the camera of choice for professionals and photography enthusiasts since the 1970s, but the actual SLR design dates back to the late 1940s. The reason for their popularity (and name) is due to the viewing system, which uses a pentaprism (a five-sided glass prism) to rotate the image coming through the lens so it can be viewed through an eye-level viewfinder. This through-the-lens (or TTL) viewing system means that the photographer gets an accurate view of what the camera is seeing and what it will be recording, making it easy to frame a shot. Although initially designed for use with film, most SLRs are now digital, hence the name "digital SLR," or dSLR.

FRONT VIEW

The front of a dSLR is the "business end" of the camera. The camera's lens dominates, and aside from the lens release button, which allows you to remove and replace the lens, there are few additional controls on either entry-level cameras, such as this Nikon, or professional-specification (pro-spec) models, such as the Canon shown opposite.

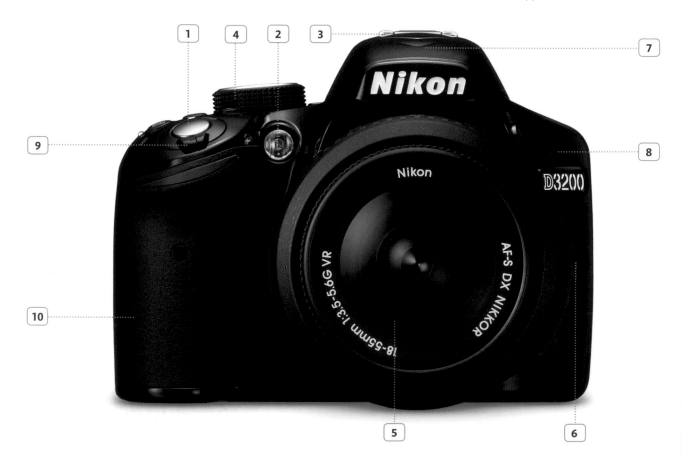

OTHER MANUFACTURERS

No matter which manufacturer's cameras you look at, most dSLRs share a very similar design. The size of the camera body may vary slightly, and the controls that are available will be slightly different (and possibly in different locations), but the vast majority of cameras will have a mode dial on the top, an LCD screen dominating the back, a viewfinder hump above that, and, of course, an interchangeable lens on the front.

FRONT VIEW KEY

1 Shutter-release button

2 Autofocus (AF) assist lamp

3 Hot shoe (for mounting a flash)

4 Mode dial

5 Lens (see p.32 for anatomy)

6 Lens release button

7 Pop-up flash

8 Microphone

9 On/Off switch

10 Hand grip

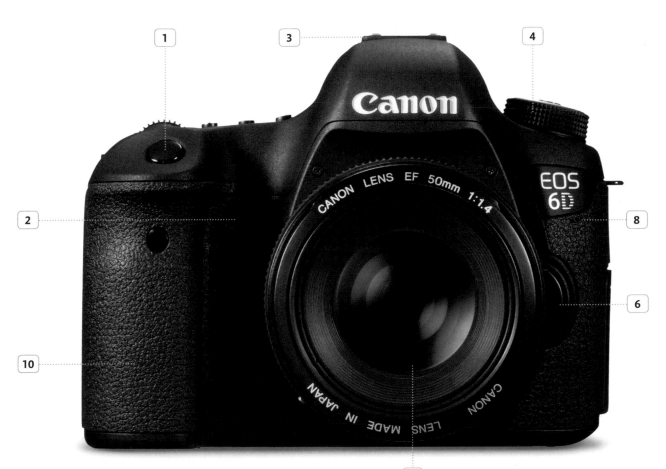

SCREEN OPTIONS

If your dSLR camera has the ability to shoot video, then it will also offer Live View, which allows you to view and frame your shots using the rear LCD screen instead of the viewfinder. This can be a very useful feature, especially if your camera has a screen that folds out and can be rotated, because it will help you shoot from less conventional angles. In turn, this can help you create more dramatic images.

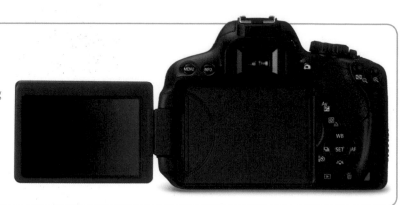

BACK VIEW

If the front of a dSLR camera is relatively sparsely populated, the back is almost certain to be covered with buttons, switches, and control wheels. Although this may seem daunting at first, all manufacturers carefully consider which controls to put on the outside of the camera (and where) for instant access, and which to keep hidden in the menu system.

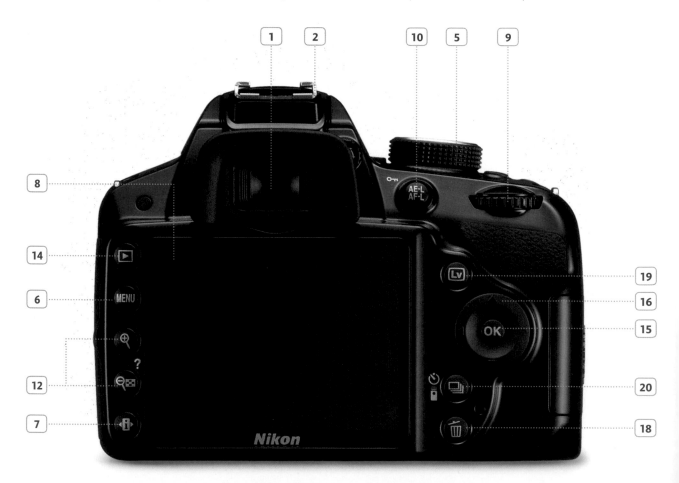

BACK VIEW KEY

1 Viewfinder	**8** LCD screen	**15** Set/OK button
2 Hot shoe (for mounting a flash)	**9** Control wheel	**16** Four-way control button
3 Movie mode/record button	**10** Exposure/focus-lock button	**17** Lock
4 Autofocus (AF) activation button	**11** AF point selection button	**18** Delete button
5 Mode dial	**12** Playback zoom button	**19** Live View button
6 Menu button	**13** Quick Control button	**20** Drive mode selection button
7 Info button	**14** Playback button	

On the entry-level Nikon (opposite), the buttons on the back are split logically between those that relate to functions requiring the LCD screen, and those that will be used primarily during shooting.

The playback and menu buttons, plus playback zoom controls, are on the left, for example, while the exposure and focus lock, Drive mode, and Live View buttons are on the right.

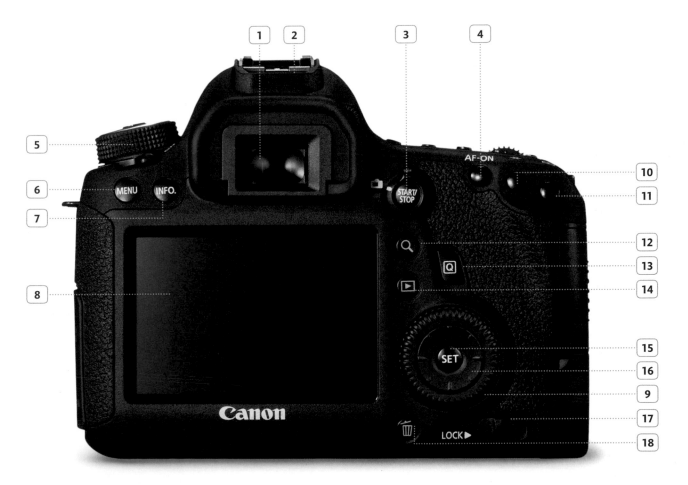

TOP VIEW KEY

1	Lens (see p.32 for anatomy)
2	Lens release button
3	ISO button
4	Shutter release button
5	Control wheel
6	Mode dial

7	On/Off switch
8	Viewfinder
9	Hot shoe (for mounting a flash)
10	Autofocus (AF) mode button
11	LCD screen
12	Drive mode selection button

13	Metering pattern selection button
14	LCD illumination button
15	Movie mode/record button
16	Pop-up flash
17	Info button
18	Exposure compensation button

TOP VIEW

When you look at the top of a pro-spec camera next to an entry-level model, key differences tend to become more apparent. Pro-spec cameras don't usually have a pop-up flash, for example, and they use top-mounted LCD displays to relay the camera settings; this is useful if the camera is mounted on a tripod. The exposure mode dial tends to be significantly different too: entry-level cameras will usually have a selection of Scene Modes to choose from, in addition to the pro-spec options.

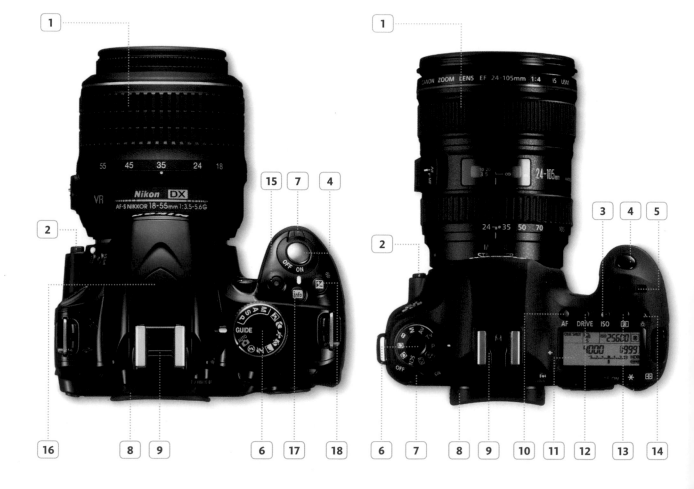

SIDE VIEW KEY

1	Lens (see p.32 for anatomy)		**7**	Lens release
2	Pop-up flash		**8**	Connection port cover
3	Hot shoe (for mounting a flash)		**9**	Mode dial
4	Viewfinder		**10**	Shutter release button
5	Flash activation/mode button		**11**	Memory card compartment
6	Function button		**12**	Control wheel

CONNECTIVITY

With the rise of HD video modes, an increasing number of dSLR cameras now feature a mini HDMI input, so you can connect your camera to a television and play movies (and images) directly from the memory card. Alternatively, you can download your images to a computer using the USB connection.

SIDE VIEW

Compared to the back and top, the sides of a dSLR are relatively clean. There are no buttons or dials, since it would be easy to knock them by accident, so the camera designers use the sides to provide access points to the camera. These are typically arranged with the memory card compartment on the right (hand grip) side of the camera body, and the various connection ports and accessory inputs on the left, often behind a rubberized flap.

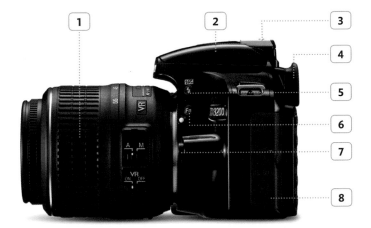

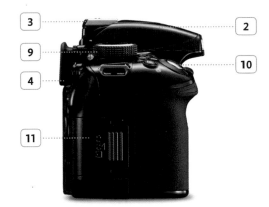

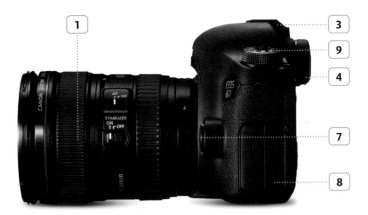

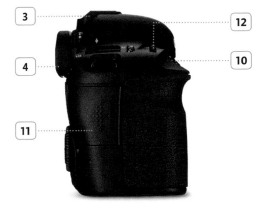

THROUGH THE **VIEWFINDER**

On dSLRs, as well as most bridge cameras and some CSCs, the viewfinder is your window on the world. It's where you look at the scene you want to photograph and frame your shots. It's also where you view information about the camera settings. Aperture, shutter speed, and ISO will all be displayed, and you'll also be able to see which focus points are being used. Most cameras show additional information here too. The illustrations below use Canon and Nikon dSLRs as representative examples, so you may find they differ from your own camera. Either way, you should look at these two pages in conjunction with your camera manual.

VIEWFINDERS

Through a typical viewfinder, the image area will be relatively clear: apart from the Autofocus points (see p.89), which are usually overlaid, there will be few other elements to distract you from framing your shot. Instead, all the shooting information you might need will appear beneath the image, so you can quickly check your settings before you shoot.

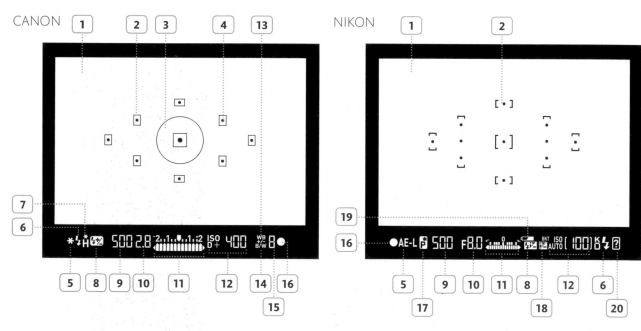

VIEWFINDER KEY

1 Focus screen	**6** Flash ready indicator	**11** Exposure level indicator	**16** Focus confirmation
2 Autofocus (AF) point	**7** Flash mode	**12** ISO settings	**17** Program shift (see pp.52–53)
3 Spot meter area	**8** Flash compensation	**13** White Balance adjustment	**18** Exposure compensation
4 AF point activation indicator	**9** Shutter speed	**14** Black-and-white mode	**19** Battery level
5 Exposure lock active	**10** Aperture	**15** Maximum burst	**20** Warning indicator

ON THE **LCD SCREEN**

In the past, a camera's rear LCD screen was used for little more than reviewing images and accessing and viewing the various menu options. Today's screens are far more sophisticated, not only in terms of their specification (large sizes and high resolutions are now standard), but also in terms of the information they relay.

Some cameras even allow you to make the rear LCD screen "Live" so you can see a variety of settings, but also control them and make changes via the LCD screen. Again, Canon and Nikon cameras are shown as examples below, so refer to your own camera's LCD screen to get to know where things are.

LCD SCREENS

The amount of data that's displayed on the rear LCD screen varies between camera makes and models. Certain camera models allow you to set the level of information depending on your needs, ranging from simple displays that show the essentials (exposure, white balance, and so on), through to displays packed with information.

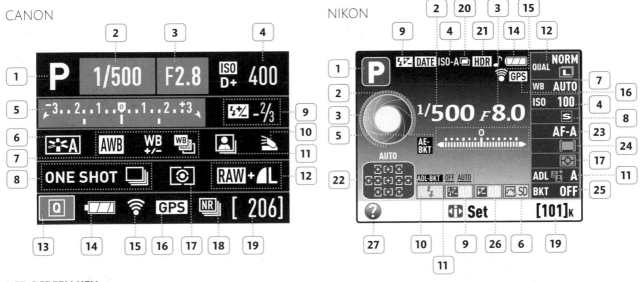

LCD SCREEN KEY

1	Exposure mode	8	Drive mode	15	Eye-Fi transmission status	22	Autofocus (AF) point indicator
2	Shutter speed	9	Flash compensation	16	GPS connection	23	Focus mode
3	Aperture	10	Flash active/flash mode	17	Metering pattern	24	AF area mode
4	ISO setting	11	Auto Lighting Optimizer/ Active D-Lighting setting	18	Multi-shot noise reduction	25	Exposure bracketing indicator
5	Exposure level indicator	12	Image quality	19	Shots remaining	26	Exposure compensation
6	Picture style (see pp.48–49)	13	Quick Control	20	Multiple exposure indicator	27	Help icon
7	White Balance setting	14	Battery level	21	HDR indicator		

OTHER **CAMERA TYPES**

Compact system cameras, or CSCs, are the most recent development in camera technology and, at the time of writing, the fastest-growing in terms of popularity and sales. The reason for this is easy to understand: a CSC is typically far smaller and lighter than a dSLR, yet it features interchangeable lenses and a sensor size commonly associated with dSLR cameras. However, it's not the only alternative, and for some photographers a high-end compact or a bridge camera (see pp.26–27) is a perfect all-in-one solution.

COMPACT SYSTEM CAMERA (CSC)

There are generally two styles of CSCs currently on the market: those that are similar to compact cameras (top), and those that take their styling lead from dSLRs, complete with mode dials and eye-level viewfinders (below). Which type is best for you depends on your style of photography: compact designs tend to favor on-the-go spontaneity.

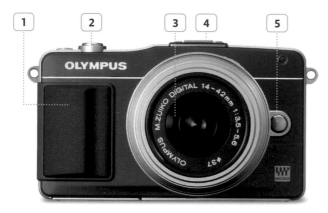

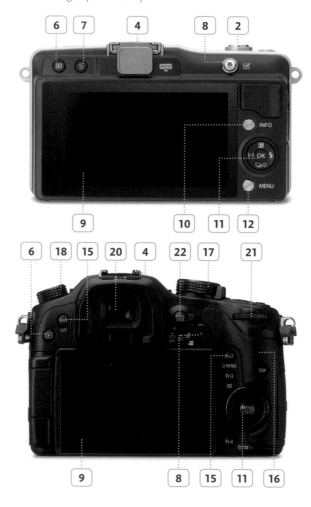

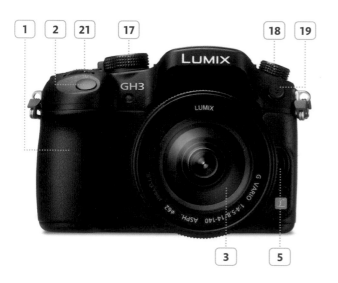

VIEWFINDER DIFFERENCES

One of the key differences between a CSC and dSLR camera is the viewfinder: a CSC uses an electronic viewfinder (EVF) rather than an optical viewfinder. Some CSCs have an EVF built in (in a dSLR style), while others have EVFs as an optional extra that slides into the accessory shoe. Some do away with an eye-level viewfinder altogether and simply use the LCD screen for framing.

COMPACT SYSTEM CAMERA KEY

1	Finger grip
2	Shutter release button
3	Lens
4	Accessory shoe/hot shoe
5	Lens release button
6	Playback button
7	Delete button
8	Movie mode/record button
9	LCD screen
10	Info button
11	Control pad and camera function buttons
12	Menu button
13	Microphone
14	On/Off switch
15	Fn (Function) button
16	Speaker
17	Mode dial
18	Drive mode selector
19	Flash PC sync input
20	Electronic viewfinder (EVF)
21	Control wheel
22	Focus lock (AF-L)/Focus mode selector
23	Image stabilization switch
24	White balance, ISO, and exposure compensation buttons

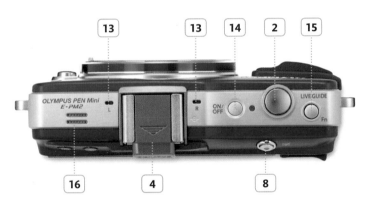

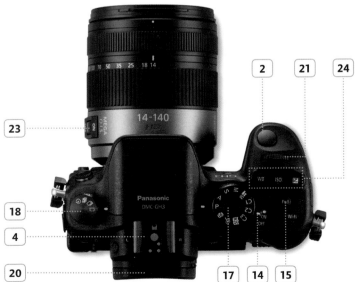

BRIDGE/SUPERZOOM

Bridge, or superzoom, cameras tend to have a pseudo-dSLR-style body shape and control layout, coupled with a fixed lens. The lens is usually an all-encompassing zoom covering a range of focal lengths, from wide-angle to super telephoto. This makes them incredibly versatile, but the small sensor inside is often the same size as those found in compact cameras.

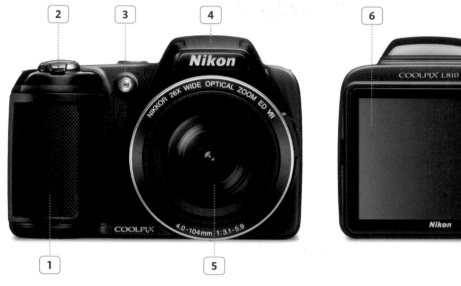

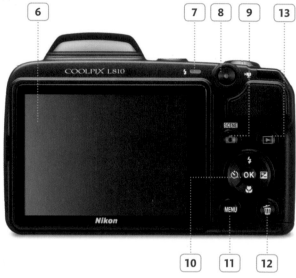

HIGH-END COMPACT

A high-end compact camera will typically allow you to shoot Raw and JPEG images, just like a dSLR camera or CSC, and it will also offer similar levels of control, including Aperture Priority, Shutter Priority, and Manual shooting modes. The zoom lens is fixed, but it tends to put image quality ahead of the focal length range, allowing stunning photos to be taken.

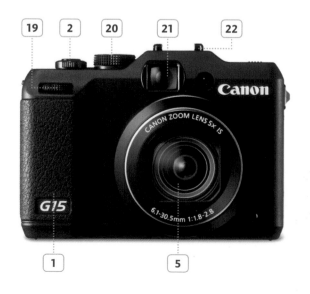

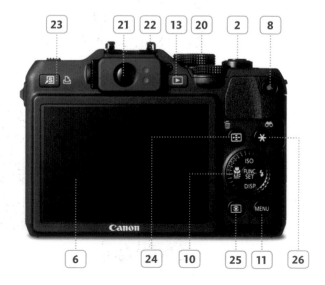

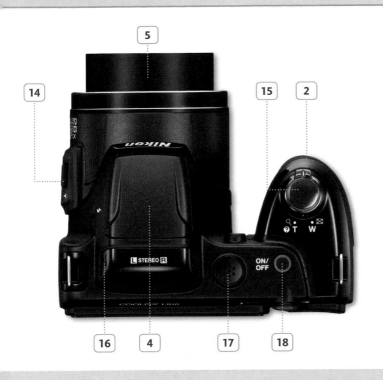

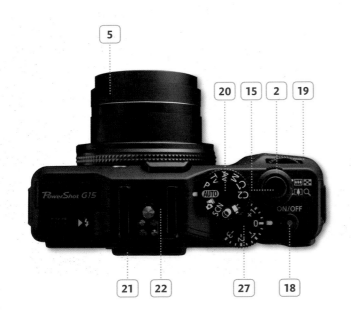

BRIDGE/SUPERZOOM AND HIGH-END COMPACT KEY

1 Finger grip

2 Zoom control

3 Autofocus (AF) illuminator

4 Pop-up flash

5 Lens

6 LCD screen

7 Flash ready indicator

8 Movie mode/record button

9 Scene mode selection

10 Control pad and camera function buttons

11 Menu button

12 Delete button

13 Playback button

14 Side-mounted zoom control

15 Shutter release button

16 Microphone

17 Speaker

18 On/Off switch

19 Control wheel

20 Mode dial

21 Viewfinder

22 Hot shoe

23 Shortcut/Direct print button

24 AF point selection button

25 Metering pattern selection button

26 Exposure/focus lock button

27 Exposure compensation dial

HOLDING YOUR CAMERA

Imagine this scenario: you've spent hundreds (perhaps even thousands) of dollars on equipment; you've made sure that you've got everything just right in terms of exposure setting, white balance, focus, and framing; and you've triggered the shutter at the precise once-in-a-lifetime moment you want to record; and after all that, your image is blurry. It's extremely disappointing and frustrating, but camera shake—movement of the camera at the point of capture—is the number one culprit behind blurred images. However, you don't necessarily need any specialty equipment to remedy the problem: in most cases, you just need to ensure that you're holding your camera correctly.

CAMERA GRIP

To keep your camera as steady as possible (without using a tripod), hold it in your right hand, with your index finger close to the shutter release button and your fingers around the camera's grip. Your left hand should support the lens, while also allowing you to control the zoom and focus rings. Keep your elbows tucked into your sides for added stability. The images on the far right show some of the most common mistakes.

REMEMBER...

■ Hold your camera and lens with both hands

■ Keep your elbows tucked in

■ Press the shutter release button gently

■ Take your shot as you finish exhaling (on your "out breath")

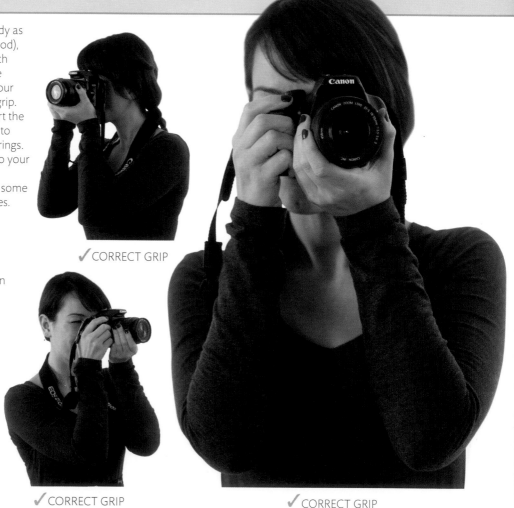

✓ CORRECT GRIP

✓ CORRECT GRIP

✓ CORRECT GRIP

VARIATIONS

The standard camera grip (see below) works well in most situations, which is why it's seen as the "correct" way to hold your camera. Sometimes, however, alternative or modified grips, as shown here, may be preferable. These may be particularly useful when you're using a longer, or heavier, lens.

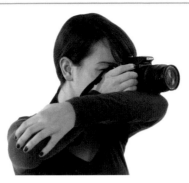

▲ CROSS-BRACING

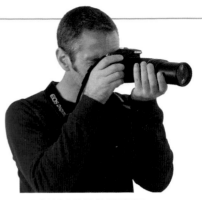

▲ LONG LENS SUPPORT

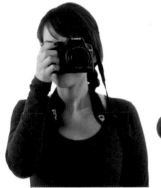

✗ HOLDING THE CAMERA WITH ONLY ONE HAND

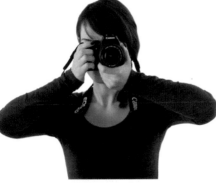

✗ STICKING YOUR ELBOWS OUT, REDUCING STABILITY

✗ LEAVING THE LENS UNSUPPORTED

✗ GRIPPING THE LENS TOO LOOSELY

VERTICAL SHOOTING

The same rules for holding your camera apply when you switch from shooting in the horizontal (landscape) format to vertical (portrait) format: keep your elbows tucked in; use your right hand to hold the camera, so you can trigger the shutter and use the control wheel to change settings; and support the lens from below.

STAYING STEADY

As well as making sure that you're holding your camera correctly (see pp. 28–29), it's equally important to adopt the most appropriate stance for your shooting position. In all instances the same basic grip is used for control and stability of the camera, but your stance will have a significant impact on your stability. The following are some of the most common shooting positions, showing the best stance, with the inset images showing the most common mistakes.

STANDING

It's likely that most of the time you'll be shooting from an upright standing position. While this may be the most comfortable, natural position, you still need to ensure that you're standing firm.

REMEMBER...
- Stand with your feet approximately shoulder-width apart

- Stand facing your subject, rather than twisting your body sideways

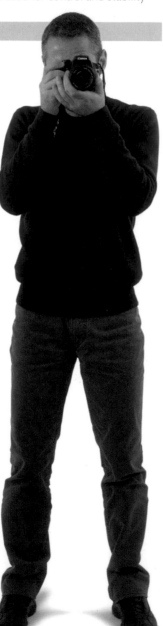

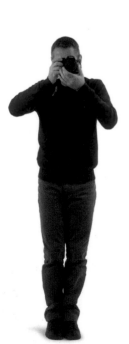

CROUCHING

Shooting from a crouching position will enable you to explore different angles, allowing you to include more of the foreground in a shot, for example. However, unless you balance yourself properly, you'll find it hard to stay steady.

REMEMBER...
- Distribute your weight evenly and avoid leaning forward

- Rest your elbows on your knees

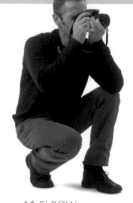

✗ ELBOW UNSUPPORTED

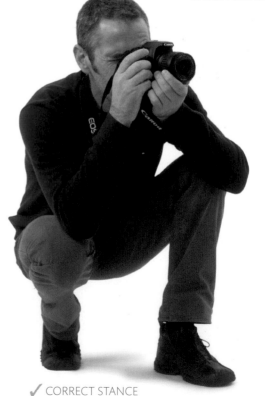

✗ TENSE, UNSTEADY STANCE

✓ CORRECT STANCE

✓ CORRECT STANCE

SITTING

You probably won't take photographs from a seated position all that often, but when you do, use your legs, knees, and feet to create a solid foundation.

REMEMBER...
■ Keep your feet apart to create a stable base

■ Rest your elbows on your knees to brace yourself

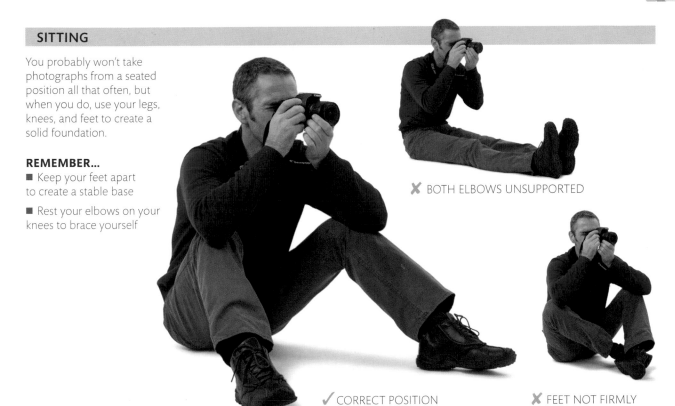

✗ BOTH ELBOWS UNSUPPORTED

✓ CORRECT POSITION

✗ FEET NOT FIRMLY PLANTED

LAYING DOWN

Shooting from a prone position allows you to capture an intriguing ground-level view of the world. But while you're trying to find the right position, it's easy to forget to hold your camera properly.

REMEMBER...
■ Support yourself on your elbows comfortably

■ Use your right hand to hold and operate the camera...

■ ...and your left hand to support and control the lens

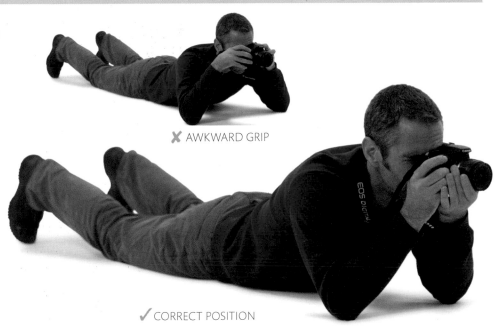

✗ AWKWARD GRIP

✓ CORRECT POSITION

ADDITIONAL **EQUIPMENT**

A dSLR camera or CSC is an interchangeable lens camera, so it perhaps goes without saying that you have the ability to change lenses—you may even have bought the camera with more than one lens to start with. Lenses will be covered in much greater detail later in the book, but this isn't the only purchase you're likely to make in your pursuit of great photographs. As well as your camera and lenses, there's a whole host of additional accessories that will help improve your pictures, ranging from a tripod to hold your camera steady, through to flashes and filters to expand your creative repertoire.

LENSES

Although most lenses have certain things in common (a focus ring and bayonet mount, for example), they don't all share exactly the same features. A zoom lock, for example, is generally found only on heavy, wide-ranging zoom lenses, and is designed to stop the zoom from extending by itself because of the weight of the glass used in its construction. Some lenses also feature image stabilization technology, to help prevent camera shake (see p.107).

LENS ANATOMY

It's easy to assume that one lens is very much like another, but nothing could be further from the truth. Physical differences, such as the size of the focus and zoom rings, can make a huge difference to the handling of a lens, as can the range of focal lengths it covers (see pp.104–105).

LENS ANATOMY KEY

1	Filter thread
2	Front lens element
3	Manual focus ring
4	Focus distance scale
5	Zoom ring
6	Focal length setting
7	Focus mode (Auto/Manual)
8	Zoom lock
9	Lens mount
10	Electronic contacts

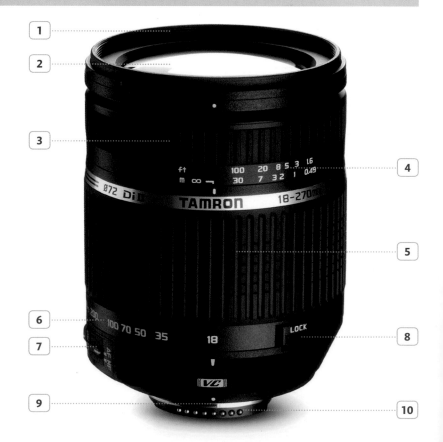

LENS TERMINOLOGY

There's quite a lot of jargon used in photography, and this is particularly true when you start to talk about lenses. If you're intending to buy a new lens, you'll encounter a world of acronyms and abbreviations that can be truly bewildering. The table to the right shows a few of the most commonly used terms that you're likely to come across, along with the different codes used by lens manufacturers to describe them.

TERM	DESCRIPTION
Aspherical (AS/ASP/ASPH)	Most lenses are curved in a "c" shape, but the surface of an aspherical lens doesn't conform to the shape of a sphere, so light is able to pass through it more evenly.
Image stabilization (IS/VR/OS/VC/ PowerOIS)	A system that uses sensors to detect camera movement. A floating lens element inside the lens moves to counteract this movement.
Low dispersion glass (ED/UD/APO/LD/SD/ HLD)	A type of glass used in the construction of a lens to reduce the appearance of colored edges (known as chromatic aberrations) in images.
Silent focus (USM/SWM/SWD/SDM/ HSM/SSM/USD)	Some of the more advanced Autofocus systems in a lens use a silent motor that minimizes any noise associated with focusing the lens.

ATTACHING A LENS

1 **ALIGN MARKS**
There will be alignment marks on both the lens and the lens mount (either on the mount itself, or to the side) to ensure that you fit your lens correctly. Align the two marks...

2 **SLIDE IN STRAIGHT**
...and slide the lens into the lens mount. The lens should fit smoothly into the camera body, but if it doesn't, don't force it—remove the lens and realign.

3 **TWIST AND LOCK**
Once the lens is slid into the camera body, turn it to lock it in place. The direction in which you turn it will depend on your camera model, so check the manual.

LENS REMOVAL

To remove a lens, you reverse the process used to fit it. Press the lens release button (usually located next to the lens mount on the camera body) and turn the lens in the opposite direction from the way in which you attached it. Once the lens is detached, fit another lens or a cap to prevent dust from getting into the sensor.

CAMERA SUPPORT

Image stabilization (sensor- or lens-based) does a great job of helping you to avoid blurred shots caused by camera shake, but these systems have their limits. They certainly won't help if you want to take very long exposures lasting half a second or longer.

However, a solid tripod will hold your camera for as long as necessary, and providing it's set up correctly, will guarantee shake-free results. It also enables you to frame your shots very precisely, which is why every serious photographer should own one.

TRIPOD ANATOMY

Aside from their three-legged design, all tripods vary slightly. One of the main differences is in their construction: while most tripods are made of aluminum, some of the more costly models are made of lightweight carbon fiber, which is a bonus if you intend to carry one for long periods of time.

TRIPOD IN ACTION

There's no getting away from the fact that a tripod makes it much slower to take a shot than using your camera handheld. However, this also gives you time to assess your scene and your camera settings, and really think about how you're going to get the best shot possible.

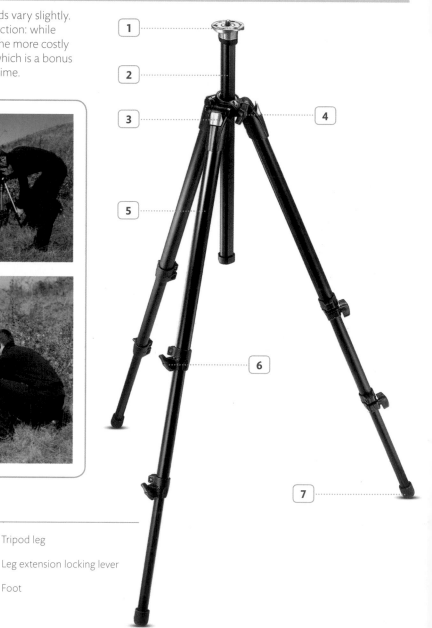

TRIPOD ANATOMY KEY

1	Tripod head mounting plate		**5**	Tripod leg
2	Center column		**6**	Leg extension locking lever
3	Leg angle lock/release		**7**	Foot
4	Center column lock			

TRIPOD HEADS ANATOMY

A pan-and-tilt tripod head (right) enables you to move your camera in any one of three directions: tilt backward and forward; tilt side to side; and pan (rotate). Each of these movements is controlled independently, usually using large locking handles, so you have very precise control over the positioning of your camera. The downside is that it's big and bulky compared to a ball-and-socket head (below), and it takes longer to set up. A ball-and-socket head has just one lock: release it and you're free to turn, tilt, and twist your camera as you choose. This makes it much quicker to use than a pan-and-tilt head, but it doesn't offer the same level of accuracy.

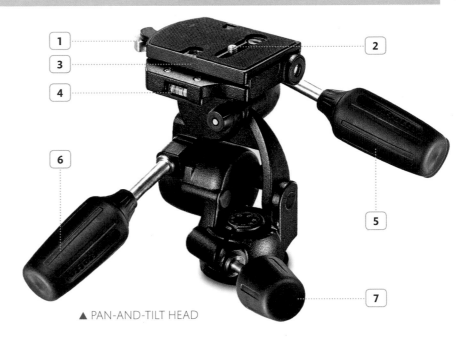

▲ PAN-AND-TILT HEAD

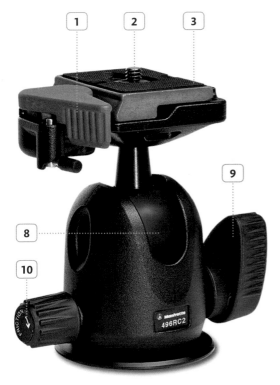

▲ BALL-AND-SOCKET HEAD

TRIPOD HEADS ANATOMY KEY

1 Quick-release lever		**6** Forward/back tilt locking lever	
2 Mount thread (typically ¼in)		**7** Panning locking lever	
3 Camera/quick-release plate		**8** Ball and socket	
4 Bubble level		**9** Ball lock/release	
5 Sideways tilt locking lever		**10** Ball friction control	

QUICK-RELEASE PLATES

Attaching and removing your camera from the tripod head is made much easier if the head has a quick-release system. This is comprised of a plate that's screwed into your camera's tripod socket, and this simply clips on to the tripod head. A lever can be used to release the camera in an instant.

LIGHTING

All dSLR cameras and most CSCs have a hot shoe on top, which allows you to attach a flash. If your camera has a built-in pop-up flash, you might wonder why you'd want to attach a hot shoe flash, but in fact it opens up a lot of creative options: it's more powerful, has greater versatility, and, most importantly, can also be used away from the camera. Flash will be explored in greater detail in chapter 6 (see pp.150–63), but here you'll find a quick tour of the options that you're likely to encounter.

FLASH ANATOMY

When choosing a flash, a model that's fully dedicated to your camera is highly recommended, because it will automate the exposure process. A tilting head is also useful, since it will enable you to use bounce flash (see pp.156–57), while more powerful flash units will generally provide the greatest versatility when it comes to lighting a single figure or a group of people.

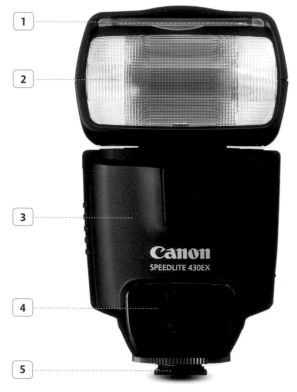

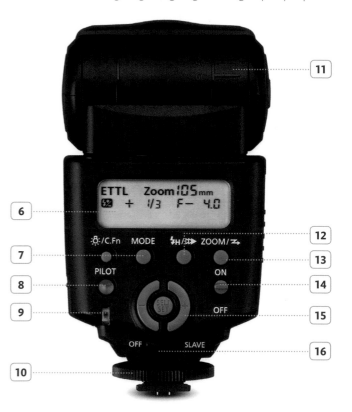

FLASH ANATOMY KEY

1	Slide out wide-angle diffuser	**7**	Mode selection button	**13**	Zoom control
2	Flash tube/diffuser	**8**	Test button	**14**	Power switch
3	Flash body	**9**	Flash ready light	**15**	Control panel navigation pad
4	Autofocus illuminator	**10**	Locking wheel	**16**	Slave mode activation switch
5	Foot	**11**	Tilt angle indicator		
6	LCD panel	**12**	Custom function settings		

OTHER FLASH TYPES

A hot shoe-mounted flash is ideal for shooting subjects situated some distance from the camera, but it's not as useful for close-ups, since the light will often pass straight over the top of the subject. Dedicated macro flash units get around this issue by positioning the flash much closer to the lens: a ring flash circles the lens entirely, while a twin flash uses two flash lights, which are controlled independently, to illuminate your subject.

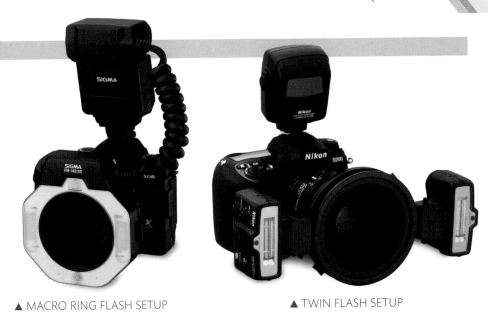

▲ MACRO RING FLASH SETUP ▲ TWIN FLASH SETUP

OTHER LIGHTING ACCESSORIES

If you start to use flash on a regular basis, you may wish to explore the wide range of different effects or looks that you can achieve with the help of additional flash accessories. Reflectors and diffusers, for example—both handheld and flash mounted—can be used to soften the light and fill in shadows (see pp.130–33).

▲ REFLECTORS AND DIFFUSERS

▲ FLASH REFLECTOR ▲ FLASH SOFTBOX DIFFUSER ▲ ON-CAMERA FLASH DIFFUSER

OTHER ACCESSORIES

The camera, along with lens, flash, and tripod, forms the backbone of most general-purpose photography kits. However, beyond those four key items are other accessories that may help in one way or another when you're out and about taking pictures. These range from bags or cases, in which to store and carry your equipment, to memory cards (dSLRs and CSCs do not come with a memory card to begin with), and spare batteries.

BAGS AND CASES

Soft or hard, over-the-shoulder, or backpack style—camera bags and cases come in a wide range of shapes, sizes, and materials, so there's sure to be one that suits your needs.

▲ TOP-LOADING CASE

▲ SHOULDER BAG

▲ BACKPACK

▲ HARD CASE

LENS FILTERS

Although digital editing can replicate the effects of some of the traditional lens filters, there are at least two filters that are still invaluable, and whose effects can't be easily replicated. Neutral density (ND) filters block out light and allow you to extend exposure times (see pp.62–63), while polarizing filters intensify skies and cut through reflections.

▲ NEUTRAL DENSITY FILTER

▲ POLARIZING FILTER

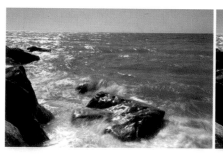
▲ WITH ND FILTER

▲ WITHOUT ND FILTER

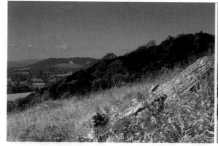
▲ WITH POLARIZER

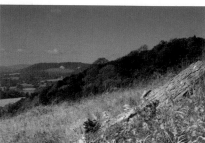
▲ WITHOUT POLARIZER

MEMORY CARDS

There are several types of memory cards currently in use, but your camera will only take one of them, so be sure to buy the right one. The capacity of all memory cards is measured in gigabytes (GB): if you intend to shoot video as well as still photographs, then a high-capacity card (16GB+) is recommended.

▲ COMPACT FLASH

▲ SD CARD

▲ SONY MEMORY STICK

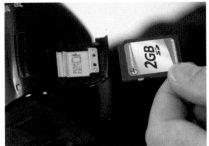

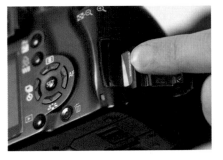

1 **OPEN MEMORY CARD SLOT**
Turn your camera off, then find the memory card slot (it's usually on the side of the camera) and slide it open.

2 **CHECK THE DIRECTION**
The card will fit only one way, so check that it's facing the right way before sliding it into the camera.

3 **INSERT THE CARD**
Press the memory card all the way into the slot (it will click into place), then close the slot.

BATTERIES

Today's camera batteries are long-lasting and very reliable. However, like any batteries, they will eventually run out and need recharging. Batteries don't last forever either, so at some point you'll need a replacement. To ensure that you're never caught without one, it's a good idea to buy an additional battery to begin with.

▲ NIKON BATTERY

▲ CANON BATTERY

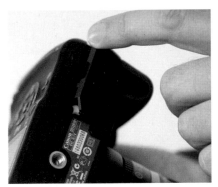

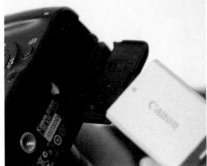

1 **OPEN BATTERY COMPARTMENT**
Find the battery compartment, which is usually situated on the bottom of the camera. Press it to unlock it...

2 **INSERT BATTERY**
...and slide in the battery. As with memory cards, the battery will only fit one way and should never be forced.

3 **LOCK BATTERY**
Push the battery in all the way until it clicks into place. Close and lock the compartment.

JPEG OR **RAW?**

With digital photography there are a couple of fundamental decisions that need to be made before you take a picture. The first question is what file format will you use? All dSLRs and CSCs (as well as some bridge and compact camera models) offer a choice of two formats—JPEG and Raw—which require slightly different approaches. As a general guide, Raw files require more work (sometimes a lot more) after they've been downloaded to your computer, but they're also capable of delivering slightly better quality images.

SHOOTING JPEGS

When your camera records a JPEG file, it processes the images so that all of the settings you've made are burned into the file. This means that the color, contrast, sharpening, and everything else you can tweak or change on your camera is applied to the image before the information is saved to your memory card. However, a JPEG file is compressed using a lossy system, which means that information can be permanently lost when it's saved: you need to be careful to avoid this.

Your camera will offer a number of JPEG quality options, typically ranging from Basic to Fine (see below). The higher the JPEG quality, the higher the quality of your images.

RAW FORMAT

The appeal of shooting Raw is simple: unlike a JPEG file, the camera doesn't process your image. Instead, you do this on your computer using Raw conversion or your image-editing software. This means you can change the appearance of a shot dramatically without affecting the image quality. For example, you're free to change the white balance, contrast, and saturation, or even make changes to the exposure. These adjustments are only set when you resave the Raw file.

BASIC	NORMAL	FINE

▲ A Basic JPEG quality setting means a high level of compression is applied to reduce the file size as much as possible. This will also reduce the image quality, so this setting is best avoided.

▲ If your image will only ever be viewed on screen, then a Normal JPEG quality setting may suffice. However, it's much better to use a Fine setting and reduce the file size on your computer.

▲ A Fine JPEG setting applies the least amount of compression to your images, so you get the highest quality result. This is the best option for all of your digital photographs.

SETTING IMAGE QUALITY

The image quality option is usually found within the camera's shooting menu, although it will only be available when you set your camera to record JPEGs: when it's set to Raw, the image is either not compressed, or high-quality lossless compression is used. As a very simple rule, set the JPEG image quality to its highest setting and don't touch it again. You can reduce the quality/file size later if you need to, but it's impossible to recover detail lost by high compression levels.

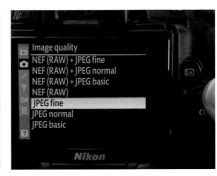

1 CALL UP THE MENU
Press the Menu button on the back of your camera and locate the correct shooting menu. (You may need to consult your manual.)

2 OPEN IMAGE QUALITY
Navigate to Image Quality (or similar) using the control pad on the back of your camera and press OK/SET to display the quality options.

3 SET IMAGE QUALITY
Select the quality setting you want to use and press OK/SET. Use the Menu button to close the camera menu and return to shooting mode.

IMAGE SIZE

As well as quality options, your camera is also likely to allow you to change the image size—measured in pixels or megapixels (MP). Unless you have very good reason to use a small size setting, it's best to shoot at the maximum image size available: you can always reduce the size of your images on your computer later if you want or need to, but enlarging small shots is certain to degrade the picture quality.

✗ Poor quality
✓ Fair quality
✓✓ Good quality
✓✓✓ Very good quality
✓✓✓✓ Excellent quality
✓✓✓✓✓ Press quality

RESOLUTION (PIXELS)	IMAGE SIZE	ON SCREEN	PRINT SIZE (INCHES)				
			4x6	5x7	8x10	16x20	20x30
640x480	0.3 MP	✓✓	✓	✗	✗	✗	✗
1280x980	1 MP	✓✓✓	✓✓✓	✓✓✓	✓✓	✗	✗
1600x1200	2 MP	✓✓✓	✓✓✓✓	✓✓✓✓	✓✓✓	✓	✗
2240x1680	4 MP	✓✓✓	✓✓✓✓	✓✓✓✓	✓✓✓✓	✓✓	✓
3032x2008	6 MP	✓✓✓	✓✓✓✓	✓✓✓✓	✓✓✓✓	✓✓✓✓	✓✓
3264x2448	8 MP	✓✓✓	✓✓✓✓	✓✓✓✓	✓✓✓✓	✓✓✓✓	✓✓✓
4000x3000+	12 MP+	✓✓✓	✓✓✓✓	✓✓✓✓	✓✓✓✓	✓✓✓✓	✓✓✓✓

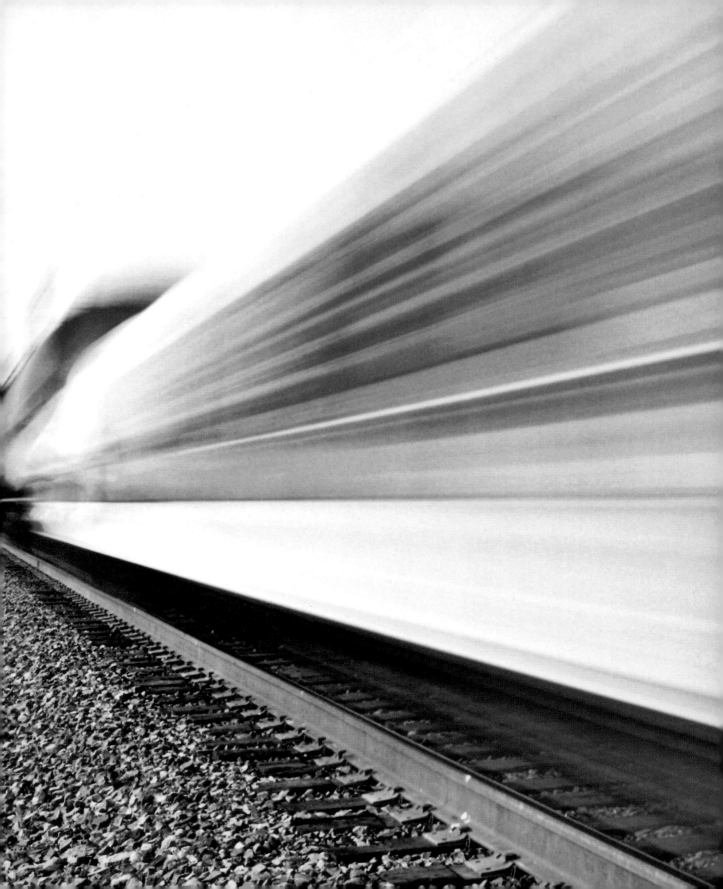

EXPOSURE

EXPOSURE

Exposure is one of the most fundamental aspects of photography, and you'll often hear photographers talking about taking an exposure or getting the exposure right. In essence, exposure is simply the process of letting light through the camera's lens to illuminate (expose) the digital sensor and produce an image. Getting the optimal exposure for your photograph relies on balancing three distinct elements.

Getting it right

The three elements that are key to exposure are the aperture in the lens, the shutter in the camera, and the sensitivity to light of the sensor itself (ISO). Technically, there's no such thing as the right exposure, just the one that you think looks best, but there's a point at which most people would agree that a picture is overly light or dark. In photographic terms, when the camera's sensor doesn't receive enough light and the resulting image is dark, it's described as underexposed. If too much light reaches the sensor and creates an overly bright image, this is described as overexposed. The aim with exposure is simply to find a happy medium.

WHAT IS EV?

EV (Exposure Value) is a single number used to describe the many permutations of aperture, shutter speed, and ISO that can be used to achieve a single overall exposure (or brightness). Each EV step is equal to a one-stop adjustment of the shutter speed, aperture, or ISO, and it's typically used when talking about exposure compensation and bracketing (see pp.80–83): +1EV means increasing the exposure by 1 stop using either the aperture, shutter speed, or ISO, for example.

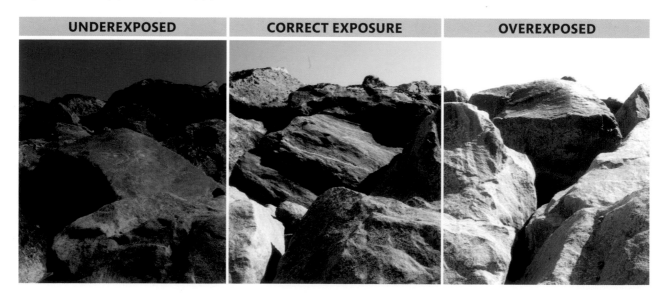

| UNDEREXPOSED | CORRECT EXPOSURE | OVEREXPOSED |

What affects exposure?

A good exposure involves balancing the aperture, shutter speed, and ISO (see pp.46–47). In doing so, you determine three things: how much light passes through the lens (aperture); the length of time that light passes through the lens (shutter speed); and how sensitive to light the sensor is (ISO). These settings can be balanced in numerous ways to produce a correct exposure in terms of brightness, but each individual setting will have a profound effect on the image.

SHUTTER SPEED

All cameras contain a shutter, which may be either electronic, turning the sensor's light-reading capability on or off, or a mechanical unit that physically opens and closes in front of the camera's sensor to allow in—or shut out—light. Shutter speed is perhaps the easiest of the exposure settings to understand.

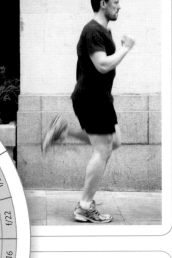

ISO

The ISO amplifies the signal that the sensor receives, effectively making it more sensitive to light. This is a bit like turning up the volume on your radio. However, just as this can increase background hiss, high ISO settings can result in noisy images if non-image-forming elements are amplified.

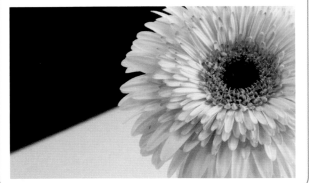

APERTURE

The aperture is, literally, a hole (or "iris") in the camera's lens that allows light to pass through to the sensor. All cameras today —including compacts and many mobile phones—have a variable aperture, so you can set the size of the hole precisely to match the prevailing light conditions.

Shutter speed and movement

The shutter speed in your camera determines how long your sensor is exposed to light, which explains why it is also referred to as the exposure time. The effect it will have on your image depends on whether there's any movement in the scene: slow shutter speeds will result in moving subjects appearing blurred (see pp.68–71), while fast shutter speeds can effectively freeze movement (see pp.64–67). If there is no movement at all in your subject (a building or a still life, for example), then all shutter speeds will produce an equally static result.

Aperture and depth of field

Since it's not intuitive, aperture is the most difficult of the three exposure settings to grasp. It'll be explained in more detail later in the chapter (see pp.54–55), but the key thing to note is that the aperture affects what is known as depth of field. Put simply, this is the amount of the scene that will appear sharp in your image: the greater the depth of field, the more elements will appear to be in focus. This is an incredibly effective creative tool since it can be used blur parts of an image to isolate a subject or direct attention, or to make everything equally sharp.

ISO and noise

At its most basic, the ISO setting controls how sensitive your sensor is to light: low ISO settings indicate low sensitivity, while high ISO settings equate to high sensitivity. On most cameras the ISO range starts at 100 (although some start at 200), and increases to ISO 3200, or higher (see right). However, as the sensitivity increases, so too does the "noise" in the image. This is effectively interference, which is seen in an image as either colored speckles (known as chroma noise) or an underlying granular texture (known as luminosity noise).

PRESSING THE SHUTTER

The shutter inside most cameras uses a pair of blades known as curtains. The first curtain opens to start the exposure, then the second follows to end it. The length of time it takes for this to happen is the shutter speed, or exposure time, and determines the amount of movement blur that will appear in your image.

 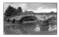

| CLOSED | 1ST CURTAIN TRAVELING | FULLY OPEN | 2ND CURTAIN TRAVELING | CLOSED |

CHANGING THE APERTURE SIZE

When you increase the size of the aperture, or open up the lens, you allow more light to reach the sensor. This reduces depth of field, so less of the scene appears in focus, but it allows a faster shutter speed and/or a lower ISO to be used.

| f/2.8 | f/5.6 | f/16 |

ISO SETTINGS

Noise Reduction (NR), whether in-camera or as a tool in your editing software, can help reduce the appearance of noise in your images. However, when you use NR you risk losing detail or reducing sharpness. As a general rule, it's always best to use the lowest ISO setting that you can.

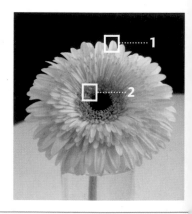

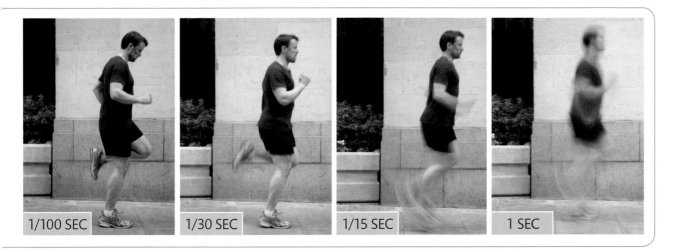

1/100 SEC | 1/30 SEC | 1/15 SEC | 1 SEC

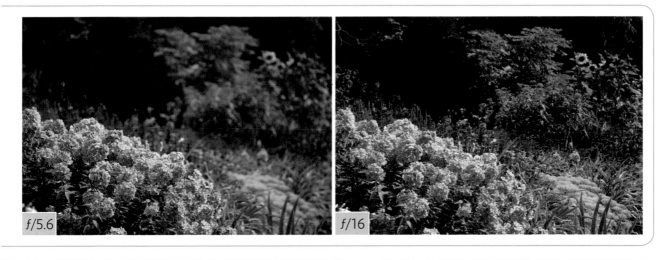

f/5.6 | f/16

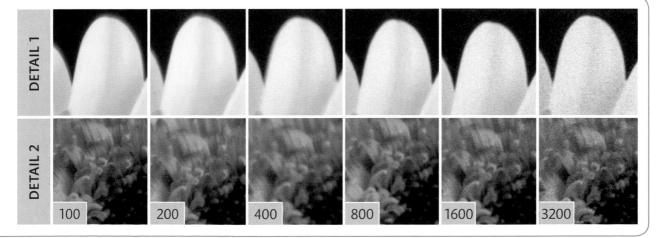

DETAIL 1

DETAIL 2

100 | 200 | 400 | 800 | 1600 | 3200

WHAT ARE **SCENE MODES?**

Your camera's Scene modes are designed to get you up and running with your camera in double-time, without your having to worry about technicalities such as exposure, white balance, and flash. As long as you know what it is that you're photographing, then the camera will do the rest, setting aperture and shutter speed, along with other parameters such as color, contrast, and even the level of in-camera sharpening. All you need to do is frame the shot and press the shutter release.

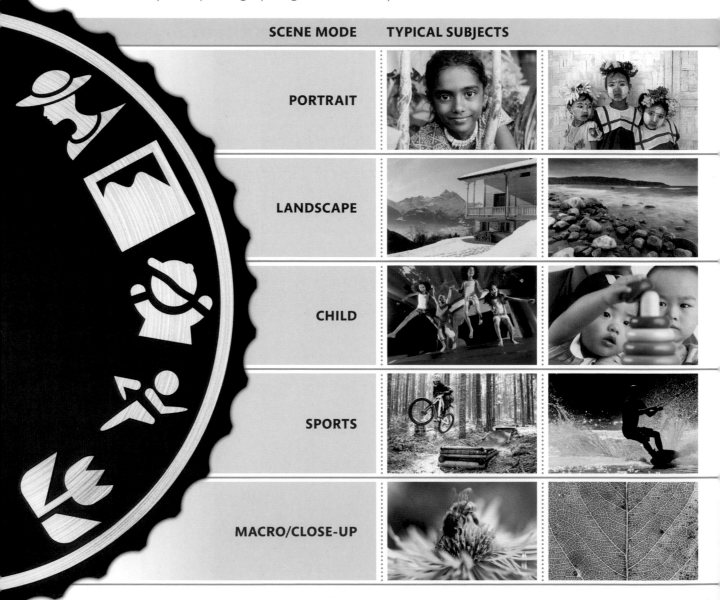

SCENE MODE	TYPICAL SUBJECTS	
PORTRAIT		
LANDSCAPE		
CHILD		
SPORTS		
MACRO/CLOSE-UP		

OTHER SCENE MODES

The modes outlined in the table below are the quintet typically found on a dSLR or CSC mode dial, but they're not the only ones available. If you check your camera manual, you may find that your particular model offers some or all of the following modes: Night portrait, Night landscape, Party/Indoor, Beach/Snow, Dusk/Dawn, Fall foliage, Pet portrait, Candlelight, Food, Hi key, Low key, Fireworks, and Document.

COMPACT CAMERA CHEATS

If you think your compact camera doesn't offer control over aperture and shutter speed, think again. The various Scene modes available on most compacts give you a modicum of control over your camera. If you want a wide aperture, for example, try using Portrait mode (regardless of what it is you're photographing), or if you want a fast shutter speed, try Sports mode. You may not have control over all aspects of your shot, but it's better than having none at all.

WHAT IT DOES	KEY SETTINGS
In Portrait mode your camera will set a wide aperture to throw potentially distracting background elements out of focus, although most cameras tend not to select the very widest lens setting. The color and contrast are both set to produce natural-looking skin tones (through neutral color and low–medium contrast), and in low-light situations the built-in flash will be used automatically.	■ Wide aperture (see pp.54–55; pp.58–59) ■ Automatic flash ■ Neutral (not overly saturated) color
When you switch to Landscape mode, your camera assumes that you want as much of the scene as possible to be recorded sharply, so it will set a small aperture for a large depth of field (see pp.56–57). Colors are intensified slightly to add vibrance to your outdoor shots—especially greens (for trees and foliage) and blues (for sky and sea)—and the flash will be switched off, regardless of the ambient light levels.	■ Small aperture (see pp.54–57) ■ Vibrant color ■ Flash off
With most cameras the difference between Child mode and Portrait mode is very small, but it is significant. Child mode uses the same wide aperture approach as Portrait mode (to blur backgrounds), but aims to use a slightly faster shutter speed to keep up with active youngsters. The color is typically set to be a little more vibrant for brighter, fun-packed shots.	■ Wide aperture (see pp.54–55; pp.58–59) ■ Fast shutter speed (see pp.62–63) ■ Vibrant color
Sports mode is all about freezing action, so your camera will select a fast shutter speed for split-second exposure times (usually accompanied by a wide aperture setting). If it needs to increase the ISO to achieve this, it will do so, even if that increases the level of noise in the image. Sports mode also sets the focus to Continuous mode so it can follow fast-moving subjects around the frame.	■ Fast shutter speed (see pp.62–67) ■ Continuous Autofocus (see pp.96–97) ■ Flash off
In Close-up mode, your camera will set a small aperture in an attempt to overcome the issues with focusing that are particular to this type of work. It will also keep the colors neutral, since it assumes a natural subject. However, unless you're using a dedicated macro lens, it can't help you to focus any closer. Flash is usually set to Auto as default in Close-up mode, but you can switch it off if you prefer.	■ Small aperture (see pp.54–55; pp.60–61) ■ Neutral colors ■ Automatic flash

WHAT ARE **AUTO** AND **ADVANCED MODES?**

If your camera has Scene modes, then it will undoubtedly have an Auto mode, and it's highly likely that you will have Program (P), Aperture Priority (A or Av), Shutter Priority (S or Tv), and Manual (M) modes available too. It's these four more advanced settings that will enable you to take control of your camera—and your photography.

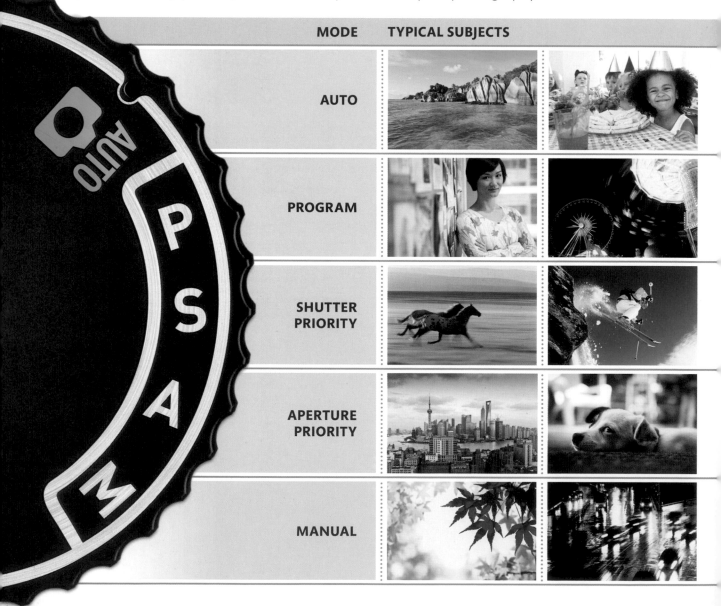

MODE	TYPICAL SUBJECTS
AUTO	
PROGRAM	
SHUTTER PRIORITY	
APERTURE PRIORITY	
MANUAL	

MOVIE MODE

 The option to shoot High Definition (HD) movies on a dSLR or CSC is a relatively recent development, but one that's now taken for granted. Using your camera to record video footage allows you to get even more out of it, and the quality is so high that dSLRs and CSCs are being used to film professional music videos, advertisements, and even some low-budget movies.

ALTERNATIVE MODES

Not all cameras have the same modes, or indeed the same way of showing them on the mode dial. Canon uses Tv for Time Value (Shutter Priority) and Av for Aperture Value (Aperture Priority), for example. Some of their models also have A-DEP (Automatic Depth) mode, which uses the active autofocus points to set an aperture that will keep everything sharp. In a similar vein, some Pentax cameras feature an Sv (Sensitivity Value) mode, or ISO Priority.

WHAT IT DOES	KEY SETTINGS
As the name suggests, Auto mode leaves all decision making to the camera, so regardless of the subject you simply have to frame the shot and press the shutter release. You don't have to worry about exposure, white balance, or any other technicalities, and, unlike Scene modes (see pp.48–49), you don't even need to tell the camera what your subject is: you just point and shoot.	■ Camera sets aperture, shutter speed, and ISO ■ Camera sets white balance ■ Flash is automatic ■ You have little control over other functions
When you switch to Program mode (see pp.52–53), you start to take a certain amount of control away from your camera and begin to have more input into how your photographs turn out. Although the camera sets the aperture and shutter speed automatically, this pairing can usually be adjusted, and you will also have control over the ISO, white balance, and certain other options, depending on your camera model.	■ Camera sets aperture and shutter speed ■ You set ISO ■ You can shift aperture/shutter pairing ■ You have control over all other functions
In Shutter Priority mode (see pp.62–73), you choose your preferred shutter speed and the camera selects the aperture setting that will provide you with the best overall exposure. Shutter Priority is best suited to subjects that need a specific shutter speed—to freeze fast-moving sports or wildlife subjects, for example, or to extend the exposure time and introduce motion blur.	■ You set shutter speed ■ Camera sets aperture ■ You have control over all other functions
Aperture Priority mode (see pp.54–61) is the longest-standing semi-automatic shooting mode, with only Manual mode having been around for longer. Aperture Priority works in much the same way as Shutter Priority, although you choose the aperture setting and the camera selects a shutter speed that it calculates will give the "correct" exposure. You have full control over all other camera functions.	■ You set aperture ■ Camera sets shutter speed ■ You have control over all other functions
In Manual mode (see pp.74–75), you only have yourself to blame if things go wrong. The camera will guide you toward the exposure that its programming deems most suitable, but ultimately it's up to you whether or not you choose to go with the camera's suggestion: you have full control over the aperture, shutter speed, ISO, and all other settings, and the camera won't override anything.	■ You set shutter speed ■ You set aperture ■ You have control over all other functions

TAKING **CREATIVE CONTROL**

While your camera's Auto and Scene modes will enable you to "point and shoot" and get a decent enough image most of the time, the fact that they leave the majority of decisions up to the camera does limit your creativity. However, you don't need to jump right in and start taking full manual control of your camera—far from it, in fact. To begin with, all you need to do is switch to Program mode, and take advantage of the extra choices it gives you. With this simple adjustment you'll be able to use more of your camera's tools, helping you to fully realize your photographic potential.

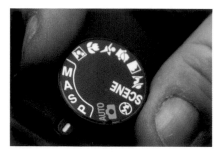

1 **SELECT PROGRAM MODE**
The first step is the most significant: switch your camera's mode dial to Program.

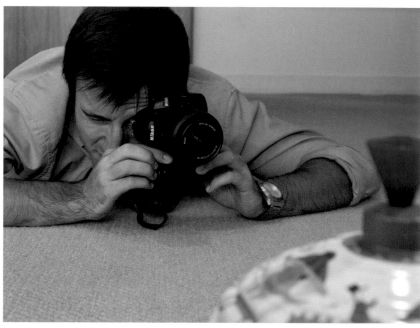

2 **PLAN YOUR SHOT**
Where and what you photograph will have an impact on the settings you choose, so decide first what it is you're hoping to achieve with your picture.

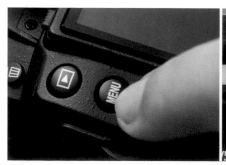
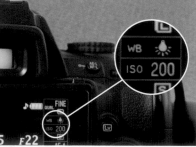

3 **SET ISO AND WHITE BALANCE**
Call up the menu and set your camera's White Balance and ISO (this is not always possible in Auto or Scene modes). There are various White Balance modes to choose from (see pp.126–29), but for an interior shot like this, either the Incandescent or Daylight setting is a good starting point.

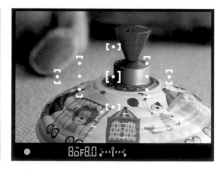

4 **CHECK EXPOSURE**
In the viewfinder, your camera will indicate its recommended shutter speed and aperture combination (the "exposure pairing"), but, unlike Auto and Scene modes, Program gives you options.

5 ADJUST EXPOSURE

Changing the exposure pairing is usually done with the camera's main control wheel. Note that the exposure shifts in a way that maintains the same overall brightness, so it won't make your picture any lighter or darker.

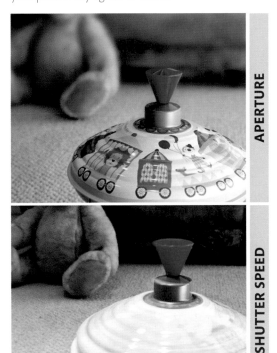

APERTURE

SHUTTER SPEED

6 SHIFT FOR APERTURE OR SHUTTER SPEED

The key difference between Auto/Scene and Program is the ability to "shift" the paired exposure setting. This will allow you to use a wider aperture to blur a background, for example, or set a slower shutter speed to blur any subject movement.

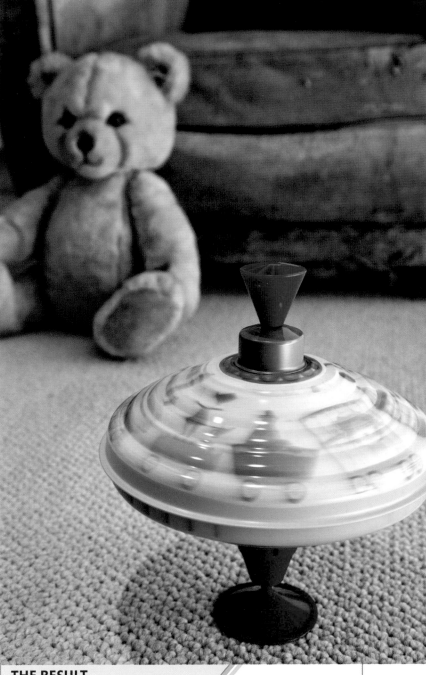

THE RESULT

It took several test shots to get this result using Program mode and shifting the exposure to increase the shutter speed until the spinning top was blurred without becoming unrecognizable.

CAMERA **SETTINGS**

 P f/11 1/30 SEC ISO 400

WHY USE **APERTURE PRIORITY MODE?**

When you switch your camera to Aperture Priority you're telling it that you're going to decide on the aperture that is used to take your photograph: the camera will then set the shutter speed automatically, so you achieve the correct exposure overall. More than this, when you choose the aperture, you're deciding what depth of field you want in your shot, which is one of the most important creative decisions you can make when taking a photograph.

IN-CAMERA

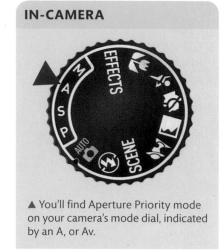

▲ You'll find Aperture Priority mode on your camera's mode dial, indicated by an A, or Av.

		IRIS	F/STOP	FOREGROUND FOCUS

WIDE APERTURE

Setting a wide aperture opens up the iris to allow more light through the lens. However, it also reduces the depth of field so that only the point you focus on appears sharp: almost everything behind and in front of this point will be blurred. This is great when you want to conceal a distracting background.

f/2.8

f/4

f/2.8

MEDIUM APERTURE

A medium aperture setting offers the best compromise between the amount of light passing through the lens and the depth of field. In addition, the lens usually delivers its best performance in terms of image sharpness at medium aperture settings.

f/5.6

f/8

f/8

SMALL APERTURE

Setting a small aperture (sometimes referred to as stopping down) restricts the amount of light passing through the lens. It also increases the depth of field, so much more of the scene appears in focus: if you use a very small aperture setting it's possible to get everything looking sharp.

f/11

f/16

f/16

MORE / LESS · LIGHT · LESS / MORE

LESS · DEPTH OF FIELD · MORE

What effects can I achieve?

The main reason for controlling the aperture is because it allows you to determine depth of field. This is the amount of the scene in front of and behind the actual focus point that appears sharp in your final image. Using a small aperture increases the depth of field, so more of your scene appears sharp, but it often results in longer shutter speeds (or higher ISO settings), which may mean that you'll need to use a tripod. Wider aperture settings reduce the depth of field and help ensure fast shutter speeds, but you need to bear in mind that choosing where to focus becomes even more important than usual.

DEPTH OF FIELD PREVIEW

When you look through your viewfinder, the lens will be set at its widest aperture so you see a bright image, but this won't show you the depth of field. Some (but not all) cameras feature a depth of field preview button, which is usually located beside the lens mount. The images below show the shot without preview (left) and with preview (right).

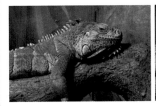

APPROXIMATE DEPTH OF FIELD

BACKGROUND FOCUS

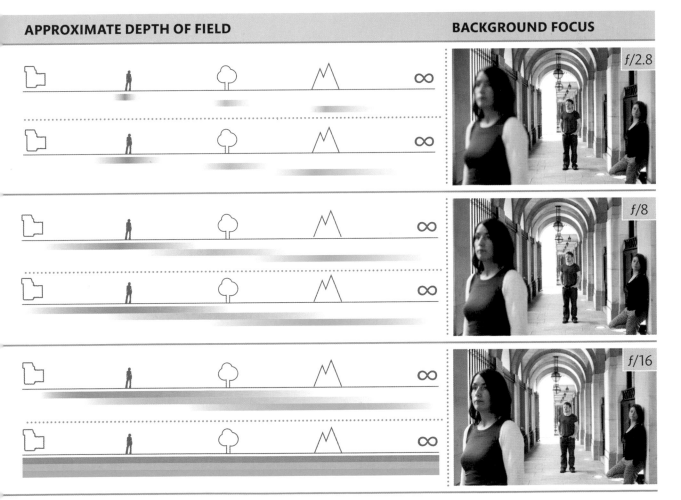

f/2.8

f/8

f/16

AREA OF SHARPNESS ■ FOREGROUND ■ MID-GROUND ■ BACKGROUND

KEEPING EVERYTHING
IN FOCUS

When you're presented with a stunning view, it's only natural to want everything in your photograph to be as sharp as it appears to the naked eye. The aperture in your lens is the primary means of controlling what is and isn't "in focus" (see pp.54–55) or, to use the correct terminology, determining the depth of field. For this type of shot—where you want the entire view to be as sharp as possible—you'll need to set a small aperture. It's also a good idea to start with the lowest ISO setting on your camera (see pp.44–47), since this will keep noise to a minimum and help maximize detail.

1 SELECT APERTURE PRIORITY
Aperture Priority should be your go-to mode whenever you want to control the depth of field, which is precisely what's required here.

2 SET APERTURE
With distant subjects, where everything in the shot is relatively far away, use the control wheel to set a medium-to-small aperture of f/8–f/16.

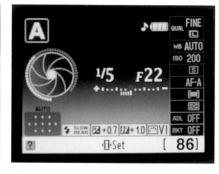

3 CHECK SHUTTER SPEED
A small aperture will lengthen the shutter speed, so be sure to check the camera's recommended exposure setting if you plan to shoot handheld.

4 REVIEW THE IMAGE
Take a test shot at your chosen aperture and review the image. Use your camera's playback zoom controls to zoom in and check the depth of field. You should be able to scroll around the image, so look at both the closest and furthest areas of your shot.

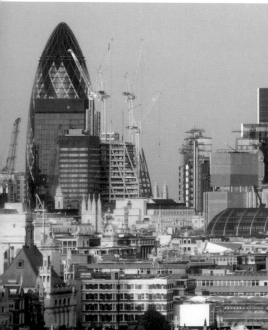

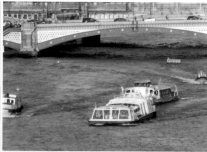

HAZE

Whenever you're photographing distant subjects, haze can be an issue, reducing contrast and clarity in your images. Fitting a UV or Skylight filter will help.

ALSO WORKS FOR...

Setting a small aperture so that you get a large depth of field is great for any situation where you want to show everything that's going on, rather than concentrating attention on a single person, area, or object. You can think of it as a general "establishing shot" that will give anyone looking at it a good idea of what it was you saw when you took the picture.

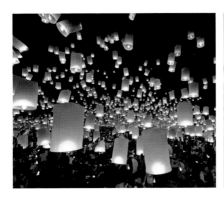
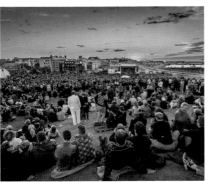

THE RESULT

An aperture of f/13 guaranteed that the boats at the bottom of the frame and the distant buildings would appear equally sharp. The resulting 1/50 sec shutter speed was fast enough to avoid movement blur.

CAMERA **SETTINGS**

P · f/13 · 1/50 SEC · ISO 100

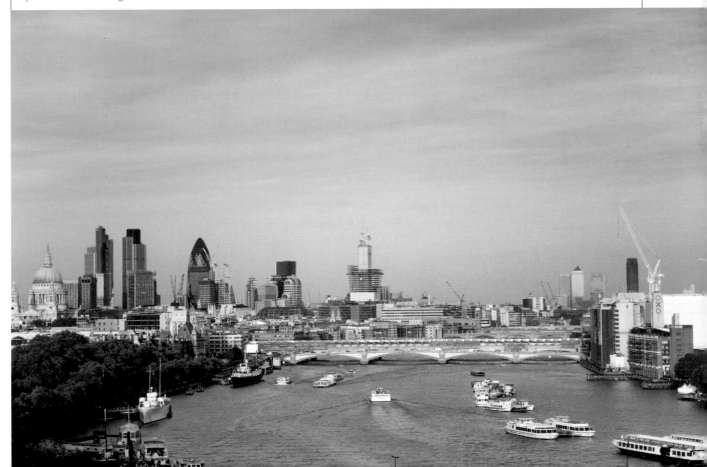

USING A **SHALLOW DEPTH** OF FIELD FOR **PORTRAITS**

Using a wide aperture is a classic portrait technique that's guaranteed to give your image maximum impact. The reason it works so well is because it can be used to focus the viewer's attention onto your subject (and away from any distractions).

The technique can work particularly well with a telephoto focal length lens, not only because this provides you with a comfortable working distance (see pp.112–13), but also because by zooming in you'll reduce the depth of field further still.

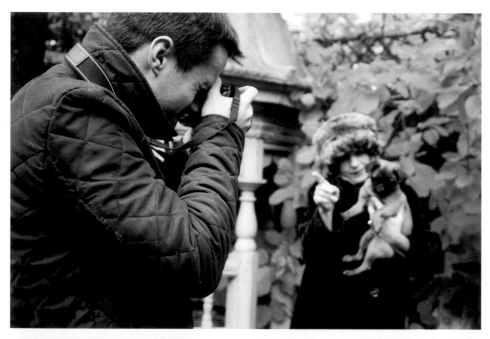

1 **POSITION YOUR SUBJECT**
For a close-up portrait shot, position your subject away from the background and zoom in to fill the frame. This is usually more practical than reducing the depth of field by trying to get very close to your subject.

2 **SELECT APERTURE PRIORITY**
For full control over the depth of field, set the exposure mode to Aperture Priority and let the camera choose the shutter speed.

3 **SET A WIDE APERTURE**
Dial in a wide aperture setting (small f-number). Note that prime lenses (see p.103) tend to have wider maximum apertures than zoom lenses.

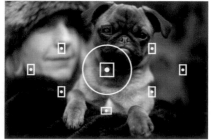

4 **SELECT A FOCUS POINT**
When you're using a wide aperture setting, focusing is critical because of the shallow depth of field. The best method is to pick the autofocus point yourself (see pp.90–91).

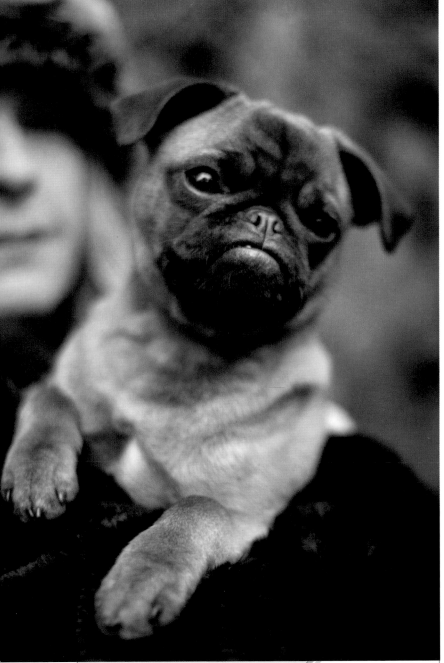

ALSO WORKS FOR...

A shallow depth of field is great for unconventional portraits, in which the face isn't necessarily the sole focus of the image. In fact, it's a truly versatile creative technique that can be used whenever you want to make a specific part of a scene the center of attention, regardless of your subject.

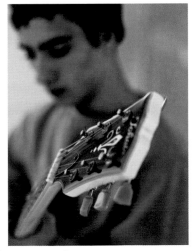

THE RESULT

Zooming in and setting a wide aperture has reduced the depth of field, with the nearest and farthest elements thrown out of focus. The sparkle in her eye further draws attention to the puppy's face.

CAMERA **SETTINGS**

 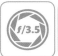

A | f/3.5 | 1/160 SEC | ISO 400

ISOLATING A SUBJECT
FROM THE BACKGROUND

When you photograph subjects that are close to the camera the depth of field decreases at all aperture settings, so even if you're using a small aperture of f/16 or f/22 it's possible for the depth of field to cover little more than an inch or two with close-up subjects (or even less with extreme close-ups).

However, setting a wide aperture is still useful, because it determines how much (or how little) of the subject appears sharp in your final photograph. Here, using a wide aperture of f/2.8 ensures that the subject really stands out against a potentially distracting background.

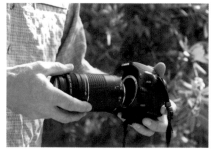

1 CHOOSE YOUR LENS
For close-up photographs you can use a dedicated macro lens, but you may find that you can get close to your subject with a long focal length setting on a zoom lens, as here.

2 SET UP YOUR TRIPOD
It's a good idea to use a tripod, since it will enable you not only to hold the camera steady, but also focus precisely on your subject.

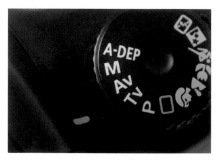

3 SELECT APERTURE PRIORITY
Switch your camera to Aperture Priority and select a wide aperture setting (f/2.8–f/4 is good). This will throw the background out of focus.

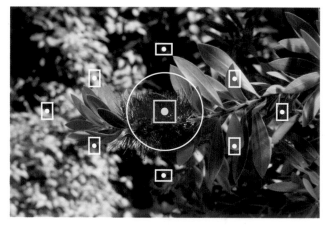

4 CHOOSE AN AUTOFOCUS POINT
Manually pick the Autofocus (AF) point setting over your subject or over the part of the subject you want to appear sharp. This may be the central AF point (as here), or an off-center point (see pp.94–95).

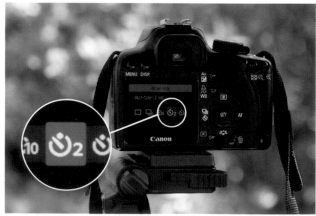

5 TRIGGER WITH SELF-TIMER
To reduce the risk of jogging the camera or changing the point of focus accidentally, trigger your camera's shutter with a remote release. If you don't have one, you can use the self-timer function instead.

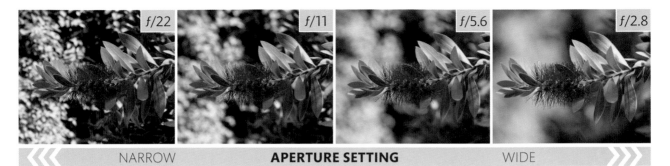

| NARROW | **APERTURE SETTING** | WIDE |

6 EXPERIMENT WITH APERTURE

You don't always have to shoot with the lens "wide open" (at it's widest aperture setting) to blur a background. In this shot the background is thrown out of focus even when a small aperture setting of f/22 is used, so the choice of aperture is more about the degree of background blur that you want—and, as you can see, this can make a big difference to the final result.

THE RESULT

A wide aperture setting of f/2.8 has transformed the leaves in the background into a creamy green blur, which allows the vivid red flower to take center stage.

CAMERA **SETTINGS**

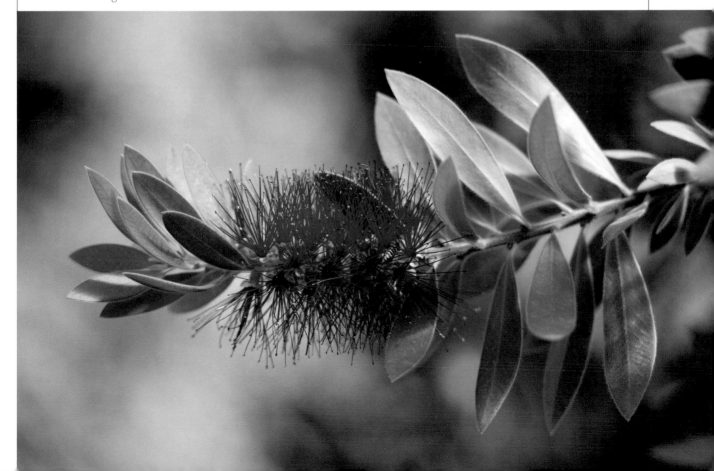

WHY USE **SHUTTER PRIORITY MODE?**

The shutter speed you use can have a profound effect on the resulting image—action may be captured in very sharp detail, blurred to convey a sense of motion, or even reduced to an abstract smear of colors. The precise effect you choose is going to be a technical and/or creative decision, but the mode of choice is Shutter Priority: you select the shutter speed and the camera will set a suitable aperture. The table below gives a very rough guide to some of the dramatic effects you can create.

IN-CAMERA

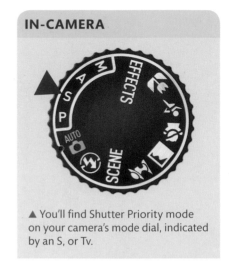

▲ You'll find Shutter Priority mode on your camera's mode dial, indicated by an S, or Tv.

SUBJECT	SUGGESTED SPEED	RESULT
SPORTS Sports photography is usually associated with high-impact, freeze-frame images of athletes captured at the peak moment of action, but blur can also be used to convey a sense of speed and movement.	**TO FREEZE** MINIMUM 1/500 SEC	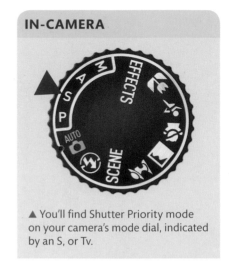
NIGHT LIGHTS If you want to achieve a fast shutter speed at night you'll usually have to use a wide aperture setting and a high ISO, which can lead to noisy images (see pp.46-47). This is why night shots tend to be taken with slower shutter speeds, which capture moving lights as a blurred trail.	**TO FREEZE** MINIMUM 1/500 SEC	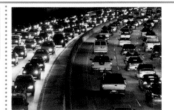
WILDLIFE As with sports photography, wildlife shots are usually crisp and clear, highlighting textures and markings, or focusing attention on the way in which the animals move. Extending the exposure time, however, is a great way of creating more abstract images of the natural world.	**TO FREEZE** MINIMUM 1/2000 SEC	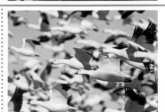
WATER Whether you depict moving water as "frozen," using a short shutter speed, or as a silky blur with a long exposure depends entirely on the mood you're trying to create. Images of razor-sharp droplets or crashing waves tend to be more dramatic, while misty water has a more atmospheric, ethereal feel.	**TO FREEZE** MINIMUM 1/1000 SEC	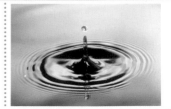

ULTRA-LONG EXPOSURES

In Shutter Priority mode there is usually a shutter-speed limit of 30 seconds. You can extend this, however, by switching to Manual mode (see pp.74–75) and selecting Bulb (B) mode, if available, by scrolling the control wheel to the end of the shutter speeds. In B mode the shutter will be held open for as long as you hold the shutter-release button (or remote release), allowing you to make an exposure lasting minutes, or even hours. Recording star trails like these requires very long exposure times: ideally upward of an hour. B mode is the only option here, and a tripod and remote release is essential.

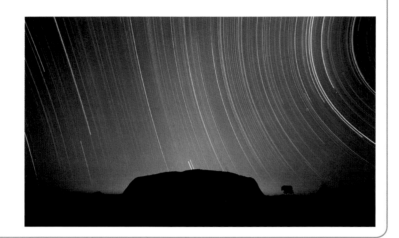

SUGGESTED SPEED	RESULT	TIPS
TO BLUR 1/60 SEC +	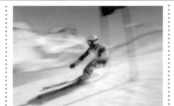	■ Very rapid movement will blur at shorter shutter speeds than more moderate movement. ■ Panning (see pp.72–73) allows you to use slow shutter speeds while still retaining some sharpness in your subject.
TO BLUR 1/2 SEC +	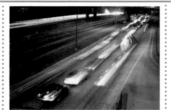	■ Very slow shutter speeds (5 seconds +) can be used to make vehicles "disappear," leaving only their light trails. ■ A tripod is essential to avoid camera shake. ■ You should NEVER use your flash to photograph moving traffic.
TO BLUR 1/125 SEC +	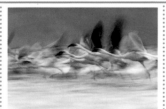	■ Telephoto lenses exaggerate movement, so use faster shutter speeds with long lenses. ■ When you're shooting handheld, activate image stabilization, if available, to reduce camera shake.
TO BLUR 1/8 SEC +		■ 1/8 sec is usually slow enough to blur fast-moving water, but 1/2 sec or longer may be needed for a slower flow. ■ Use a neutral density filter so you can extend the exposure time and create a misty, milky effect (see pp.70–71).

FREEZING **MOVEMENT**

As you've already seen, the shutter speed you choose will have a profound effect on the way in which movement is recorded in your image, making Shutter Priority the go-to mode for moving subjects. This is especially true of fast-moving subjects, since the smallest difference in exposure time (and we're talking about thousandths of a second) can make the difference between a sharply recorded subject and one that's slightly blurred. However, it's not only high-speed subjects that you need to think about: the branches of trees blowing in the wind, flowing water, or even people walking in the street are all examples of more modest movement that could appear blurred unless you are careful.

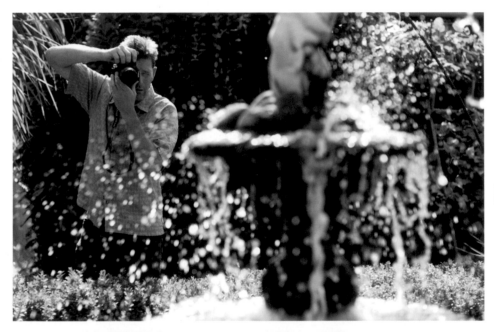

1 FRAME YOUR SUBJECT
No matter what you're photographing, always walk around your subject to determine the best viewpoint. For a shot like this, you'd need to pay careful attention to the background to ensure that the water droplets stand out.

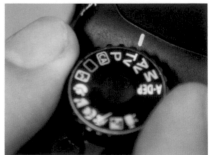

2 SELECT SHUTTER PRIORITY
Set your camera to Shutter Priority so that you have full control over the shutter speed: the camera will select the aperture.

3 ADJUST SHUTTER SPEED
Select the shutter speed by turning the main control wheel on your camera. To freeze movement, aim for a shutter speed of at least 1/500 sec.

4 ACTIVATE CONTINUOUS DRIVE
Activating your camera's Continuous Drive mode allows you to make a number of exposures in rapid succession, so you can pick the best later.

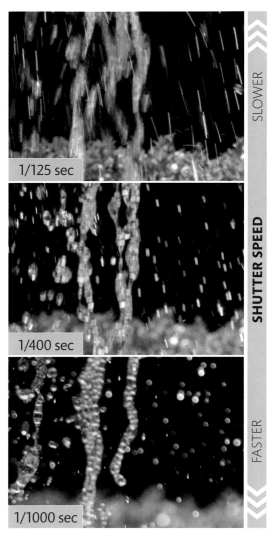

1/125 sec

SLOWER

SHUTTER SPEED

FASTER

1/400 sec

1/1000 sec

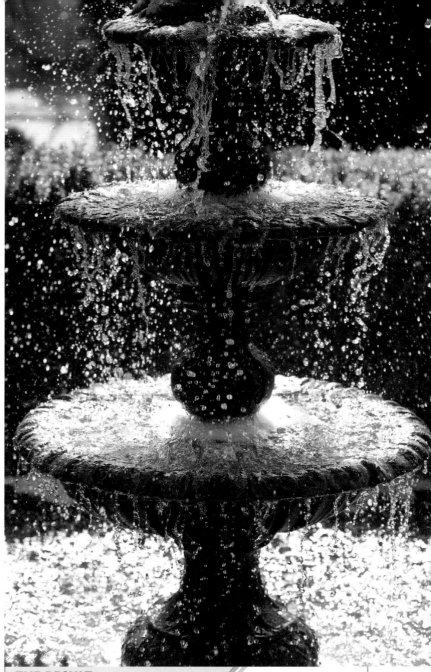

5 EXPERIMENT WITH SHUTTER SPEEDS

It is worth taking several shots using a variety of shutter speeds so that you have a choice of exposures: sometimes a small amount of motion blur may be preferred to absolute sharpness.

SPEED OF MOVEMENT

The shutter speed you need to set to freeze your subject depends entirely on the speed at which it is moving: the faster the subject, the faster the shutter speed required to stop it in its tracks. If in doubt, use the fastest shutter speed possible and hope that it's quick enough.

THE RESULT

Ensuring that every tiny droplet was as sharp as possible meant using a fast shutter speed of 1/1600 sec. To achieve this we increased the ISO to 400.

CAMERA **SETTINGS**

FREEZING **EXTREME MOVEMENT**

When you aim your camera at something that is moving very quickly, you need split-second exposure times if you want to avoid motion blur. Shutter Priority is the obvious mode for this, but it's not as easy as just setting the fastest shutter speed available. You must also pay close attention to the aperture setting and ISO, because you need to make sure that enough light reaches the sensor in this briefest of moments. In turn, this may have an impact on depth of field, so accurate focusing is also critical: in extreme situations you may need to prefocus.

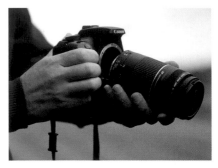

1 CHOOSE YOUR LENS
To get close to the action, you'll need a long focal length lens, so fit a prime telephoto lens or a long-reaching zoom that extends to at least 200mm.

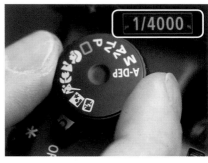

2 SET SHUTTER SPEED
Switch your camera to Shutter Priority mode and dial in a short shutter speed. How short will depend on the speed of your subject, but for this shot 1/4000 sec was needed.

3 INCREASE ISO
Unless it's really bright, you will probably have to increase the ISO so your camera can set an aperture. Treat ISO 1600 as the upper limit, however, to avoid excessive noise.

4 PREFOCUS
Because your camera's Autofocus (AF) system may not react quickly enough to a high-speed subject, it's a good idea to prefocus (see pp.98–99). Manual focus can be useful here, or you can use an off-center AF point (see pp.94–95).

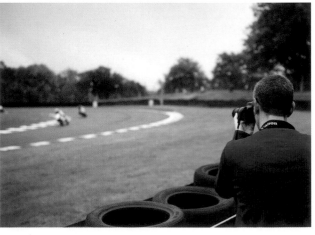

5 RELEASE THE SHUTTER
To stand the best chance of capturing the image you want, you should fire the shutter a split-second before your subject hits the zone of focus. This action will compensate for the brief delay between pressing the button and the exposure happening.

ALSO WORKS FOR...

Ultra-short shutter speeds are useful
for freezing subjects that you might
not normally consider "high-speed"
but that require surprisingly brief
exposure times if you want to record
all of their detail sharply. The beating
wings of a bird can quickly become
a blur, for example, and the time it
takes for a tennis player to hit the
ball or a golfer to play their stroke
can be equally fleeting.

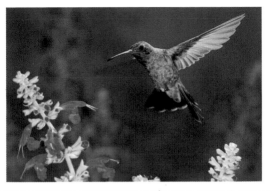

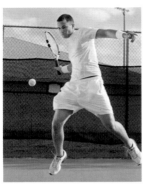

THE RESULT

Timing is everything with this type of shot. Practice
is the only way of knowing what shutter speeds work
best for you, and when precisely you need to trigger
the shutter.

CAMERA **SETTINGS**

 S **f/5.6** **1/4000 SEC** **ISO 400** **AWB**

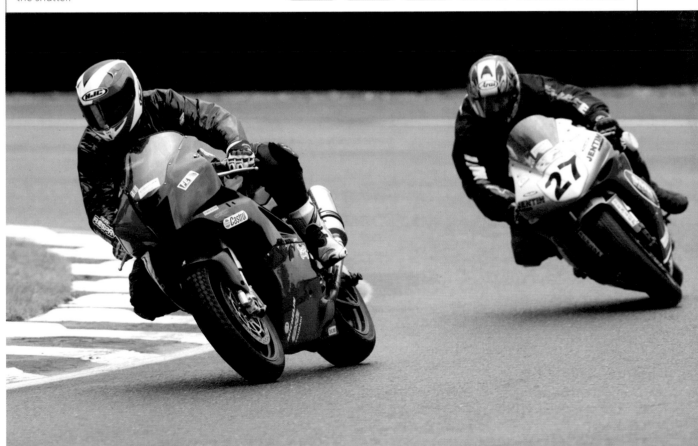

CREATING **MODERATE MOVEMENT BLUR**

While fast shutter speeds can be used to "freeze" a moving subject (see pp.64–67), the opposite is also true—slower shutter speeds can be employed intentionally to allow something to appear blurred in your picture. Again, Shutter Priority is the ideal mode for this, because it allows you to decide on the precise shutter speed you want to use (giving you full control over the level of blur), while the camera sets an aperture to match. This typically means that you'll be shooting with medium to small aperture settings (to restrict the amount of light passing through the lens). A low ISO setting is also a good starting point.

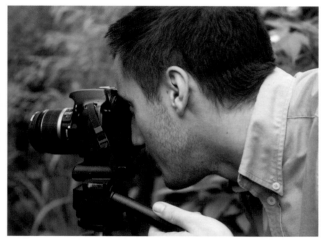

1 **SET UP YOUR TRIPOD**
A tripod is essential for avoiding camera shake when you're using a slow shutter speed. Make sure it's set up somewhere stable and the legs are locked.

2 **FRAME YOUR SHOT**
With your camera on a tripod you can frame your shot precisely, choosing to crop it so that the entire subject is seen or, as here, to zoom in for a slightly more abstract result.

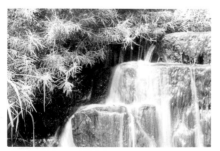

3 **SELECT SHUTTER PRIORITY**
Turn your camera's mode dial to Shutter Priority so you can adjust the shutter speed.

4 **ADJUST THE SHUTTER SPEED**
On most cameras you set the shutter speed using a control wheel next to the shutter-release button.

5 **CHECK THE EXPOSURE**
Your camera will try to select a suitable aperture, but this isn't always possible. Review your image to make sure it's not overexposed.

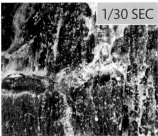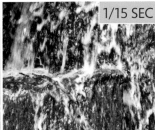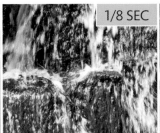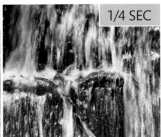

| 1/30 SEC | 1/15 SEC | 1/8 SEC | 1/4 SEC |

FASTER **SHUTTER SPEED** SLOWER

6 EXPERIMENT WITH SHUTTER SPEEDS

There are varying degrees of "slow" shutter speed, and each one will affect the way in which your subject is recorded. There's no reason why you shouldn't take several shots using different shutter speeds, increasing the amount of movement blur as you go, so you have a number of options to choose from.

THE RESULT

Careful selection of the shutter speed has allowed the water cascading over these rocks to appear blurred, while the camera has set an aperture that provides a good overall exposure.

CAMERA **SETTINGS**

S | ◉ | f/22 | 1/6 SEC | ISO 100 | ☀

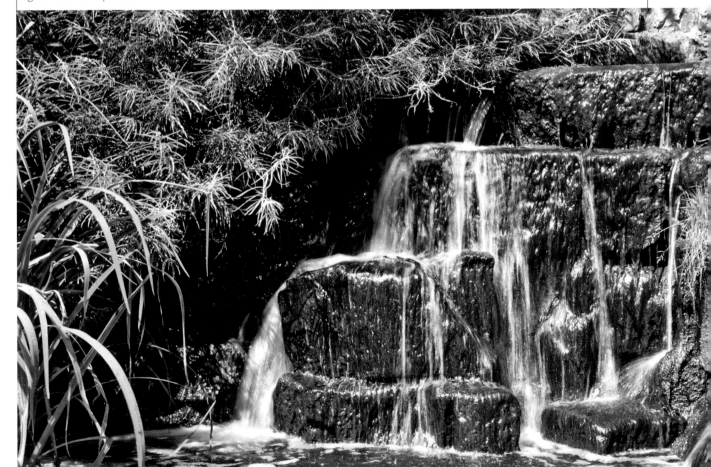

CREATING **EXTREME** MOVEMENT BLUR

When you start using super-slow shutter speeds, the world can look very different. Ordinary streets take on a futuristic appearance thanks to trails of light left by otherwise invisible traffic; people walking will simply disappear; and water can be transformed to mist when exposure times are measured in seconds, rather than fractions of a second. A neutral density (ND) filter (see p.38) is essential for this technique if you're shooting in daylight, and may also prove beneficial in extending the exposure in low-light conditions. Don't forget that the stronger the filter, the longer your shutter speeds can be.

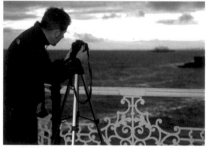

1 SET UP YOUR TRIPOD
It almost goes without saying that you'll need to make sure your camera is locked down on a solid tripod so it can't move during your super-long exposure.

2 FIT A NEUTRAL DENSITY FILTER
An ND filter reduces the amount of light that comes through the lens, which enables you to extend exposure times. Because it's "neutral," the color in your image is unaffected by the filter.

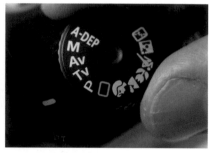

3 SELECT SHUTTER PRIORITY
Set your camera to Shutter Priority and dial in a slow shutter speed: most dSLRs and CSCs will allow you to set an exposure time of up to 30 seconds.

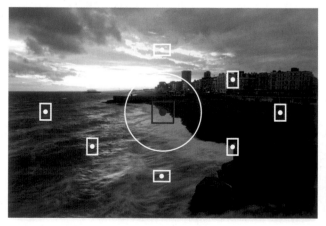

4 CHOOSE AN AUTOFOCUS POINT
In low-light situations it's a good idea to select the central Autofocus point (see pp.88–91), then lock focus and recompose your shot (see pp.92–93). Alternatively, you could focus manually.

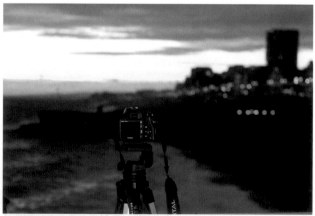

5 TRIGGER WITH SELF-TIMER
Rather than press the shutter-release button yourself (which risks knocking the camera and causing camera shake), use your camera's self-timer or a remote release, if you have one.

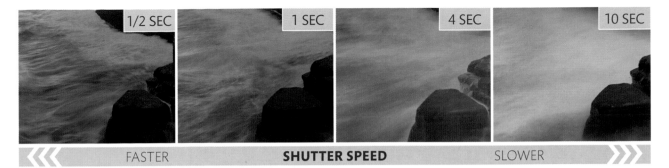

1/2 SEC | 1 SEC | 4 SEC | 10 SEC

FASTER **SHUTTER SPEED** SLOWER

6 CONTROL THE BLUR

The level of blur in your image depends on two things: how quickly (or slowly) the subject is moving and the shutter speed you use. You probably won't have much control over the subject's speed, but you can still vary the way in which the movement is recorded. With water, the longer the exposure, the more "silky" it will appear.

THE RESULT

Using an ND filter on the lens allowed us to increase the exposure time to 20 seconds, even though there was still light in the sky when this shot was taken. As a result, the sea looks more like mist than water.

CAMERA **SETTINGS**

S | (metering) | f/22 | 20 SEC | ISO 100 | (sun)

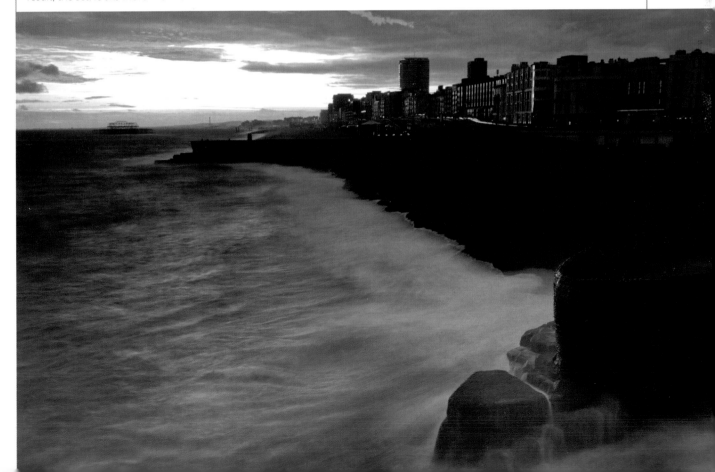

PANNING FOR
SHARPNESS AND BLUR

Freezing and blurring movement are both ways in which you can control the appearance of motion in an image, but what if you want a sharp subject and a sense of motion too? The good news is that this is easily achievable. The solution is to "pan" with your subject, which basically means following them with your camera while you take your photo. Although it's unlikely that the subject will be as razor sharp as it would be if you used a motion-freezing shutter speed, it won't be blurred beyond recognition either; what blur there is will serve to enhance the idea that it is moving.

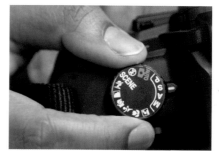

1 SELECT SHUTTER PRIORITY
Turn the mode dial to Shutter Priority and choose your shutter speed: something in the region of 1/60 sec is a good starting point.

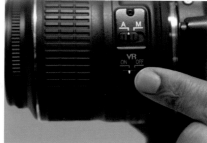

2 ACTIVATE IMAGE STABILIZATION (IS)
For handheld panning shots, switch your IS on. Some lenses offer an IS option specifically for panning, so activate this useful feature if you have it.

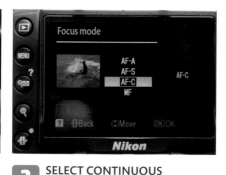

3 SELECT CONTINUOUS AUTOFOCUS
Unless your subject is moving really fast, Continuous Autofocus (AF) mode is the best option—it will keep adjusting focus to keep your subject as sharp as possible.

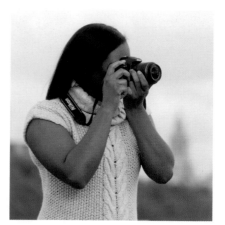

4 TRACK YOUR SUBJECT
Look through the camera's viewfinder and follow your subject as it approaches you.

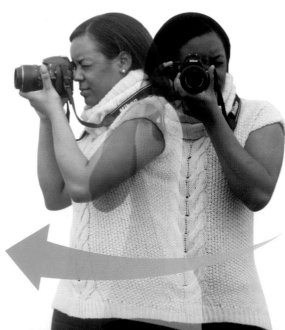

5 PAN THE CAMERA
Just before your subject reaches the point where you want to take your shot, gently press the shutter-release button. Continue to track your subject with your camera as you do so, turning at the waist so that you pan smoothly.

HIGH-SPEED PANNING

When you're photographing very fast-moving subjects, your AF system may not lock on accurately in time to capture the moment. In this situation, focus manually (see p.88) at a predetermined point and wait for your subject to arrive: don't forget to pan quickly as you take your shot though.

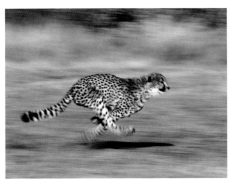
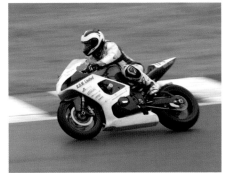

THE RESULT

Panning has created a more dynamic result than a "frozen" shot would have done: the blurred pedestrians and city backdrop contrast strongly with the sharper cyclist.

CAMERA **SETTINGS**

S | 1/60 SEC | ISO 100

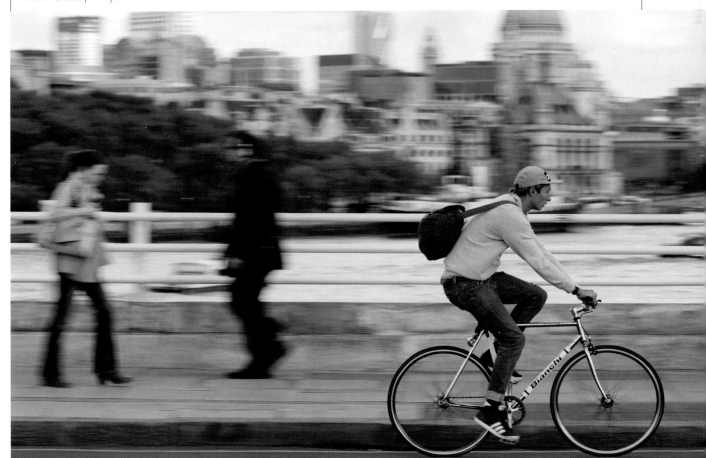

TAKING FULL
MANUAL CONTROL

For some people, switching the camera to Manual mode makes them feel like an expert, as if it's somehow the sign of a great photographer. The truth is, Manual won't enable you shoot any better than you can in Aperture Priority or Shutter Priority modes. What it does, however, is allow you to set the aperture and shutter speed yourself (as well as the ISO), and no matter where you point the camera, it won't change the settings. In challenging lighting conditions this can be a good reason to take manual control of your camera, especially if you use it with a gray card too.

1 SET TO MANUAL
Whenever you want to set the aperture, shutter speed, and ISO yourself there's only one mode to choose, and that's Manual.

2 SET METERING PATTERN
For the greatest accuracy, set your camera to take an exposure reading using its spot or partial metering pattern (see pp.76–77).

USING A HANDHELD LIGHT METER

An alternative to a gray card is to use a handheld light meter. This type of exposure meter reads the light falling onto your subject (known as an incident reading) rather than the light being reflected off it (a reflected reading). The advantage of this is that the meter isn't fooled by how light or dark the subject appears.

3 USE A GRAY CARD
Place a photographer's gray card in the scene, under the same light as your subject. Aim your camera at the gray card, so the card is under the central autofocus point (this is also the spot meter area on most cameras).

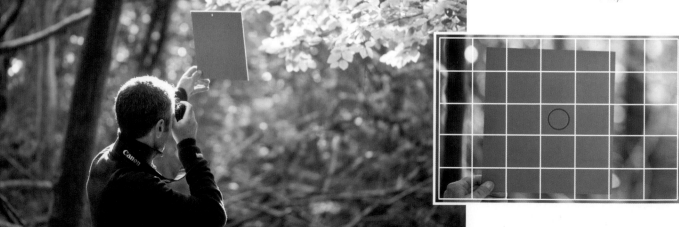

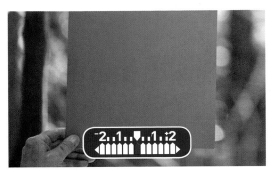

4 USE THE EXPOSURE SCALE
Use the exposure scale in the viewfinder to assess exposure. A shift toward "+" indicates overexposure, toward "-" indicates underexposure.

5 MAKE ADJUSTMENTS
Set aperture and shutter speed until the scale shows the correct exposure, indicated by a "0" or a triangle. Once your exposure's dialed in, you can remove the gray card and take the shot.

THE RESULT

Despite the heavy backlighting and deep shadows in the background, the exposure for this challenging shot is perfect thanks to the use of a gray card and manual exposure mode.

CAMERA **SETTINGS**

M | ● | f/2.8 | 1/80 SEC | ISO 100 | ☀

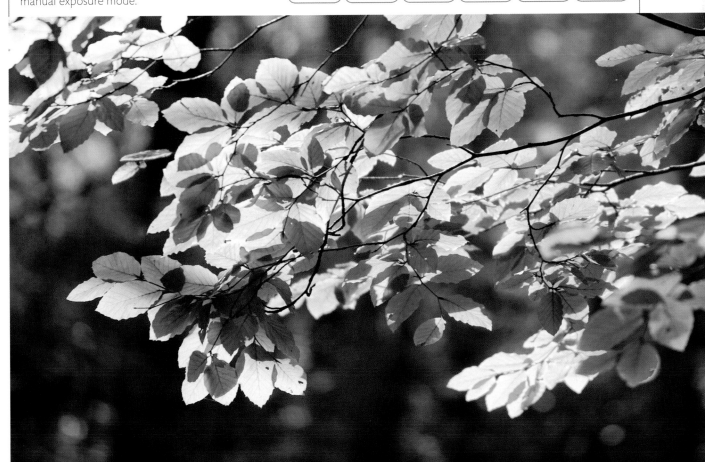

WHAT ARE **METERING PATTERNS?**

Getting the exposure "right" is largely about choosing the most suitable combination of aperture, shutter speed, and ISO (see pp.44–47). However, in order to make that choice, you and/or your camera need to know precisely what's going on in terms of the light levels: unless you know how much (or how little) light there is in a scene, it's impossible to know precisely what settings are needed. Thankfully, all modern cameras have an array of exposure metering patterns to point you in the right direction.

IN-CAMERA

▲ The metering pattern options are usually accessed using a button on the back of your camera.

Exposure meter

The exposure metering system in your camera is an incredibly complex device, which is designed to measure the light in a scene to create an accurate exposure. However, these meters are not infallible, because they work on the basis that the subject you want to photograph would average out as a midtone, which isn't always the case. Therefore, to help you get the most accurate light readings, different metering patterns are employed, allowing you to assess the light levels from the entire frame or, if you want to exclude any overly bright or dark subject areas, just a small part of it.

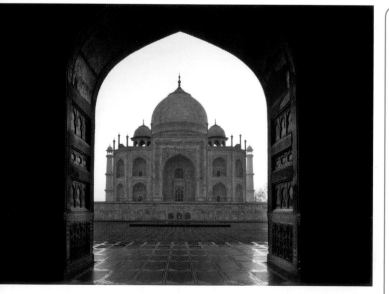

▲ Which metering pattern you select depends on the subject you're photographing: for a shot like this, with tricky, contrasty lighting, spot metering would be a good choice.

PARTIAL METERING

Partial metering is found mainly on Canon cameras and can be thought of as a large spot area: it doesn't read as much of the scene as center-weighted metering, but it's not as small as a true spot meter (see opposite).

METERING PATTERN

MULTI-AREA

Depending on the make of camera, multi-area metering goes under many different names: Evaluative, Matrix, Honeycomb, and Multi-segment are just a few of the names used. However, they all refer to a similar principle: the camera takes its exposure reading from the entire frame. In most instances the scene is broken down into distinct areas, or segments, which are measured independently. The camera then averages out all of these measurements to give an exposure reading. Because the whole scene is taken into account, this type of metering pattern tends to be very accurate in a wide range of situations.

CENTER-WEIGHTED

Of all the metering patterns, center-weighted metering is the most long-standing; some might argue that it's no longer as relevant as it used to be, especially when you consider how sophisticated multi-area metering patterns have become. However, it is still a feature on almost all cameras, and has its uses. Center-weighted metering is most useful when your subject occupies the center of the frame and is surrounded by a predominantly light or dark background—portraits are a prime example. Because the metering pattern is biased toward the center of the frame, it's less likely to be influenced by any extreme tones toward the edges.

SPOT

When you switch your camera to its spot metering mode, it will take an exposure reading from a very small and precise area, usually at the center of the frame, although sometimes it can be linked to the active focus point (see pp.90–91). The benefit of using a spot metering pattern is that it won't be affected by the surrounding area, so if your subject is very small in the frame and surrounded by a large expanse of dark or light (a figure in snow, for example), the extreme tones won't affect the exposure reading. With some high-end cameras, multiple spot readings can be taken and averaged out, and/or the size of the area used for the meter reading can be changed to make it slightly larger or smaller for even greater precision.

WHAT IS A
HISTOGRAM?

The histograms that pop up in your camera and editing software when you review your image can initially seem rather daunting. With a little experience, however, reading a histogram becomes second nature, allowing you to see just how the tones (from light to dark) are distributed across your image. Because it relies on a graphic display, a histogram isn't affected by the light you view it under (as an LCD screen can be), so it's an incredibly effective way of checking whether your exposure is good.

IN-CAMERA

▲ All dSLRs and CSCs allow you to call up a histogram when you review your images on the LCD screen. This is far more accurate than simply assessing the brightness of the image on screen.

UNDEREXPOSED	CORRECT EXPOSURE	OVEREXPOSED

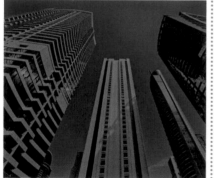
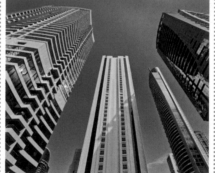
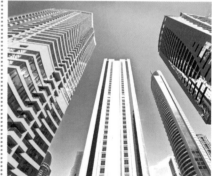

When the bulk of the histogram is toward the left of the scale, it means that there are a lot of dark tones in the image. If it isn't a particularly dark scene, then the shot is almost certainly underexposed. In extreme cases the graph will hit the left end of the scale, indicating that some of the darkest tones are lost.

The ideal histogram will have the tonal spread fitting within the ends of the graph. This tells you that you've recorded all of the detail in the scene, from the very darkest areas through to the brightest. Because a full tonal range has been recorded, this type of image responds well to further editing.

If your histogram crashes into the right end of the scale it means that certain areas are pure white, and no amount of processing will enable you to bring out any detail: it's lost for good. When the histogram suggests that this might be the case, adjust the exposure and shoot again.

How to read a histogram

Essentially, the dark tones/shadows in your image are represented at the left edge of the histogram, while the right end represents bright tones/highlights. The height of the graph shows how many pixels have a particular tone, but this can be largely ignored. What's more important is that the graph fits within the scale: if it appears to go off the scale to the right, then certain highlight areas have become pure white; if it appears to go off the scale to the left, then shadow detail has been lost. This loss is known as clipping.

| VERY DARK | DARK | MEDIUM | LIGHT | VERY LIGHT |

▲ SCALE OF TONES

LOW KEY

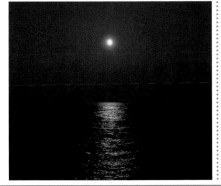

Here, the histogram is shifted to the left, which would suggest that this particular image has been underexposed. However, this example shows why you can't rely purely on the histogram: the shot is of a dark subject, so you'd expect to see more dark tones present.

HIGH KEY

This high-key image is made up primarily of bright, light tones, with little in the way of shadow. Because of this, the histogram is shifted to the right. That's not a problem in itself, but it's a good idea to keep an eye on the end of the histogram to avoid clipping too many light areas.

SILHOUETTE

When an image is made up of a combination of very dark and very bright areas, as is the case with this silhouette, the histogram tends to appear split between the two ends of the scale. In this particular instance it doesn't really matter if the highlights or shadows are clipped.

FINE-TUNING EXPOSURE

Although your camera's metering system does a great job of getting the exposure right, it's not infallible. There will be times when a picture comes out lighter or darker than anticipated, and the most common reason will be because the scene you're photographing is either very dark or very bright.

In this situation your camera will try to expose it as if it's a midtone (see pp.124–25), so a bright scene will appear dark and vice versa. When this happens, exposure compensation can be used: dialing in positive (+) compensation will brighten an image, and negative (-) compensation will darken it.

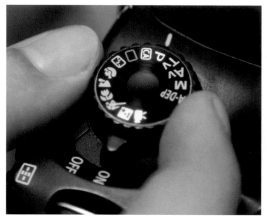

1 SELECT A MODE
Exposure compensation can be applied in Program, Aperture Priority, or Shutter Priority modes. It's not usually available in Auto, Scene, or Manual modes.

2 TAKE A TEST SHOT
There's no surefire way of determining the correct amount of exposure compensation to apply—and it depends on the look you're after—but taking a test shot at the camera's recommended exposure setting will give you a good starting point.

3 ASSESS YOUR IMAGE
Your test shot's histogram will tell you whether your image is under- or overexposed (see pp.78–79) and give an indication of how far out the exposure is.

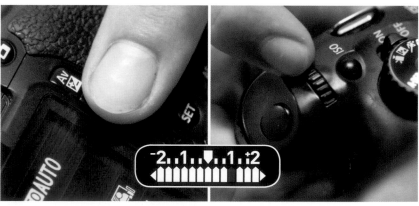

4 APPLY EXPOSURE COMPENSATION
To apply exposure compensation, press and hold the exposure compensation button (left), and turn the main control wheel (right). If you're working in Aperture Priority mode, exposure compensation will adjust the shutter speed; in Shutter Priority mode, it will adjust the aperture.

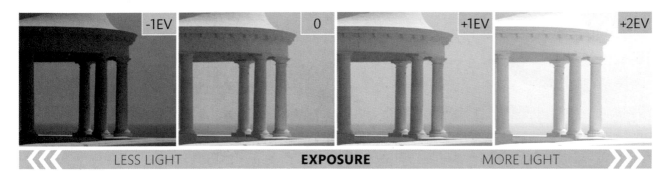

| -1EV | 0 | +1EV | +2EV |

◄◄◄ LESS LIGHT　　　　**EXPOSURE**　　　　MORE LIGHT ►►►

5 TAKE A SET OF EXPOSURES

The precise level of exposure compensation needed will vary from shot to shot, even with the same subject, so it's a good idea to take a series of shots with different levels of compensation applied. Alternatively, you could start by dialing in a small amount of exposure compensation and using your camera's exposure bracketing feature (see pp.82–83).

THE RESULT

If you let the camera determine the exposure, the dominant bright tones in this scene would lead to underexposure. With a touch of exposure compensation, however, the shot sparkles.

CAMERA **SETTINGS**

P　◉　*f/13*　1/50 SEC　ISO 100　☀

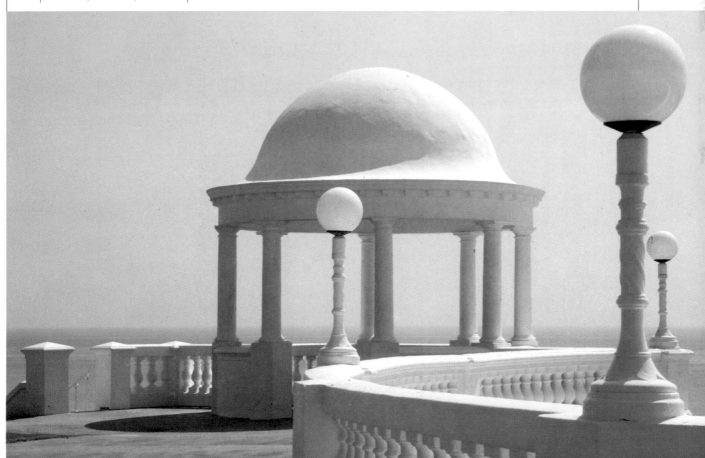

USING **AUTOMATIC EXPOSURE BRACKETING**

Although you can apply exposure compensation (see pp.80–81) to tweak the camera's suggested exposure, it means taking a shot and assessing its histogram, which takes time. With moving subjects this has obvious implications, because the moment you want to record may have passed by the time you've made your changes and are ready to shoot again. That doesn't just apply to fast-moving subjects —a fleeting break in the clouds that produces a patch of light can be just as time-sensitive. In these instances, activating your camera's Automatic Exposure Bracketing (AEB) feature is the answer.

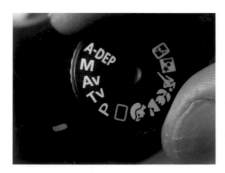

1 FRAME YOUR SHOT
It's always a good idea to set your camera up on a tripod if you've got time (and a suitable subject). When you're using AEB it's especially useful because it will allow you to fire off your exposure sequence without any movement between frames.

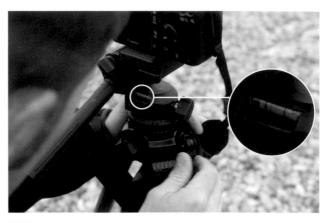

2 LEVEL YOUR TRIPOD
Whenever you're shooting a landscape (and by extension, a seascape), it's important to keep the horizon level, but special care should be taken when you're setting up on an uneven or soft surface such as pebbles or sand. Use your tripod's built-in bubble level to guide you.

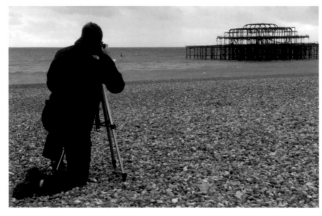

3 SELECT A MODE
On most cameras it isn't possible to use AEB in Auto, Manual, or Scene modes, so choose Program, Aperture Priority, or Shutter Priority instead.

4 ACTIVATE AEB
AEB is found as a menu option or accessed via a button on your camera. In both cases you need to set the number of frames and an exposure gap.

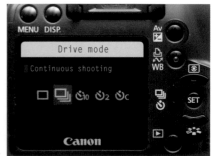

5 ACTIVATE CONTINUOUS DRIVE
When using AEB you need to take your bracketed sequence as a "burst" of shots, so set your camera to Continuous Drive mode.

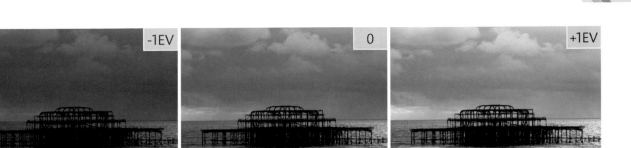

LESS LIGHT **EXPOSURE** MORE LIGHT

6 TAKE A SET OF EXPOSURES

Hold down the shutter-release button to take your bracketed exposure sequence. For this image we set AEB to make three exposures at 1-stop increments. This meant that we ended up with one shot that's 1 stop darker than the camera's suggested exposure setting (-1EV), another at the suggested exposure (0), and a third that's 1 stop brighter (+1EV).

THE RESULT

When we opened the images on the computer we decided that the exposure that's 1 stop brighter than the suggested reading works best: the extra exposure really makes the water shimmer.

CAMERA **SETTINGS**

 1/500 SEC ISO 400

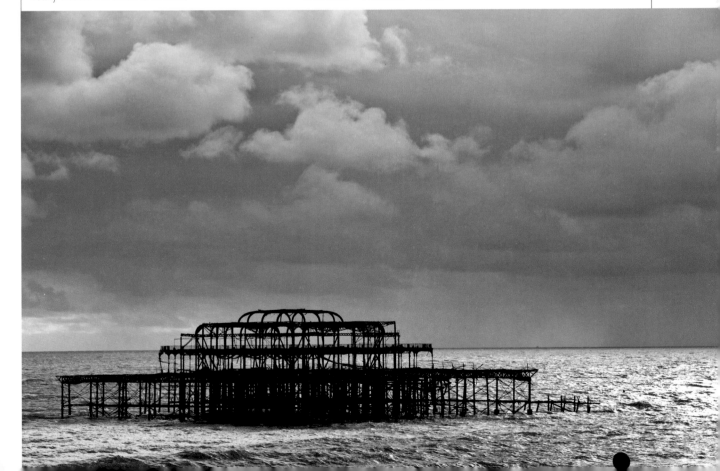

WHAT IS
HDR IMAGING?

The dynamic range of a scene refers to the brightness range between the darkest shadow and the lightest highlight, or, in layman's terms, the contrast. This is important for photographers because a camera's sensor can only record a limited dynamic range: if the range of a scene exceeds the capability of the camera, the highlights, shadows, or both will be clipped (see pp.78–79). However, there's a practical—and creative—solution: High Dynamic Range (HDR) imaging.

Shooting for HDR

The idea behind HDR imaging is to take a number of shots of the same scene, adjusting the exposure between shots so you have one shot that records detail in the brightest highlights; another that records all the shadow detail; and additional exposures in between. These images are then combined using HDR tools or software.

The easiest way of capturing your initial sequence is to use your camera's Automatic Exposure Bracketing feature (see pp.82–83). Setting the number of frames to 3 or 5, and the spacing between them to at least ±2EV, will be sufficient in most instances.

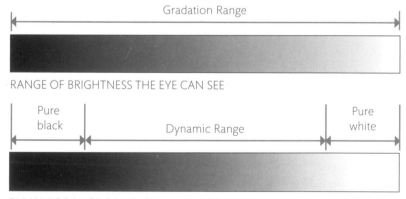

Gradation Range

RANGE OF BRIGHTNESS THE EYE CAN SEE

Pure black | Dynamic Range | Pure white

DYNAMIC RANGE OF A DIGITAL CAMERA

▲ Because our brains constantly adjust for different brightness levels, we can see a wide range of tones. However, a digital camera's sensor has a fixed dynamic range—anything outside that range will appear as pure black or pure white.

HDR SOFTWARE

Once you've shot your exposure sequence, you need to use editing software to merge them using a process known as tone-mapping. This takes the best pieces (in terms of exposure) from each image and combines them into a single picture. Your current software package may have some sort of built-in HDR feature, but stand-alone software, dedicated to to HDR imaging, tends to produce much more sophisticated results.

EXPOSURES

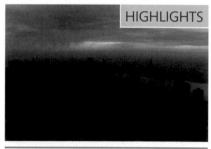

HIGHLIGHTS

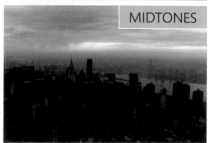

MIDTONES

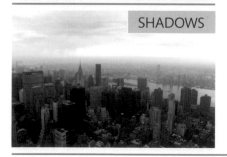

SHADOWS

IN-CAMERA DYNAMIC RANGE OPTIMIZATION

An increasing number of camera manufacturers have developed in-camera tools to help deal with scenes of high dynamic range. These include Auto Lighting Optimizer from Canon, Active D-Lighting from Nikon, and D-Range Optimizer from Sony. Each works in a slightly different way, but the general approach is the same: the exposure is set to preserve as much detail as possible in the high-light areas, and then the shadow areas are lightened in-camera to prevent them from appearing too dark. This image shows the same scene both without (left) and with (right) in-camera dynamic range optimization.

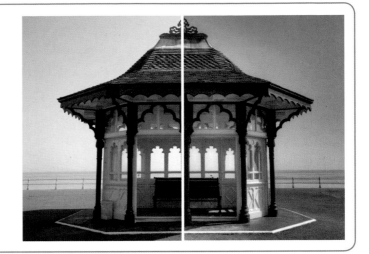

MERGED HDR IMAGE

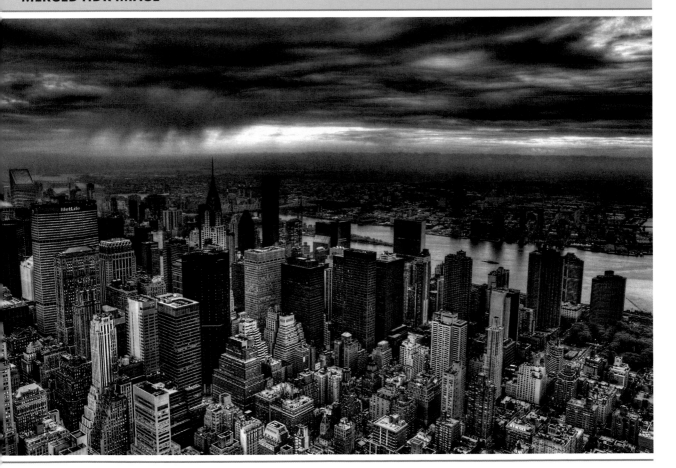

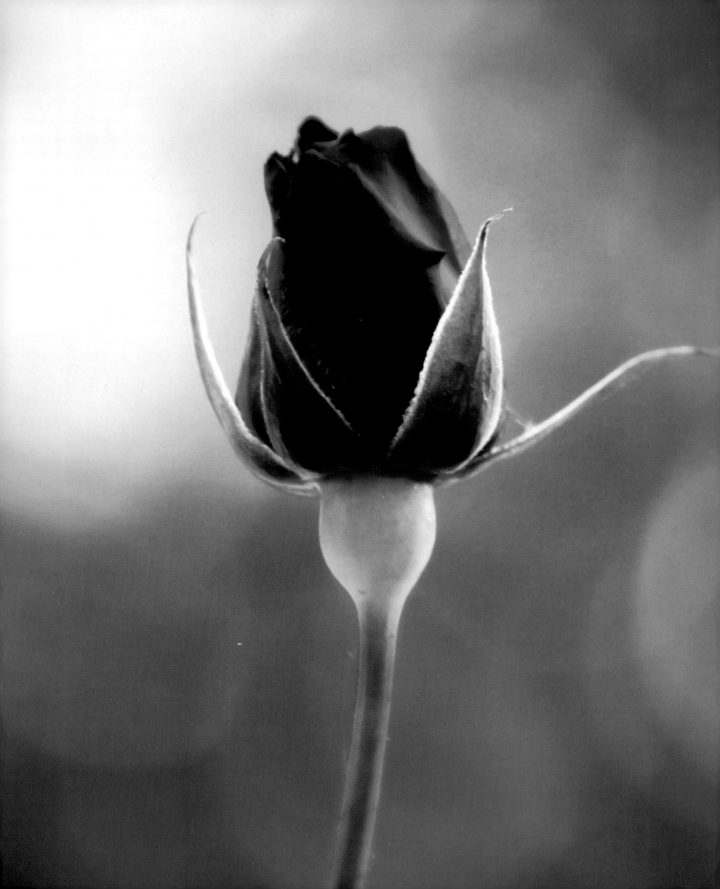

FOCUSING

FOCUSING

After exposure, focusing is perhaps one of the most important areas in photography. Most people will tolerate colors that are a little off, or a slightly awkward composition—and these can often be corrected using editing software—but an out of focus shot will almost always look wrong (unless it's a deliberate creative effect). Moreover, there's very little you can do to salvage a blurred photograph, so getting the focus right is an essential skill. In this chapter you'll discover the tools your camera has to help you, and how best to use them.

Manual focus

Before Automatic Focusing (AF) systems were developed, the only way to get a sharp picture was to focus the lens by hand, manually adjusting it until the image in the viewfinder appeared to be in focus. Although this is a much slower process than using a modern AF system, the advantage is that you can choose precisely where you want to focus.

This can be useful for a number of reasons. For example, you may wish to focus on a particular point in a scene for creative effect, or you may need to take over from the camera when low light and/or low contrast make it difficult for the AF system to lock onto your subject.

Manual focus is also the best option when you're photographing close-up subjects, or are working with a very shallow depth of field—in any situation, in fact, where you want to have absolute control over the point at which your lens is focused.

◀ Low light and low contrast are two common situations in which modern AF systems can struggle, but this is another: photographing someone (or something) through glass. The various reflections can easily throw the AF system off track, making manual focus a more reliable alternative.

Autofocus points

All cameras now have AF, and all AF systems rely on one or more focus points, which are sensors that the camera uses to set the focus. The precise number of focus points depends almost entirely on the level of the camera you're using, with advanced models tending to have more AF points than entry-level cameras. However, the number of AF points isn't the only factor affecting accuracy: the spread of the points and the sophistication of the focusing system behind them is equally important.

ENTRY LEVEL

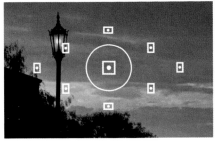

ADVANCED

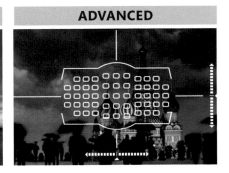

Autofocus modes

There are three AF modes that you need to familiarize yourself with if you want to get the best from your camera: One-shot (or Single-shot), Continuous, and an Automatic option. As a simple rule, One-shot AF is usually used for static subjects; Continuous AF is the better choice when your subject is moving; and Auto is the one to go for if you anticipate that your subject *might* move.

ONE-SHOT **CONTINUOUS** **AUTO**

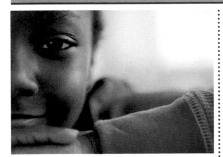 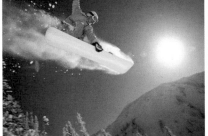 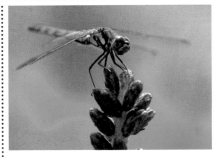

One-shot AF is perhaps the most commonly used mode for general subjects. In One-shot AF mode you activate the focusing system and the camera uses one or more focus points to try to set the focus. Once it's locked on, it will maintain focus at that distance until you take a shot or release the AF.

If you're shooting a moving subject, Continuous AF (see pp.96–97) may be the mode to go for. In this mode the camera will adjust the focus if it detects that your subject is moving toward or away from the camera. It will continue doing this until you press the shutter-release button fully.

Called AF-A by some manufacturers, many cameras have a focusing option that will switch between One-shot and Continuous AF automatically. If the subject is static, then One-shot AF is used, but if the subject is moving (or starts to move), the camera will switch to Continuous AF.

USING **MULTI-AREA** AND **SINGLE-POINT AUTOFOCUS**

When they first start taking photographs, most people will begin by placing the subject of their shots front and center. A figure, building, plant, or other point of interest will be sharply focused and in the middle of the frame. This is perfectly acceptable, but in photography—as with many other art forms—positioning the main subject in the center of the frame can very quickly feel a little predictable. To introduce more dynamism into your images, consider placing your subject off-center and then selecting the Autofocus (AF) point that you want your camera to use.

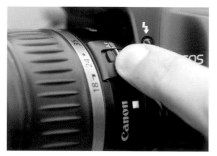

1 ACTIVATE AUTOFOCUS
Make sure that your camera is set to AF. Depending on your equipment, you may need to set this on both the camera and lens, or just the camera body.

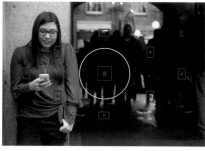

2 SELECT ALL AF POINTS
To be sure your camera is set to Multi-area AF, press the AF point button and turn the control wheel until all of the AF points show as "active."

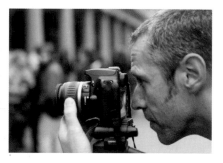

3 FRAME YOUR SHOT
With the camera deciding which AF point it will use, all you need to do now is frame your shot and take the picture. But you may decide that you need more control.

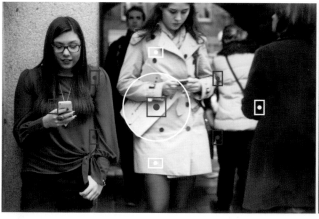

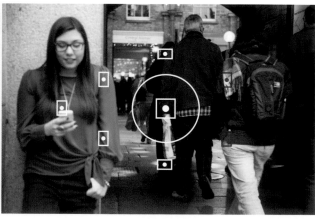

4 FOCUS
Pressing the shutter-release button halfway down will activate the AF system, and your camera will decide which AF point (or points) is appropriate. The focus point(s) that the camera has chosen to use will be highlighted in the viewfinder, or on the rear LCD screen if you're using Live View. This will usually (but not always) be the closest or most high-contrast area. If you're happy with the camera's choice, press the shutter-release button down fully to take the photo.

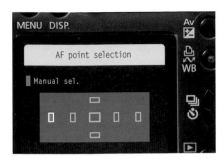

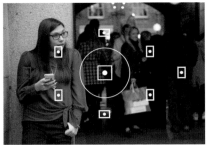

ZONE FOCUS

In addition to Multi-area and Single-point AF selection, some cameras that utilize a high number of focusing points offer "zone focusing." This allows you to choose a group of AF points (typically top, bottom, left, right, or center), and the camera then selects a single AF point from this area. In effect, the camera is making the final decision, but you are guiding it to a specific part of the frame.

5 ADJUST FOCUS
If you're not satisfied with the camera's choice, you can select an AF point yourself by pressing the AF point button and turning the control wheel.

6 CHANGE POINT OF FOCUS
Here, the focus point was shifted deliberately to the figure at the left of the frame, so there was no chance of the camera picking an inappropriate AF point.

THE RESULT

To inject some energy and movement into our composition, we chose to contrast the stillness of the girl with the busy shoppers by using a slow shutter speed (see pp.62–63).

CAMERA **SETTINGS**

M	▭	f/22	1/2 SEC	ISO 100	AWB

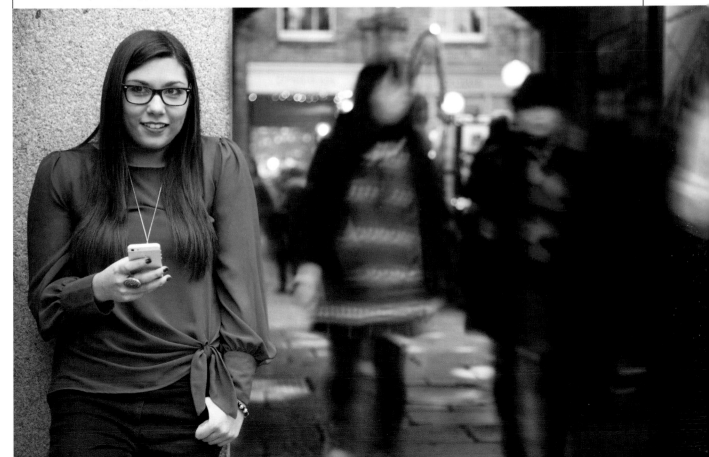

FOCUSING AND **REFRAMING**

Selecting a single Autofocus (AF) point (see pp.90–91) is often all that's needed to focus on off-center subjects, but it's not always the most convenient way to do it. Selecting the relevant AF point takes time, especially if you have to scroll through a lot of focus point options, so it's not particularly conducive to spontaneous handheld shooting. There's also a chance that your camera may not actually have a suitably positioned AF point to start with. In both cases, the answer is to use just one AF point and "lock" the focus before reframing the scene and taking your shot.

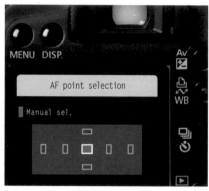

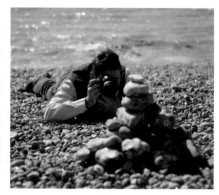

1 ACTIVATE AUTOFOCUS
Make sure that your lens is set to AF (with some camera models you'll need to set the camera to AF too), and that the focusing mode is in Single-shot, rather than Continuous Autofocus.

2 SELECT THE CENTRAL AUTOFOCUS POINT
Press your camera's focus point selection button and turn the control wheel to select the central AF point.

3 FOCUS
Aim your camera at your subject so the area you want to focus on is under the central AF point. Press the shutter-release button halfway down to focus.

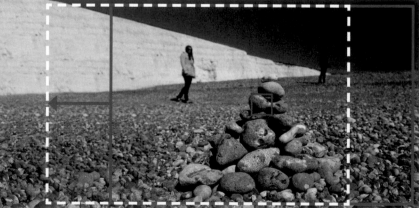

4 REFRAME YOUR SHOT
Keep the shutter-release button half depressed to "lock" the focus (and the exposure, see box, opposite). After focusing (indicated by the red box) you are now free to move the camera: as long as you are in Single-shot AF mode and you keep your finger on the shutter release, the camera will maintain focus at that point. Once you've reframed your shot (as indicated by the white dotted line in the diagram above) press the shutter-release button fully to take the photo.

AUTOMATIC FOCUS LOCK

As well as locking the focus, depressing the shutter-release button halfway down will also lock the exposure. In some situations you won't want this to happen, because moving your camera to reframe your shot may mean that the exposure needs to change too (if the reframed scene is any lighter or darker). In this case, instead of using the shutter-release to lock focus, use your camera's Automatic Focus Lock (AF-L) button. AF-L usually doubles as the Exposure Lock, but you can customize it via your camera menu so that it locks only focus. This means that you can lock focus and recompose, and the exposure will change if necessary.

THE RESULT

The success of this slightly esoteric shot required three things: a low (ground level) vantage point; a very shallow depth of field (see pp.58–59); and precise control over the point of focus.

CAMERA **SETTINGS**

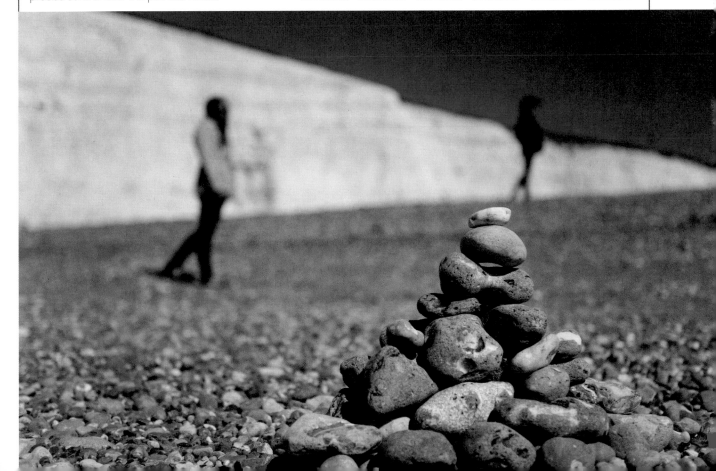

CONTROLLING YOUR
POINT OF FOCUS

Before the advent of Automatic Focusing (AF) systems, focusing a lens by hand was the only option. In the early days of AF, many photographers still preferred to choose the point of focus for themselves, rather than relying on the camera and its then slow and unwieldy automation.

Although today's AF systems are incredibly fast and accurate compared to their predecessors, to some extent the same thinking still applies: taking full control and setting the focus manually puts you in the driver's seat, and guarantees that what you want in focus in your shot is indeed in focus.

FOCUS SETTINGS

This won't apply to all cameras, but it's important to set not only your lens to Manual Focus but your camera too, to deactivate its Autofocus motor. If you don't, you could damage the motor.

1 SELECT MANUAL FOCUS
Set your lens to Manual Focus (MF) if it has this option. Some lenses have an option that allows you to focus manually at any time, without changing the setting.

2 FRAME AND FOCUS
With your camera and lens set to Manual, you can frame your shot and choose your point of focus. Be sure to turn the focus ring on your lens, and not the zoom ring—on some lenses the two are close together.

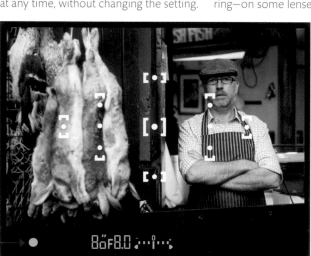

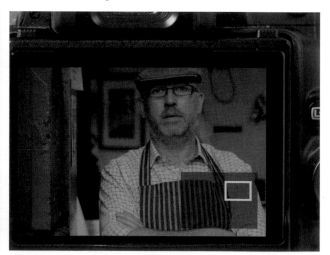

3 CHECK THE VIEWFINDER
Most dSLR cameras have a focus confirmation in the viewfinder display—usually a dot or asterisk that appears when focus is set (here indicated by the green dot on the left). In MF mode this still works, so you can use it as a guide to focusing.

4 ADJUST FOCUS USING LIVE VIEW
If you have Live View available, it's likely that you'll be able to magnify a central section of the preview image to help you to focus precisely. This option varies between cameras, so check your manual.

ALSO WORKS FOR...

Choosing to use Manual Focus is usually
a creative decision, but there are times when
it becomes a necessity. The most common
of these is when you're working in low light.
To function efficiently, an AF system requires
light and contrast: the more there is of each of
these, then the quicker the AF will be. However,
this means that your camera will sometimes
struggle to lock onto your subject in low-light
and low-contrast conditions, which makes
Manual Focus the only reliable option.

THE RESULT

For this shot we wanted to keep the farmer sharp
and his produce slightly blurred, rather than showing
it in graphic detail, so switching to Manual Focus
was an obvious choice.

CAMERA **SETTINGS**

A | f/2.8 | 1/125 SEC | ISO 400

TRACKING A **MOVING SUBJECT**

Your camera's default single-shot Autofocus (AF) mode is more than a match for static subjects, but you may find that your results aren't quite as sharp as you'd like when your subject starts to move. The reason for this is simple: Single-shot AF focuses at a specific point and keeps the lens focused at that distance until you have your exposure. If your subject moves toward you or away from you before this happens, then it will start to become less focused. In these situations the answer is fairly straightforward: switch to Continuous AF mode, which allows the focus to adjust continuously until you shoot.

1 **BE READY**
Using your camera handheld gives you greater flexibility when it comes to photographing a subject that could move erratically around the frame.

FOCUS TRACKING

In addition to Continuous AF, some cameras offer focus tracking (also referred to as Dynamic AF). In this mode, your camera will attempt to predict how your subject will move around the frame and use different AF points to maintain focus. So, not only will it adjust the focus as the camera-to-subject distance alters, but it will also actively follow your subject.

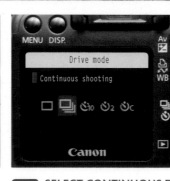

2 **SELECT CONTINUOUS AF**
Switch your camera to Continuous AF mode, so the focus will be adjusted automatically as your subject moves around the frame. On most cameras this is done via a button on the camera body.

3 **SELECT CONTINUOUS DRIVE**
Press the Drive mode button and set the shooting mode to Continuous. Be aware that some cameras have more than one Continuous setting (typically Lo and Hi).

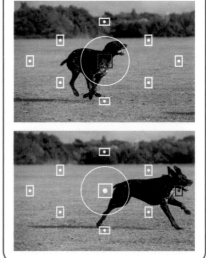

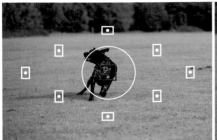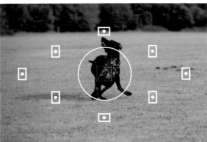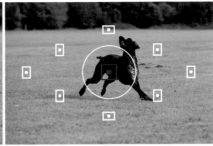

4 ACTIVATE CONTINUOUS AF
Once you have tracked your subject—in this case an excitable dog—sufficiently to get it under an AF point, half-depress the shutter-release button to activate your camera's Continuous AF system. The camera will automatically attempt to focus on your subject, and maintain focus, as long as it remains under the AF point. When the subject is in the optimal position, press the shutter-release button fully and hold it down to make a series of exposures.

THE RESULT

With both the camera's AF and Drive mode set to Continuous we increased our chances of getting that one "decisive" shot.

CAMERA **SETTINGS**

M | f/5.6 | 1/640 SEC | ISO 200 | AWB

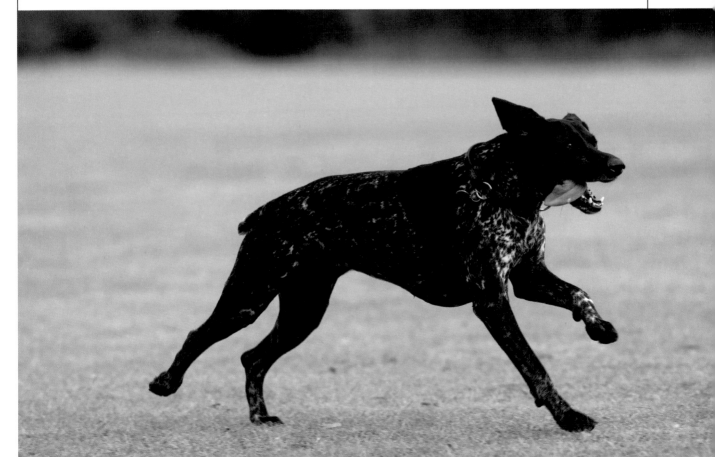

FOCUSING ON **HIGH-SPEED SUBJECTS**

No matter how sophisticated your camera's Autofocus (AF) system is, or how many focus points are available, the physical process of focusing a lens takes time. Even if it appears instantaneous, there's a fraction of a second before the lens "locks on." While this isn't a problem with the majority of subjects, it can be frustrating when you're trying to focus on something that's moving really quickly. Continuous AF will help up to a point, but it still needs a moment to identify the subject—and if it's moving at high speed, it could be gone before that's happened. In this situation, prefocusing is the answer.

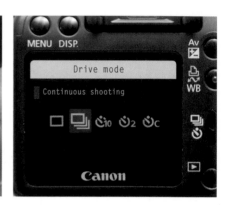

1 **SWITCH TO MANUAL FOCUS**
Although it might seem counterintuitive, when it comes to photographing fast-moving subjects, you should switch to manual focus rather than relying on your camera's AF system.

2 **SELECT A MODE**
Set Aperture Priority (see pp.54–55) if you want to control the depth of field, or Shutter Priority (see pp.62–63) to control the appearance of movement, then set the aperture or shutter speed accordingly.

3 **SELECT CONTINUOUS DRIVE**
Switch to your camera's Continuous Drive mode (rather than Single-shot) so you can hold down the shutter-release button and shoot a burst of frames.

4 **PREFOCUS**
Focus manually at the point where you anticipate your subject being: in this case, a particular point on a race track. The key is to try to predict where your subject will be and focus on that point.

5 **WATCH AND WAIT**
Just before your subject reaches the predicted point of focus, trigger the shutter, holding it down to capture a series of images.

ALSO WORKS FOR...

Prefocus can be used for any subject that moves very quickly—typically something faster than the camera's AF system can deal with—as long as you know where the action will take place. Use your camera's fastest continuous shooting mode and record JPEGs rather than Raw files, as this will allow your camera to record more frames in a burst, at a faster rate.

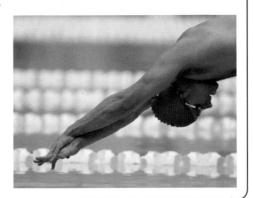

THE RESULT

Prefocusing can be tricky to master, but when everything comes together—focus, exposure, and timing—the reward is an extremely sharp shot, no matter the speed at which your subject is moving.

CAMERA **SETTINGS**

 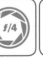 1/125 SEC ISO 100 AWB

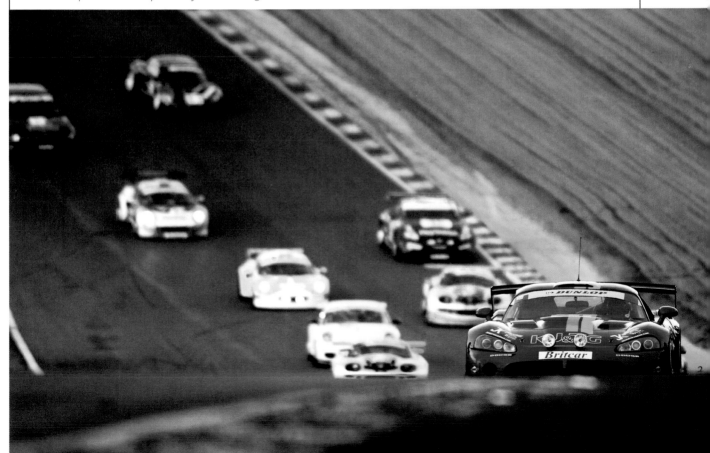

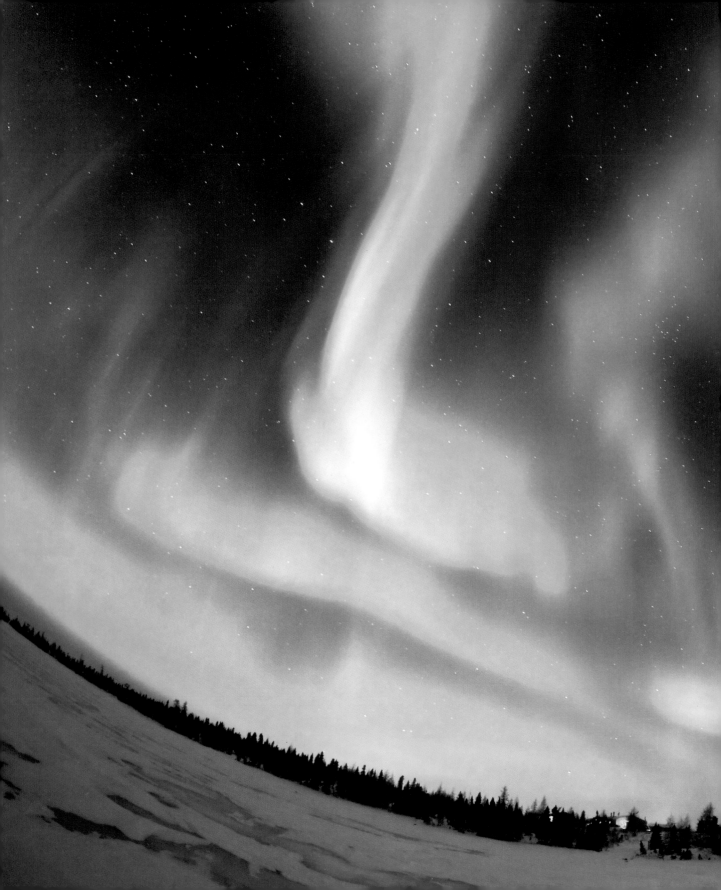

4

LENSES

LENSES

The lens is one of the most critical components in photography, and the quality of the lens is arguably even more important than the quality of your camera: a top-of-the-range camera will never achieve the results it is capable of if it is paired with a lower grade lens, but a good lens can unlock the full potential of even the most modest SLR camera or CSC. In this chapter, you'll find out what lenses are available, and how to get the best from them.

WIDE-ANGLE FOCAL LENGTH	STANDARD FOCAL LENGTH

Wide-angle focal lengths have a wide angle of view which enables them to get it all in, and for many photographers, that's reason enough to own one. But they can do so much more: when used for close-up work, they can appear to exaggerate the distance between near and far elements, while providing an extensive depth of field that enables both to be kept in focus.

An image from a standard lens is roughly the same as we see with our eyes. Strictly speaking, the standard focal length is equal to the diagonal measurement of the sensor, which is 43mm for a full-frame 35mm sensor, but a 50mm focal length is more widely used. On cameras with APS-C sized sensors, a 35mm focal length is considered standard, while for FourThirds systems, 25mm is standard (see p.106).

BEST USED FOR

■ Wide-angle lenses are great for landscape photography when you want to record a large-scale scene (see pp.108–09).

■ When used with care, wide-angle lenses can be very useful for interior shots when space is limited (see pp.110–11).

BEST USED FOR

■ A standard lens is a good choice when an entirely natural-looking perspective is required.

■ Prime standard lenses have wide maximum apertures, so are ideal when you want to focus selectively.

PRIME LENSES

A prime lens is one with a fixed focal length, such as a 28mm lens, 35mm, 50mm, and so on. Although not as versatile as a zoom lens that covers multiple focal lengths, prime lenses are typically cheaper, have faster maximum apertures (which is great for low-light photography), and, most importantly, can often deliver better results than a zoom lens. This is simply because it's easier to optimize the design of a lens for a single focal length, rather than a range.

▲ 17MM ▲ 35MM ▲ 50MM ▲ 85MM ▲ 180MM

TELEPHOTO FOCAL LENGTH

A telephoto lens has a telescopic effect, with long focal lengths (75mm+) that enable you to get closer to distant subjects. This is useful when you're trying to photograph something that you can't get physically closer to, but you do need to be careful: long focal lengths magnify movement, so use a tripod or image stabilization to avoid camera shake.

BEST USED FOR

■ Traditionally, a telephoto lens is used for sports or wildlife photography (see pp.114–15).

■ Mild telephoto lenses in the region of 75–150mm are widely considered as ideal for portraits (see pp.112–13).

MACRO FOCAL LENGTH

A macro lens allows you to focus at a much closer range than other lenses allow, so you can really fill the frame. Technically, true macro offers 1:1 reproduction, so a subject will appear life-size on the sensor. However, zoom lenses that have a macro setting don't usually offer that level of magnification: a ratio of 1:2 (half life-size) or 1:4 (a quarter life-size) is more common.

BEST USED FOR

■ Small subjects such as flowers and insects (see pp.116–19).

■ Although designed primarily for close-up photography, macro lenses can also be used for other subjects: a 150mm macro makes a good telephoto lens, for example.

WHAT IS FOCAL LENGTH?

All lenses are described by a focal length, whether it's a single focal length for a prime lens (see p.103) or a range of focal lengths covered by a zoom lens. Put simply, the focal length of a lens gives you an indication of its angle of view, as illustrated below, so you have an idea of how wide it is, or how much of a telephoto effect it will have when it's attached to your camera. The focal length(s) that you use most will generally be dependent on the subjects you prefer to photograph.

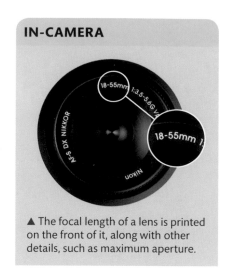

IN-CAMERA

▲ The focal length of a lens is printed on the front of it, along with other details, such as maximum aperture.

ANGLE OF VIEW	75°	63°	43°

The angle of view refers to the amount of a scene that a lens can see and record on your camera's sensor. It's usually based on a diagonal measurement.

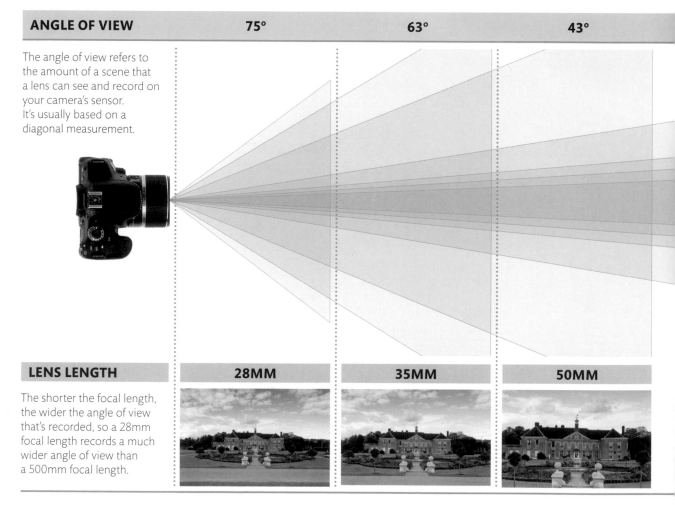

LENS LENGTH	28MM	35MM	50MM

The shorter the focal length, the wider the angle of view that's recorded, so a 28mm focal length records a much wider angle of view than a 500mm focal length.

FISHEYE LENS

A fisheye lens is an extreme wide-angle lens, with a focal length of 14mm or less and an angle of view of around 180 degrees. There are two types of fisheye lens: circular and full-frame. As its name suggests, a circular fisheye lens produces round images on the sensor (right), which can limit its appeal for general photography, although the effect can be striking. Full-frame lenses are more popular, since they produce a rectangular image that covers the entire frame (far right).

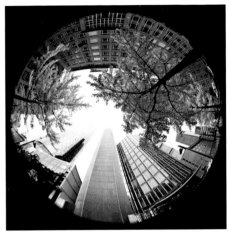

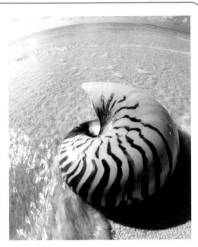

| 18° | 10° | 7½° | 5° |

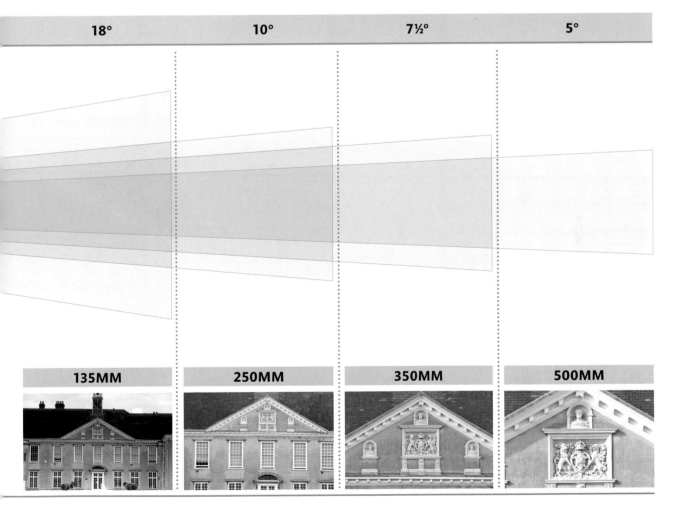

| 135MM | 250MM | 350MM | 500MM |

Sensor size and crop factor

If you've recently bought—or are intending to buy—a new camera, then you're probably aware that different cameras use different sized sensors. Some use a full frame (36 x 24mm) sensor, others use a smaller, Advanced Photo System type-C (APS-C) sensor (23.6 x 15.7mm or 22.2 x 14.8mm), and some use a 17.3 x 13mm FourThirds sensor. Although this doesn't change what you can photograph (or how), it does have an impact on focal length.

The example below demonstrates the effect of taking the same picture with the same focal length, but using cameras with different sized sensors. The dotted blue line shows the area that would be recorded if you were using a camera with a full-frame sensor, which is the sensor size used to measure focal lengths. The other colors shows the effect

of using a camera with a smaller sensor: as the sensor gets smaller, the angle of view narrows, making the lens behave as if it were a longer focal length.

To account for this, a crop factor, or focal length magnifier, is used to determine the effective focal length of a lens. For example, a Nikon with an APS-C sized sensor has a crop factor of 1.5x, so a lens with a 100mm focal length will actually behave like a 150mm lens. With a crop factor of 2x, the same lens on a FourThirds camera would have an effective focal length of 200mm.

SENSOR SIZE KEY

FULL FRAME 36x24mm	APS-C Canon 22.2x14.8mm
APS-C Nikon 23.6x15.7mm	FourThirds System 17.3x13mm

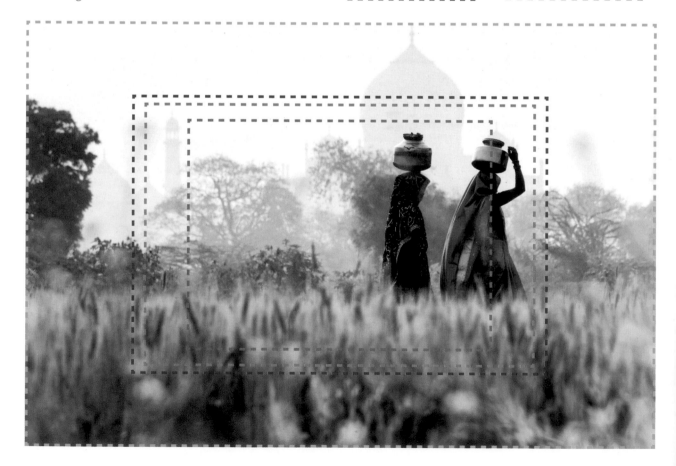

Image stabilization

Camera shake is one of the most common causes of blurred images, and is guaranteed to ruin what might otherwise be a great shot. It usually occurs when you shoot handheld, and is most often a result of your own tiny, involuntary movements.

Image stabilization is a technology built into some lenses to help prevent camera shake. It does this through the use of sensors in the lens, which can detect any camera movement. When they do, a special group of lens elements inside the lens moves in the opposite direction to compensate, which keeps the image in the same place on the sensor while you take your shot. This means you get a sharp result, even if you're a little shaky yourself.

SUPERZOOM LENS

A superzoom is a specific type of zoom lens that covers a wide focal length range, typically in the region of 18–200mm or 18–300mm (this example is 18–270mm). Although wide-ranging, this type of lens increases risk of camera shake, since long focal lengths will amplify even the tiniest movement, so image stabilization is essential.

SUBJECT	WITHOUT STABILIZATION	WITH STABILIZATION
MOVING SUBJECTS Image stabilization can't prevent blur that is caused by a subject moving during an exposure, but it can help you to get a sharper result when you're shooting handheld, without your having to change the exposure settings.	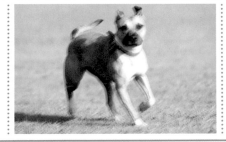	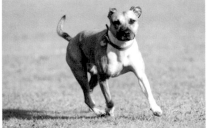
WORKING IN MACRO Macro and close-up photography is all about magnifying small subjects so that they fill the frame. However, the slightest camera movement will be magnified too, so image stabilization is very important when it comes to this type of shot.	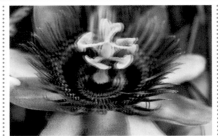	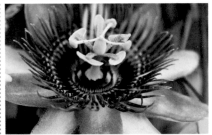
USING A TELEPHOTO LENS Telephoto lenses let you get up close to distant subjects, but in doing so they exaggerate any camera movement. Ideally, you'd use a tripod when you're zooming in like this, but if you don't have one with you, image stabilization will help keep things steady.		

USING A WIDE-ANGLE LENS
OUTDOORS

Wide-angle lenses and outdoor photography are a near-perfect match for each other. The great outdoors offers sweeping views and often dramatically changing weather conditions that are just begging to be captured in their entirety. However, using a wide-angle lens can sometimes reduce the impact of a scene, because distant elements appear very small in the frame and you may end up with large swathes of featureless sky at the top of your shot. So get as close as you can to your subject and, if you have an empty sky, think about including foreground interest to compensate.

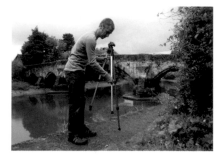

1 SET UP YOUR TRIPOD
For landscape scenes (or any other shot, if you have the time) it's a good idea to set your camera up on a tripod to reduce the risk of camera shake.

2 FIT A LENS HOOD
A lens hood is always useful in combating flare (see pp.146–47), even on seemingly dull days. It's even more important with wide-angle lenses that have a large front lens element.

3 LEVEL YOUR CAMERA
Level your tripod so the horizon doesn't slope to one side. Although you could correct this with your editing software, getting it right with your camera is a much better option.

4 SELECT APERTURE PRIORITY
Use Aperture Priority and set a small aperture to achieve an extensive depth of field.

5 TAKE A TEST SHOT
Take a test shot and assess the image on screen: if necessary, adjust the aperture or exposure.

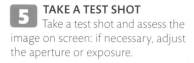

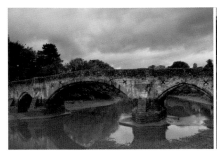

6 REFRAME IF NECESSARY

Take the time to look at the framing of your shot. Most wide-angle photographs taken outdoors can benefit from having something in the foreground, so consider tilting your camera downward slightly or lowering your tripod so it is closer to ground level.

BARREL DISTORTION

Because of their wide viewing angle, wide-angle lenses are prone to displaying "barrel distortion." As the name suggests, this distortion results in images appearing as if they have been projected onto a barrel, so the center of the frame appears inflated. The severity of the distortion varies between lenses, but as a general rule, the wider the focal length, the more pronounced the barreling.

THE RESULT

The wide-angle focal length allowed us to record the full span of the bridge, while the muted colors in the original scene made it an ideal candidate for black-and-white conversion (see pp.176–77).

CAMERA SETTINGS

A | 1/25 SEC | ISO 200 | AWB

USING A WIDE-ANGLE LENS
INDOORS

Although wide-angle lenses are a perfect match for expansive landscapes, they're also a great choice when you're indoors and space is more restricted. In this situation the wide angle of view will enable you to record as much of your chosen interior as possible. However, there are two important things to remember.

First, a wide-angle lens is likely to display barrel distortion (see p.109), so you need to take care when placing walls or other vertical (or horizontal) planes close to the edges of the frame. Second, when you aim a wide-angle lens upward, any vertical elements in the image will tend to converge.

1 CHOOSE A LENS
Attach your chosen wide-angle lens, whether it's a fixed focal length or a wide-angle zoom.

2 SELECT APERTURE PRIORITY
Aperture Priority will not only allow you to determine the depth of field in your shot, but also the shutter speed: smaller apertures result in longer exposure times.

3 SET UP YOUR TRIPOD
If you anticipate using a slow shutter speed—to blur figures moving through the scene, for example—use a tripod, or activate your camera's image stabilization, if it has this feature.

4 EXPLORE VIEWPOINTS
Unless you're using a slow shutter speed, don't feel that you have to use a tripod. Handholding your camera will allow you to explore more unusual shooting angles.

KEEP IT LEVEL

You can minimize the effects of barrel distortion, which makes straight lines appear to bow outward, by keeping your camera level and as square to the subject as possible.

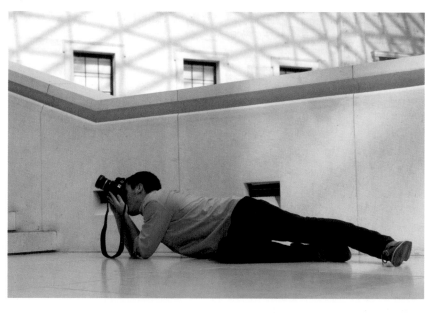

5 **SELECT A FOCUS POINT**
With such a wide angle of view, it's a good idea to select a single focus point yourself (see pp.90–91), so you know precisely where your camera is focusing.

ANGLES

A wide-angle focal length can offer a dramatic perspective, which is part of its appeal. Even though distortion can be an issue, don't be afraid to experiment and "work the angles."

THE RESULT

Shooting from down low and tilting the camera intentionally gives this museum interior shot a dramatic edge. The inclusion of a human figure provides a sense of the scale of the building.

CAMERA **SETTINGS**

USING A TELEPHOTO LENS
FOR PORTRAITS

Although there's really no such thing as a "portrait lens," there's a general (and long-standing) consensus that using a mild telephoto focal length is usually the best option when you want to take pictures of people without including vast expanses of background. There are two main reasons for this choice: it won't distort your subject's face as a wide-angle lens would, and it allows a comfortable "working distance." This is the distance you would need to be from your subject to take a head-and-shoulders portrait. A telephoto lens is also great for taking "candid" portraits—the distance encourages your subject to "forget" you're there.

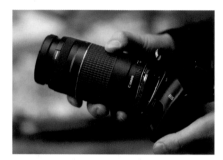

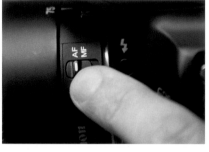

1 ATTACH A LENS
A focal length of around 75–135mm is ideal for portraits, so fit an appropriate prime lens, or a zoom lens that covers this range.

2 SET AUTOFOCUS
Make sure that your camera (and lens) is set to Autofocus and that image stabilization is switched on if you intend to shoot handheld.

3 SELECT CONTINUOUS SHOOTING MODE
Continuous Shooting mode will allow you to fire a burst of shots, which will capture the most fleeting expressions.

4 FRAME WITH LIVE VIEW
Using Live View (if your camera has it) will enable you to frame your shot using the camera's rear LCD screen, allowing you to communicate with your subject, if necessary, without having a camera in front of your face.

PRIME LENSES

A 50mm prime lens (see p.103) is perfect if you're using a camera with an APS-C sized sensor. It will give you an angle of view equivalent to a 75–80mm focal length when the crop factor is taken into account (see p.106). Most 50mm prime lenses also have a wide maximum aperture, which is great for blurred backgrounds.

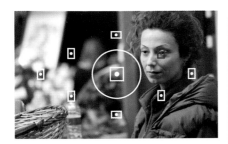

5 **FOCUS**

As a general rule you should aim to focus on your subject's eyes whenever you're shooting a portrait, simply because this is the first place that people tend to look at.

ALSO WORKS FOR...

A telephoto focal length is also a good choice for close-up photography, especially when flying insects are involved. A popular focal length for macro lenses is 105mm, since the longer focal length means you don't have to get as close to your subject, so are less likely to scare it away.

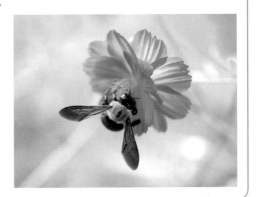

THE RESULT

A mild telephoto focal length allowed a comfortable distance between photographer and subject, so she is less self-conscious than she might have been with a camera inches from her face.

CAMERA **SETTINGS**

| A | ▭ | f/2.8 | 1/60 SEC | ISO 400 | AWB |

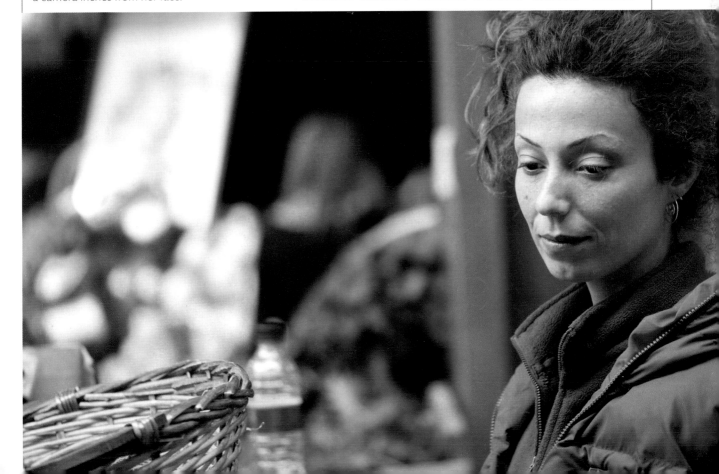

USING A TELEPHOTO LENS
FOR DISTANT SUBJECTS

A short telephoto focal length is a popular choice for portraits because you don't want to be inches away from the person's face, but with some subjects you'll need a longer lens. Most wildlife, for example, isn't going to sit and wait while you get up close and personal with your camera, and for the majority of sporting events you'll need to photograph from the sidelines. In these situations shooting handheld is often preferable because it gives you the freedom to move the camera quickly to follow fast-moving subjects, but as the focal length increases so too does the risk of camera shake. It's therefore even more important than usual to make sure that you use your camera correctly.

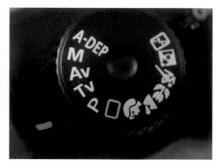

1 ATTACH YOUR LENS
Fit a telephoto lens to your camera. Something in the region of 200–400mm is ideal, whether it's a fixed focal length (prime) lens or a zoom lens.

2 ACTIVATE IMAGE STABILIZATION
Any movement will be magnified by a long lens, so switch on your camera's image stabilization, if available (see also Step 4).

3 SELECT A MODE
When you're using a long handheld lens, it's a good idea to set the shutter speed to counter camera shake. That means using either the Program or Shutter Priority mode.

4 BRACE YOURSELF
Image stabilization and a fast shutter speed will help you to avoid camera shake, but it's still a good idea to rest the camera on something solid if possible.

SHUTTER SPEEDS

A simple rule with long lenses is to use a shutter speed that's at least 1/focal length. So with a 200mm focal length, for example, set your shutter speed to 1/200 sec and for 400mm focal length use 1/400 sec.

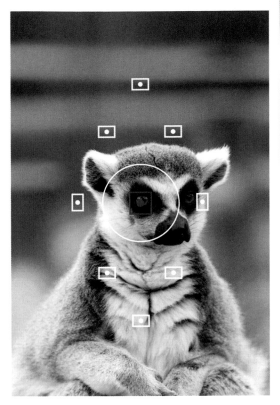

5 SELECT A CENTRAL AUTOFOCUS (AF) POINT

Select the central AF point manually (see pp.94–95), choose your point of focus—in this case, the lemur's eye—then reframe your shot if necessary (see pp.92–93).

ALSO WORKS FOR...

A long telephoto lens will also appear to compress perspective, so can be used creatively to "stack" distant subjects, such as buildings.

THE RESULT

Using a 300mm focal length ensured the lemur filled the frame, but it's important that the focus is precise: for wildlife shots like this, focusing on the eyes almost always creates the most impact.

CAMERA **SETTINGS**

S | | f/5.6 | 1/300 SEC | ISO 400 | AWB

USING A MACRO LENS
FOR MOBILE SUBJECTS

Macro photography requires much greater precision than other genres when it comes to focusing, and the slightest shift can throw a subject entirely out of focus. The reduced depth of field that comes from close-up work (see p.119) also means that smaller apertures are commonly used with low ISO settings, which results in a slow shutter speed. None of these things are particularly conducive to handheld photography, but when you're shooting mobile subjects, the flexibility of a handheld camera is precisely what you need.

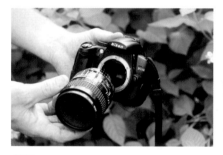

1 ATTACH YOUR LENS
A dedicated macro lens is the best choice for close-up photography, although some zoom lenses have a macro setting that will suffice.

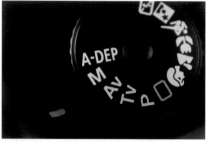

2 SELECT A MODE
Manual or Aperture Priority are the ideal exposure modes for macro photography, because you will often want to control the depth of field.

3 DETERMINE EXPOSURE
For a backlit shot like this, use the camera's center-weighted metering pattern (see p.77), but set the exposure one stop brighter to avoid underexposure.

4 SWITCH TO MANUAL FOCUS
Although Autofocus will work with macro shots, it's sometimes easier to focus manually.

5 FOCUS
With a small, moving subject it's better to focus on your subject initially and then move the camera closer to and farther away from it to keep it in focus, rather than constantly adjusting the focus. This is only possible if you're shooting handheld.

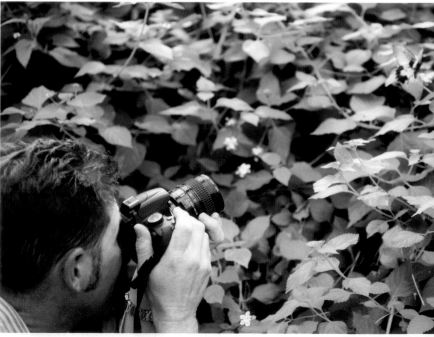

ALSO WORKS FOR...

Backlit subjects are easier to find when you're shooting close-ups than when you are photographing something on a larger scale. Look for dew drops on leaves and individual blades of grass, or for translucent petals with light striking them from behind. Shoot either early or late in the day, when the sun is low in the sky and more elements in the landscape are lit from behind.

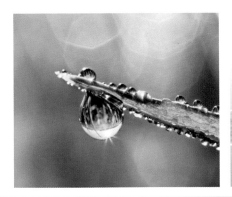

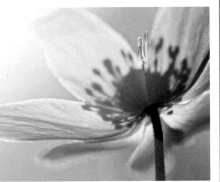

THE RESULT

Getting close to this backlit butterfly was the only way of filling the frame. In this respect, handholding the camera is preferable since you have greater freedom to move around your subject.

CAMERA **SETTINGS**

M | 1/500 SEC | f/4 | ISO 400

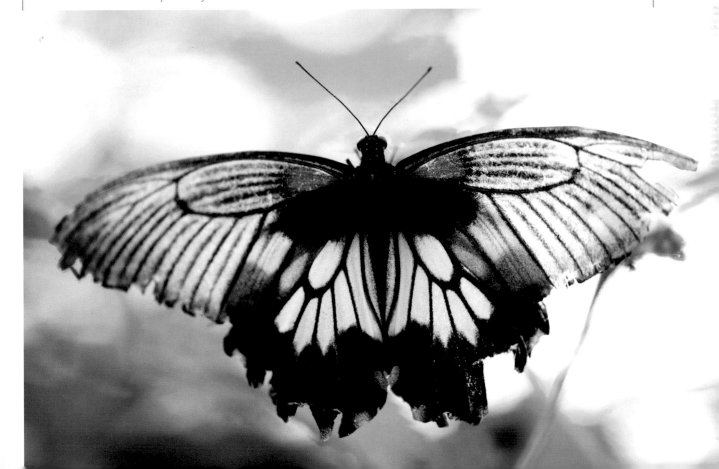

USING A MACRO LENS
FOR STATIC SUBJECTS

A tripod is useful in most areas of photography, but it's even more important for close-up and macro work—at least if you're photographing a static subject. The reason for this is simple: the closer you are to your subject, the less depth of field there is at any given aperture setting. This means you'll often want to use small aperture settings to maximize the depth of field in your close-up shots, and a low ISO setting for image quality. However, this combination can result in a slow shutter speed that increases the risk of camera shake. The answer, of course, is to attach your camera to a tripod.

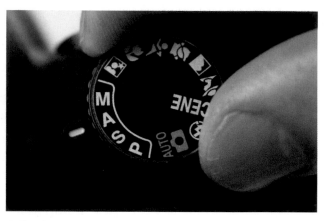

1 SET UP YOUR CAMERA
Fit your macro lens (or set your lens to its macro setting) and attach the camera to a tripod so you have precise control over the framing of your shot.

2 SELECT APERTURE PRIORITY
Use Aperture Priority mode so you can control the depth of field, but be aware that this will be severely reduced with close-up subjects (see box opposite).

WITHOUT DIFFUSER **WITH DIFFUSER**

3 USE A DIFFUSER
Contrast can appear heightened when you're photographing something that's on a small scale, so it's useful to have a pop-up diffuser on hand (see p.37). Since you don't need to worry about the camera moving, you can hold the diffuser in one hand and tilt it this way and that to see what effect it's having on your subject. It's a good idea to take shots with and without the diffuser so you have a choice.

DEPTH OF FIELD

The shorter the distance between the lens and the subject, the shallower the depth of field becomes at any given aperture: so while an aperture setting of f/16 might give you a depth of field that can be measured in yards or meters in a landscape photograph, it can be reduced to just a few inches—or even less—when the subject is much closer to the camera.

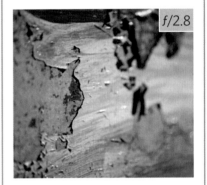
f/2.8

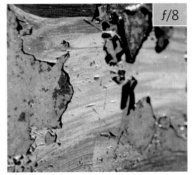
f/8

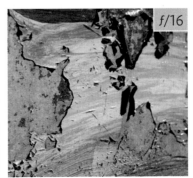
f/16

THE RESULT

We took the final shot using a diffuser to soften the hard shadows. Shooting square with the peeling paintwork meant depth of field was less of an issue than it might otherwise have been.

CAMERA **SETTINGS**

 A f/11 1/60 SEC ISO 100

AVAILABLE
LIGHT

AVAILABLE LIGHT

When photographers talk about available, or ambient, light, they're simply referring to any light that exists in a location before they set up a flash or other lights. The available light could be artificial (tungsten, for example), natural, or a combination of these. Appreciating how best to use this light, in terms of its color, direction, and strength, is often the difference between an average and an outstanding shot.

Quality of light

All light falls into one of two categories: hard or soft. This refers to how diffuse the light is: that is, how it is dispersed. When it comes to photography, it is important to appreciate the difference between the two, because they can create significantly different results; one may be better suited to a particular subject than the other. On an overcast day the light will be soft since the sunlight is scattered by clouds; this is perfect if you want to take portraits without heavy shadows being cast across your subject's face. However, in some situations you may prefer hard light, such as direct overhead sunlight, which will create dark, hard-edged shadows that are great for graphic architectural shots (see pp.138–39).

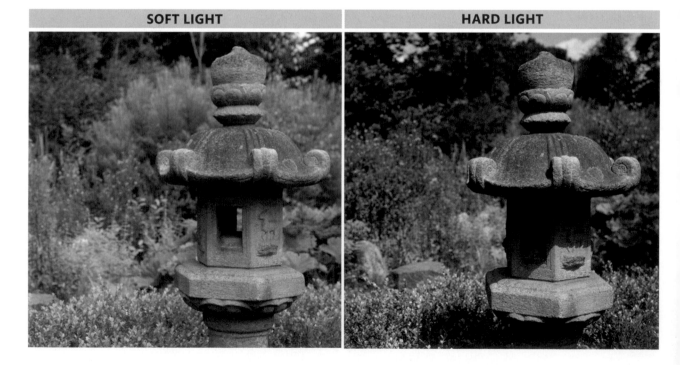

| SOFT LIGHT | HARD LIGHT |

Direction of light

As well as the quality of light, the direction from which the light is coming will also play a key part in the look of your photographs, via the effects you can achieve with shadows (see table, below). When you're relying on available light, your options may be more limited than when you're using a more controlled light source, such as off-camera flash (see pp.160–63). Sometimes, to obtain the result you want, you may need to move your subject (if possible), or change the position you're shooting from.

POSITION OF LIGHT		EXAMPLE
HIGH When the light is coming from above, the resulting shadows will be small and fall directly below your subject. The intensity of the shadows will depend on the quality of the light: hard light will create dark, hard-edged shadows, and soft light will give a more subtle, amorphous effect.		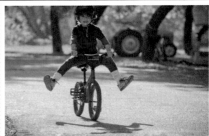
LOW When the light is coming from a low angle (as it does at the beginning and end of the day), shadows are elongated. This creates a strong sense of space and mood in a photograph, and it's partly for these reasons that many landscape photographers prefer to shoot at dawn and dusk.		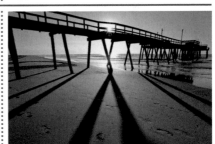
IN FRONT When the light strikes your subject from the front, the illumination will be even and any shadows will be thrown behind it. This is ideal when you want to shoot shadow-free portraits, regardless of whether the light is soft or hard.		
BEHIND When the light is behind your subject, it will naturally throw the side you're photographing into shadow, but this isn't necessarily a bad thing: backlighting is perfect for creating silhouettes (see pp.144–45) or producing a halo around your subject (see pp.142–43).		

WHAT IS THE
COLOR OF LIGHT?

All light sources have a color temperature (see below). Our eyes and brain adjust continually to these variations, so that the world around us stays fairly neutral. For example, if we enter a tungsten-lit room from outdoors, we won't perceive much of a change, even though the indoor light is orange and daylight is blue. Cameras adjust for these variations through the White Balance feature (see opposite).

▼ Color temperature is measured in degrees Kelvin (K): the cooler (more blue) the light, the higher its temperature. Daylight has a nominal color temperature of 5,500K.

TONE		TEMPERATURE	TYPE OF LIGHT	EXAMPLE
COOLER		12,000K AND HIGHER	CLEAR SKYLIGHT IN OPEN SHADE/SNOW	
		10,000K	HAZY SKY LIGHT IN OPEN SHADE	
		7,000K	OVERCAST SKY	
		6,600K		
		5,900–6,000K	ELECTRONIC FLASH	
		5,500K	MIDDAY	
		4,100K		
WARMER		3,750K		
		3,600K		
		3,500K	PHOTOLAMP	
		3,400K		
		3,200K	SUNSET/SUNRISE	
		3,100K		
		3,000K		
		2,900K	100-WATT LIGHT BULB	
		2,800K		
		1,900K	CANDLELIGHT/FIRELIGHT	

TONE

WHITE BALANCE SETTINGS

AUTO
With Auto, the camera assesses the scene and calculates the white balance: you have no input.

DAYLIGHT
At around 5,500K, this is the ideal setting if you're shooting at midday under a cloudless sky.

CLOUDY
Your camera's Cloudy setting is slightly warmer than Daylight, making it useful for shooting outdoors on overcast days.

SHADE
The Shade setting is designed to compensate for the cool shadows created outdoors on a sunny day.

TUNGSTEN
Also known as Incandescent, this setting is good for indoor shots under regular domestic lighting conditions.

FLUORESCENT
Most cameras offer a variety of Fluorescent settings to compensate for different indoor artificial lights.

FLASH
This setting is balanced for electronic flash, which at around 6,000K is often slightly cooler than Daylight.

CUSTOM
The Custom setting allows you to set your own white balance, often by using a white or gray card (see pp.128–29).

White balance

All digital cameras offer White Balance adjustment. This is the system that compensates for different lighting conditions, adjusting the color in your images so that they appear neutral. There are several options available, including an Automatic White Balance (AWB) setting that allows the camera to set what it calculates is the most appropriate white balance, plus a selection of preset values for specific color temperatures (see table, left). Some cameras also have a custom setting that allows you to set your own white balance (see pp.128–29). However, as the images below demonstrate, there's not always such a thing as the right white balance: each one of these pictures could be seen as acceptable, depending on your personal preference.

AUTO

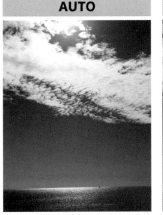

DAYLIGHT

SHADE

FLUORESCENT

SELECTING THE CORRECT
WHITE BALANCE

The color of the light around us changes throughout the day, and is also affected significantly by its source—be it daylight or an artificial light. Your camera's Automatic White Balance (AWB) will generally be a match for most straightforward lighting conditions, but can start to struggle when it's confronted with mixed lighting: a shot taken indoors by a window, for example, or a subject lit by artificial lights with different color temperatures. In this situation you may need to take control and set the white balance yourself, choosing the setting that's most appropriate for the picture you are taking.

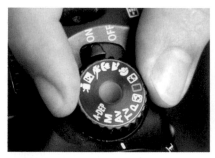

1 SELECT A MODE
You can generally set the White Balance in any mode other than Auto or Scene modes: Program mode is a good choice if you still want the camera to set the exposure for you.

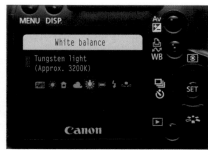

2 SET THE WHITE BALANCE
Access your camera's White Balance settings and choose the one that most closely matches the lighting conditions you are shooting under.

3 TAKE A TEST SHOT
Exit the White Balance menu and take a test shot so you can assess the accuracy (or otherwise) of the setting you've selected.

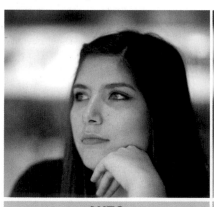

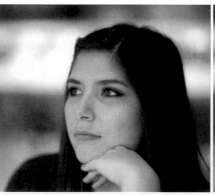

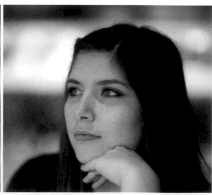

| AUTO | DAYLIGHT | INCANDESCENT |

4 ADJUST THE WHITE BALANCE
If your test shot reveals an unexpected or undesirable color cast, adjust the White Balance and shoot again. In this example the Daylight setting is too warm (orange), while setting the White Balance to Incandescent for the interior tungsten lights results in an image that is overly cool (blue). With the White Balance set to Auto the results are somewhere between the two presets in terms of color, but it's still a little cool.

CREATIVE EFFECTS

Although the usual aim is to get the colors "right" in an image, there are occasions when setting the incorrect White Balance can actually result in a more striking picture. The most common effects are a Daylight setting used under tungsten lighting (producing deep orange tones) or an Incandescent White Balance setting used outdoors (creating strong blue tones). Of course, you can explore the results of any other "wrong" White Balance setting.

THE RESULT

Our preferred choice of White Balance for this shot was the Cloudy setting. This isn't the most obvious choice given the lighting conditions, which proves that it's worth experimenting with your settings.

CAMERA **SETTINGS**

A | f/2.8 | 1/250 SEC | ISO 400

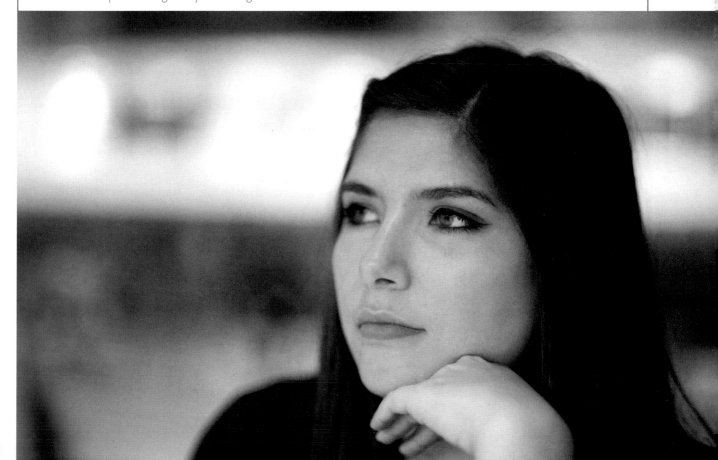

SETTING A **CUSTOM WHITE BALANCE**

Leaving your camera's White Balance set to Auto or, better still, choosing one of its White Balance presets is usually all you need to do to get consistently accurate results. However, there may be times when you find yourself struggling to overcome a stubborn color cast. This happens most often when you're trying to take photographs under mixed lighting conditions—incandescent and daylight, for example—where the two (or more) light sources have very different color temperatures (see pp.124–25). Short of removing one of the light sources, there's often no other choice but to set a custom White Balance.

1 ASSESS THE PROBLEM
With incandescent lighting overhead and a window nearby, finding a single White Balance setting that produces a neutral result is impossible.

2 SHOOT A NEUTRAL TARGET
The precise process varies between cameras, but you'll need to shoot a neutral gray target (in this instance, a gray card) to use as the basis for your custom White Balance.

TUNGSTEN **DAYLIGHT**

White balance
AUTO Auto
Incandescent
Fluorescent
Direct sunlight
Flash
Cloudy
Shade
PRE Preset manual

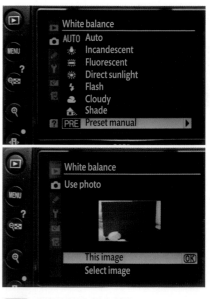

White balance
Use photo

This image OK
Select image

3 SET YOUR TARGET
Go into the White Balance menu and select the neutral target photograph to set your custom White Balance.

4 **BEWARE OF LIGHTING CHANGES**
A custom White Balance will only be accurate if the lighting remains exactly the same, so be alert to even minor changes in the light.

WHITE BALANCE DISC

Smaller and more convenient to carry with you than a gray card, a white balance disc fits over the front of your lens in a similar fashion to a lens cap. You simply take a shot of the light source through the disc and use that to set your custom White Balance. Some manufacturers produce versions that are designed to add a little warmth to skin tones in portrait photographs.

THE RESULT

A custom White Balance has ensured that the flowers in this still life are neutral. There's still a hint of cool daylight and warm tungsten in the rest of the shot, but this just adds to the atmosphere.

CAMERA **SETTINGS**

 1/30 SEC ISO 400

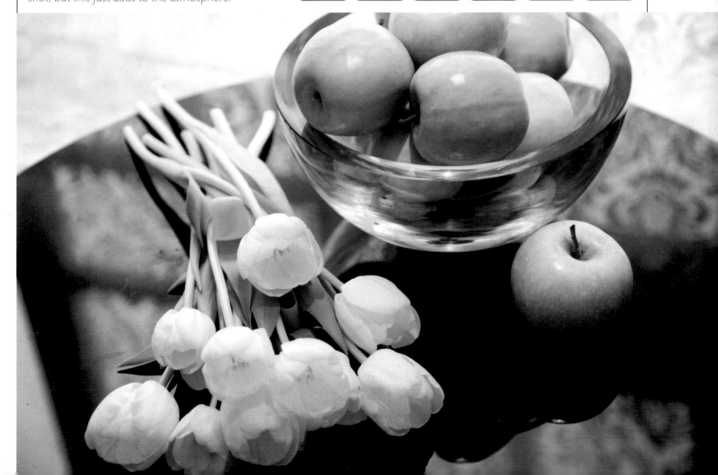

USING **REFLECTORS TO ADD LIGHT**

Although ambient natural light is ideal for photography, it does have one quite significant downside: you have very little control over it. However, that's not the same as having no control, and perhaps one of the simplest, cheapest, and arguably most effective ways in which you can modify ambient light is to use one or more reflectors to bounce it back onto your subject. As you'll see, a single reflector is great for filling in shadows without having to worry about flash, and by varying the direction, angle, and even the color of your reflector, you can make radical changes to your shot.

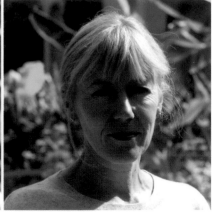

1 ASSESS THE PROBLEM
With the light coming from slightly behind the subject, most of her face is in deep shadow.

2 POSITION A REFLECTOR
Holding a reflector in front of your subject will bounce light back onto her face: either ask your subject to hold the reflector (if it won't affect the shot), or get a friend to help.

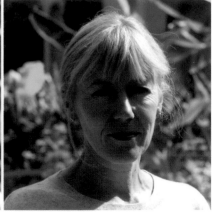

3 ADJUST THE DISTANCE
You can effectively control the amount of light that's reflected back onto your subject by varying the distance between your subject and the reflector: the shorter the distance, the stronger the fill. This is where it's useful to have an assistant, since it will be easy for them to vary the distance and angle at which they hold the reflector.

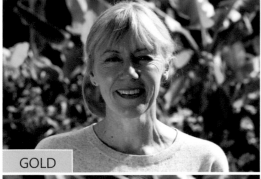

GOLD

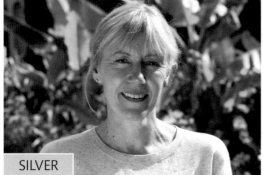

SILVER

4 **TRY DIFFERENT REFLECTORS**
A white reflector isn't your only option: most kits come with other colors too. Gold will give your subject a warm glow, while a silver reflector can be used for a "harder" fill.

DIFFUSERS

A diffuser reflects light to fill in shadows, and can soften the light before it reaches your subject (see pp.132–33). This is because a diffuser between your subject and the light source will scatter the light and make it less harsh.

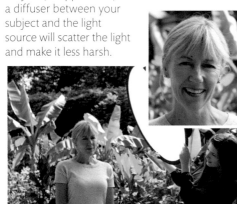

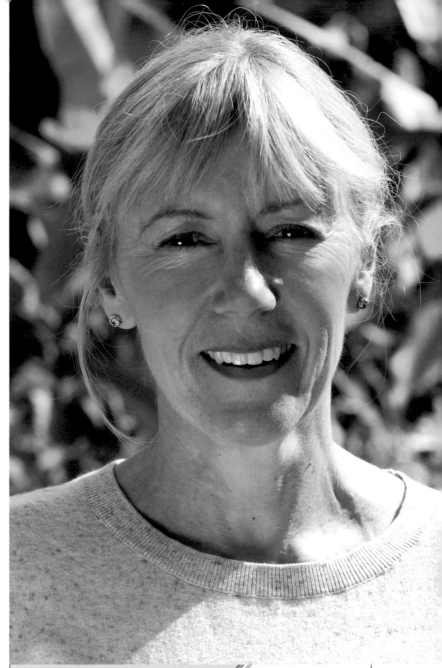

THE RESULT

Using a reflector has helped lift the dark shadows that were originally affecting this portrait, so we can now see details of the subject's face. It's a subtle difference, but an effective one.

CAMERA **SETTINGS**

S | f/5.6 | 1/160 SEC | ISO 100

USING A DIFFUSER
TO SOFTEN LIGHT

Although a reflector can be used to "fill in" shadows in photographs taken in direct sunlight (see pp.130–31), it has one slight drawback—it effectively adds a second light source to your shots. Sometimes this isn't what you want, and rather than creating a second light source, you just want the overall light to be softer. In this situation the tool you require is a diffuser, which uses a translucent material to scatter the light passing through it. Commercial versions of these are widely available and often have a "pop-up" design similar to reflectors, which allows them to be folded up when they're not needed.

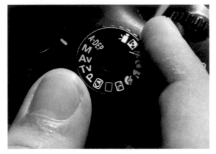

1 **SELECT A MODE**
Because a diffuser affects the light falling onto the subject, it's entirely up to you which exposure mode you use: even Auto will work in this instance.

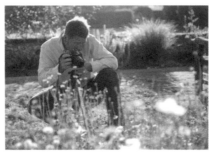

2 **POSITION YOURSELF**
Diffusers are most useful when the light is bright and behind you. Fortunately this will also mean that the subject is lit from the front, which is usually desirable.

3 **DEPLOY THE DIFFUSER**
Position your diffuser between the light source (in this case, the sun) and your subject.

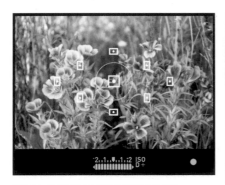

4 **CHECK THE VIEWFINDER**
You can see immediately what effect the diffuser is having on your subject, and it often helps if you look through the viewfinder or use your camera's Live View mode.

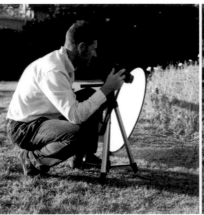

5 **REPOSITION THE DIFFUSER**
Move the diffuser around until it's having the desired effect. You will find this much easier to do when your camera is mounted on a tripod or you have someone with you who can hold the diffuser for you.

CLOUD COVER

If you don't have a diffuser on hand, you may be able to make use of nature's own diffuser. The image on the left shows the flower in full direct sunlight, while the one on the right was taken when the sun disappeared behind a cloud for a moment.

THE RESULT

With delicate subjects such as flowers, diffusing the light can have a significant impact on the image. Here it has minimized the shadows, which prevents the shot from appearing "hard," with too much contrast.

CAMERA **SETTINGS**

▼ SHOT WITHOUT DIFFUSER

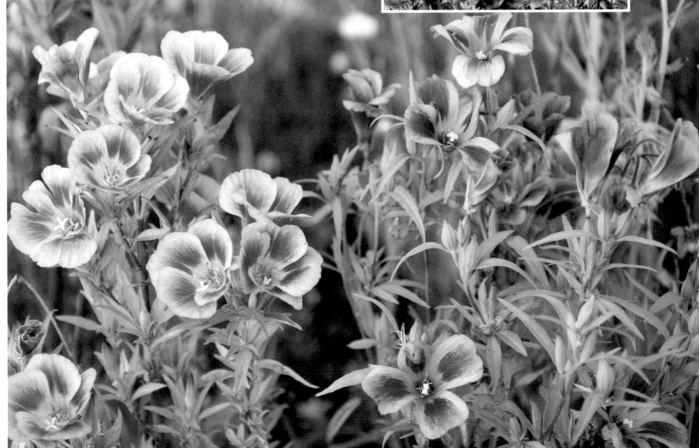

WORKING IN LOW LIGHT
OUTDOORS

Photography is all about exposing your camera's sensor to light, so you might wonder why you would bother taking pictures when the light levels are low: surely that would just make things difficult? In a way you'd be right, since exposure, focusing, and white balance all become a little trickier when light levels drop. At the same time, however, your subject can be transformed if you shoot in the early evening or at night, especially if you're photographing outdoors: floodlit buildings, light trails from cars, and even the color of a twilight sky can produce stunning shots that are just not possible during daylight hours.

1 **SET UP YOUR TRIPOD**
If you're working outdoors with a static subject there's no excuse not to use a tripod: your photographs will be much better for it.

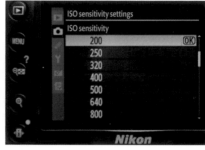

2 **SET ISO**
With your camera on a tripod you can use a relatively low ISO to minimize noise. Something in the region of ISO 200–400 will work well.

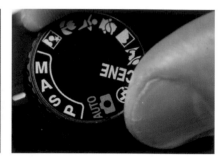

3 **SELECT APERTURE PRIORITY**
Getting a reasonable depth of field requires a relatively small aperture, so set the camera to Aperture Priority and dial in an aperture setting of about f/8.

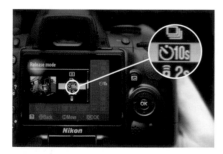

4 **TRIGGER WITH SELF-TIMER**
Unless you have a remote release, use your camera's self-timer to trigger the shutter. This reduces the risk of camera shake when you press the shutter.

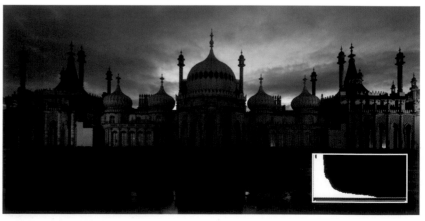

5 **ASSESS THE IMAGE**
Play back the image and call up the histogram (see pp.78–79). If the bulk of the histogram is shifted to the left (as it is here), the image might be considered underexposed; a shift to the right would suggest overexposure.

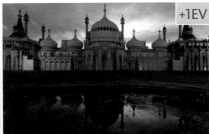
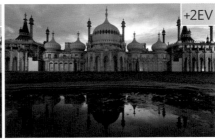

| 0 | +1EV | +2EV |

LESS LIGHT **EXPOSURE** MORE LIGHT

6 SET EXPOSURE COMPENSATION

Depending on the look you're after, dial in positive (+) exposure compensation to increase the exposure and brighten your image, or use negative (-) compensation to darken it (see pp.80–81). You might also want to consider bracketing your exposures (see pp.82–83) so you have a number of different options to start with.

THE RESULT

The optimal exposure reveals plenty of detail in the building, but the exposure isn't so bright that the shot appears to have been taken in broad daylight.

CAMERA **SETTINGS**

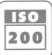

| A | | f/11 | 6 SEC | ISO 200 | AWB |

WORKING IN **DIMLY LIT INTERIORS**

Unless you're taking pictures in a glasshouse, or somewhere with huge windows, photographing indoors will almost inevitably involve low ambient light levels. Of course, you can use flash if you want to (and are permitted), but more often than not you'll simply have to rely on what light is available to you. This not only raises issues regarding exposure, but also with color balance, since you may be dealing with incandescent and fluorescent light sources, sometimes mixed with daylight. However, low light indoors doesn't have to be a challenge: your camera has all the tools you need.

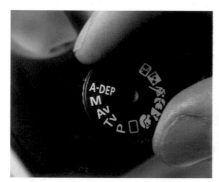

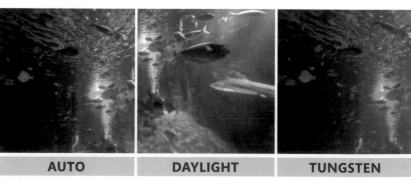

1 SET UP YOUR TRIPOD
When the light levels are low, shutter speeds naturally get longer, even if you use a wide aperture and high ISO setting. If it is possible to do so, set up a tripod.

2 IF YOU CAN'T USE A TRIPOD
If setting up a tripod is not possible, then steady the camera by resting it on or against a solid surface. If there's no such suitable surface, switch your camera to Live View and make use of your neck strap: extend your arms to add tension (as shown here) and hold your camera firm.

AUTO DAYLIGHT TUNGSTEN

3 SELECT APERTURE PRIORITY
Switch to Aperture Priority and set a relatively wide aperture. An aperture of around f/5.6 will let in plenty of light but still provide a modest depth of field.

4 SET WHITE BALANCE
The White Balance setting you use will depend on the prevalent light source. In this aquarium there was a mix of fluorescent and tungsten lighting, making the correct option hard to determine. However, by shooting a number of test shots it's possible to get the look you're after.

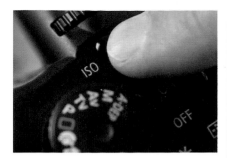

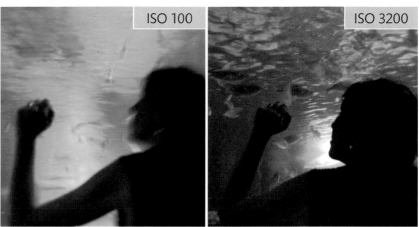

ISO 100　ISO 3200

5 SET ISO
Increase the ISO until the camera suggests a shutter speed of 1/60 sec: this will reduce the risk of camera shake with focal lengths up to around 100mm.

THE RESULT

The combination of a wide aperture and high ISO allowed us to use a "safe" shutter speed that works when shooting handheld. The image may be a little busy, but it's also sharp, which is more important.

CAMERA **SETTINGS**

A | | f/2.8 | 1/60 SEC | ISO 3200 |

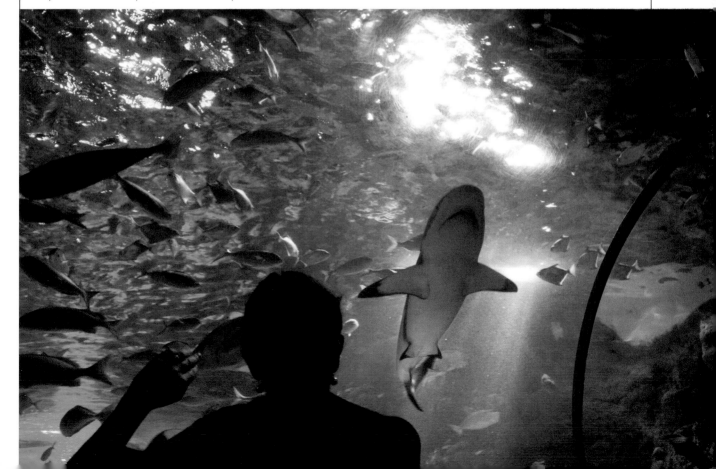

EXPLOITING **LIGHT AND SHADOW**

Many experienced photographers—especially those with a keen interest in landscape photography—advise against taking pictures when the sun is high in the sky and the light is particularly harsh. To a certain extent they're right, since the hard shadows cast by a noon sun aren't always flattering to either landscapes or portraits. But that doesn't mean you can't take any photographs at all—you just need to pick the right subjects. Architecture is a great place to start, since you can use shadows to your advantage, exploiting them to define crisp edges and create striking graphic images.

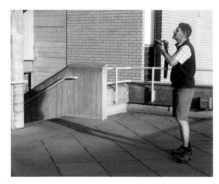

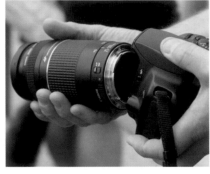

1 **ASSESS THE LOCATION**
Although you can dive right in and start shooting, it's worthwhile taking a little time simply to look at your subject and decide what it is you want in the shot.

2 **ATTACH A LONG LENS**
Using a telephoto lens for architectural shots is a great way of isolating part of the building, but it will magnify the slightest movement so it's a good idea to use a tripod.

3 **KEEP IT LEVEL**
You can adjust your images in your editing software (see pp.168–69), but it will save you a lot of time if you get straight lines with the camera, so level your tripod before you shoot.

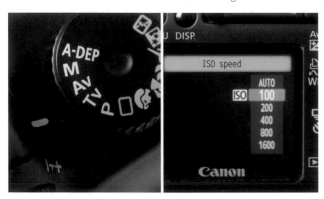

4 **CHOOSE YOUR SETTINGS**
Set your camera to Aperture Priority so you can control the depth of field, and choose a low ISO setting (ISO 100–200). If there's movement in the shot that you want to control (people in front of a building, perhaps), then you may want to choose Shutter Priority instead.

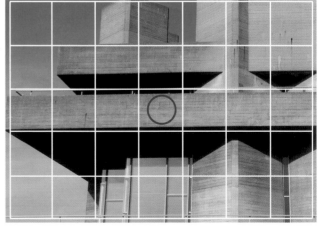

5 **SET THE METERING MODE**
Switch to your camera's spot metering pattern (see p.77) and aim the camera at a sunlit area of the building to take your exposure reading: gray concrete is perfect for this.

6 REFRAME
Hold the Auto Exposure Lock button or shutter-release button to lock the exposure while you reframe your shot.

ALSO WORKS FOR...

The heavy shadows created by harsh light can be used creatively for a wide range of subjects. However, since shadows will generally conceal detail, a bold, graphic shot should be your aim. Converting to black and white (see pp.176–77) often enhances this effect.

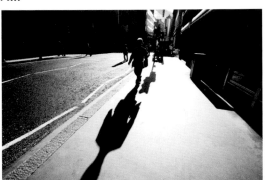

THE RESULT

A tight crop has reduced this modernist architecture to simple gray shapes, but the dark, blocky shadows add essential contrast. The clear blue sky is the perfect backdrop.

CAMERA **SETTINGS**

 A
 ●
 f/8
 1/100 SEC
 ISO 100

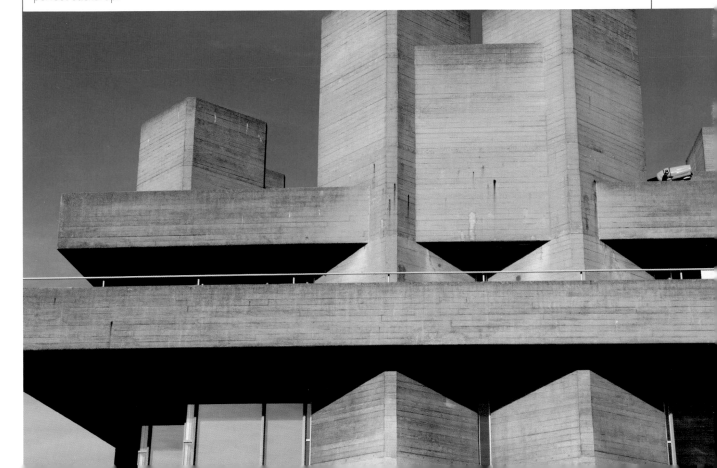

EXPOSING FOR **THE HIGHLIGHTS**

In some ways, the sensor in a digital camera is very similar to transparency, or slide, film. Don't worry if you're not familiar with this type of film—all you need to know is that it's much easier to reveal detail in the shadow areas of a digital image than it is to extract detail in highlighted areas that are overexposed. The technical reason for this is that once the camera has

recorded part of an image as "white," it's as bright as it can possibly be: it won't have any detail, and even your editing software can't bring out what isn't there. So, when you're faced with a high-contrast scene and are wondering how to expose it, the answer's simple: expose for the highlights and sort out the shadows later (see pp.172–73).

1 **FRAME YOUR SHOT**
For this technique you'll probably need to take several shots, so if the framing is critical you'll have to set up your camera on a tripod.

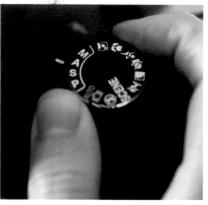

2 **SELECT A MODE**
Set the exposure mode to something other than Auto, Manual, or a Scene Mode as you'll need to apply exposure compensation (see pp.80–81).

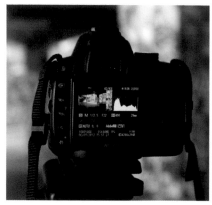

3 **TAKE A TEST SHOT**
Take a shot at the exposure suggested by the camera and review it on-screen. Call up the histogram so you can see the tonal range (see pp.78–79).

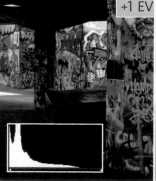
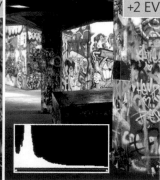
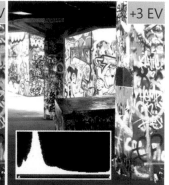

0 +1 EV +2 EV +3 EV

◄◄◄ LESS LIGHT **EXPOSURE** MORE LIGHT ►►►

4 **DIAL IN EXPOSURE COMPENSATION**
Assuming your test exposure doesn't clip the highlights, dial in positive exposure compensation (see pp.80–81) and shoot again. Start at +1 stop and assess the image's histogram, paying

close attention to the right (highlight) end of the graph. The aim is to get the histogram to end as close to the right edge as possible, but without going off the scale. Here, +1 stop was sufficient.

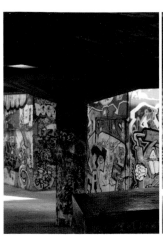
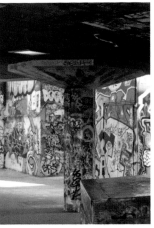

5 ADJUST THE SHADOWS

The final step happens when you've got the image on your computer. Use your editing software's Levels tool (see pp.170–71) to adjust the shadow areas without affecting the highlights. It's entirely up to you whether you make the shadows lighter or darker.

LIVE VIEW

Some cameras allow you to have a histogram "live" on-screen when you use the camera's Live View mode. If your camera allows this then there's no need to play back your image and assess its histogram—use the Live View histogram as a guide instead.

THE RESULT

Our final shot maximizes the detail recorded in the brightest areas of this high-contrast scene, but without sacrificing the shadows.

CAMERA **SETTINGS**

 A f/5.6 1/30 SEC ISO 100

CREATING A **HALO OF LIGHT**

When Kodak launched its Brownie camera at the beginning of the 20th century, the advice they gave to the new breed of photography enthusiasts was to always take pictures facing away from the sun, never toward it. To some extent that advice is still valid today: if you photograph with the sun in front of you there's a very strong chance that your images will suffer from lens flare (see pp.146–47), and whenever your subject is lit from behind, there's the risk that it will appear as a silhouette (see pp.144–45). If you're careful, however, lighting your subject from behind can also produce stunning results.

1 SELECT A MODE
It's likely that you'll need to adjust the exposure from the camera's recommended reading, so choose something other than Auto or a Scene mode. Aperture Priority is best for a close-up shot like this since it allows you to maximize the depth of field.

2 TAKE AN EXPOSURE READING
Use your camera's spot meter (see pp.76–77) to take an initial exposure reading from a midtone area of your subject. Alternatively, you could take a reading from a gray card (see pp.74–75).

3 TAKE A TEST SHOT
In challenging lighting conditions it can be hard to get the exposure right the first time, so it's a good idea to take a shot and call up the histogram on playback (see pp.78-79). Here the exposure is a little too bright and the highlights are clipped slightly as a result. With a detailed subject like this, this isn't ideal.

4 **ADJUST THE EXPOSURE**
To reduce the exposure, dial in negative (-) exposure compensation (see pp.80–81). For this shot, -1 stop of compensation was needed to prevent the highlights from being blown out.

BACKLIT PORTRAITS

Backlit portraits can work out very well, with the light adding a beautiful halo to hair. However, with the light coming from behind your subject there's always the risk that the face will be in shadow. To counter this, consider using a reflector (see pp.130–31) or fill flash (see pp.154–55). Here, a gold reflector was used to add a warm glow to her skin tones.

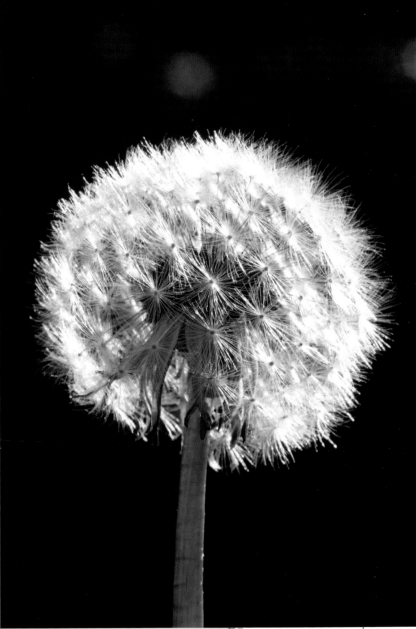

THE RESULT

Shooting from a low angle and choosing a dark background helps this dandelion seed head to stand out, but it's the strong backlighting that makes the image really glow.

CAMERA **SETTINGS**

A | ● | f/32 | 1/60 SEC | ISO 400 | ☀

CREATING A **SILHOUETTE**

Although many people think that specific lighting conditions are needed to create a silhouette, this isn't necessarily true—any subject that can be photographed against a bright background has the potential to be transformed into a silhouette. The key is to look for recognizable subjects that can be "read" without relying on every last detail: plants, people, and architecture can all work well. Strong graphic shapes become the most important element in the shot, but color should be a consideration too—do you want to create an almost black-and-white image, or use background color to set off your subject?

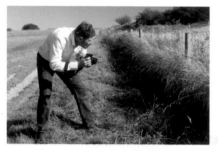

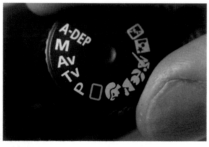

REFLECTED LIGHT

You don't have to shoot toward an obvious light source, such as the sun, to create a striking silhouette: light reflecting off glass, metal, or water can just as readily provide the strong backlight that you need.

1 CHOOSE A VIEWPOINT
The strongest silhouettes have a plain, uncluttered background, so look at your subject from different angles to see where you'll get the best shot.

2 SELECT A MODE
You need to be in control of your exposure when you're shooting silhouettes, so use Program, Aperture Priority, Shutter Priority, or Manual modes. For this shot Shutter Priority was selected because the breeze was disturbing the grass and the seed heads, so a fast shutter speed was needed.

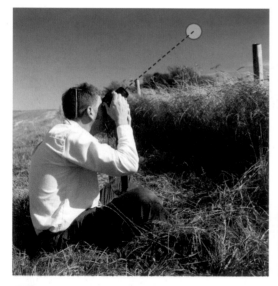

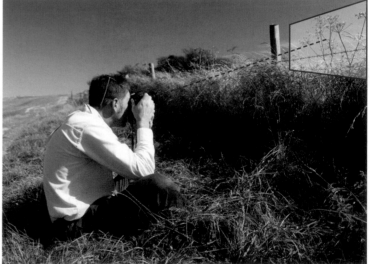

3 SELECT SPOT METERING
Switch your camera to its spot metering pattern (see pp.76–77) and take an exposure reading from the bright background. This will ensure that your subject is underexposed.

4 LOCK EXPOSURE AND RECOMPOSE
Lock the exposure by holding down your camera's Automatic Exposure Lock (AE-L) button and then reframe your shot. You may need to access your camera's menu to make sure that the AE-L button doesn't lock the focus too (see pp.92–93).

ALSO WORKS FOR...

Dawn or dusk are perhaps the best times for creating silhouettes. The low angle of light provides the perfect backlit conditions, and there's also the increased chance of capturing some striking colors in the sky. Shooting with the "wrong" White Balance setting (see pp.126–29), can also produce interesting results.

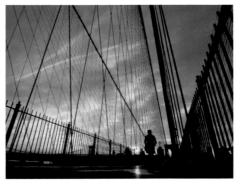

THE RESULT

The striking pattern formed by the seed heads and the barbed wire works well in silhouette. We shot from a low angle looking upward, so that the sky, rather than the field beyond, formed the background.

CAMERA **SETTINGS**

A • f/8 1/250 SEC ISO 100 AWB

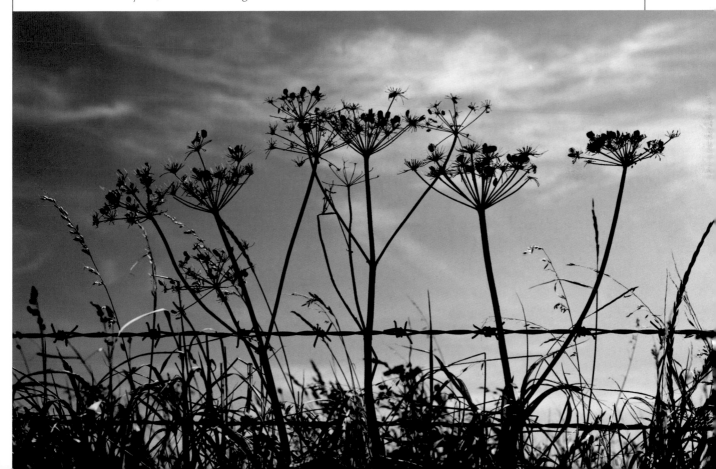

HOW DO YOU WORK WITH **LENS FLARE?**

You've probably seen plenty of photographs that have been affected by lens flare, whether it manifests as colored "blobs" that emanate from a source of light (typically the sun) or simply as an overall loss of contrast. Camera lenses are made up of numerous glass elements that are designed to control, direct, and focus light onto your sensor. However, when you take a photograph with your lens pointed toward a light source, some of the light can reflect off the various elements, rather than passing through them, resulting in flare.

Avoiding lens flare

The most obvious way to avoid lens flare is to aim your camera away from the light source, so you take the picture with the light behind you. Although effective, this can be restrictive—if you always stick to this rule, then all of your photographs will be lit from the front. There will also be shots that you'll miss out on, due to the position of your subject in relation to the sun or other light source.

Instead, it's far better to be aware of flare (and its causes) and understand the ways in which you can work around it. This can be done by blocking the light source with your subject or another element in the scene, or using one of the techniques below.

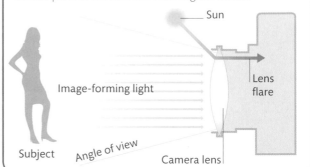

HOW IT HAPPENS

Flare is caused by non-image-forming light (either in the scene being photographed or out of shot) reflecting off various parts of the lens and reaching the sensor.

Sun

Lens flare

Image-forming light

Subject

Angle of view

Camera lens

LENS HOOD	SHIELD WITH YOUR HAND	MAKESHIFT SHADE

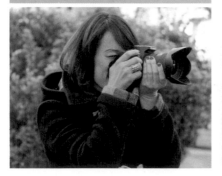

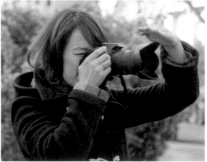

▲ A lens hood is designed to shade the front of your lens and minimize the amount of light that can hit it from the side, reducing the chance of flare.

▲ If you can hold the camera steady, you can use one hand to shield the front of your lens. You can do this in addition to using a lens hood.

▲ Not all lenses come with a lens hood, but you can use items such as magazines or maps to make an effective impromptu lens shade.

Using flare creatively

Although lens flare is often seen as an undesirable addition to a photograph, it's not always all bad. In some situations flare can actually have a positive impact on a picture, enhancing the atmosphere and giving an impression of dazzling sunlight or adding a splash of color to an otherwise subdued scene.

 Some photographs work best when you include the source of the flare (the sun, for example) in the frame. This not only enhances the flare, but also means that anyone viewing your picture will see that including it was a conscious decision on your part, rather than a mistake.

▼ The flare in this shot is subtle, yet effective. It demonstrates that you don't always need to include the light source in the frame to use flare creatively.

▲ The starburst effect of the low sunlight filtering through the trees is an integral part of this shot, and is as much the subject as the woodland itself. Without it the atmosphere would be entirely different.

▲ Flare doesn't have to dominate a photograph to have an effect. In this urban scene it imparts a sense of the heat of the day on this busy city street, but it doesn't overpower the detail in the lower half of the image.

FLASH

FLASH

After a lens, a flash is the most popular add-on accessory for dSLRs and CSCs (and some high-end compacts as well), augmenting the built-in unit found on most cameras. As you'll discover in this chapter, the versatility of today's flashes can really broaden your photographic capability, regardless of whether you simply use your camera's pop-up flash or decide to invest in an external hot shoe flash. The table below describes some of the most useful (and creative) flash modes.

RED-EYE REDUCTION	SLOW SYNC
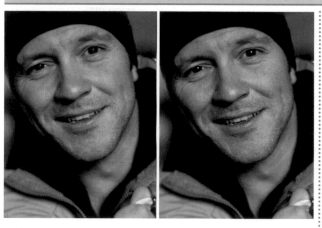	

Red-eye occurs most often when you're photographing people (or animals) in low-light situations and they're looking directly at the camera. It's caused by light from your flash entering your subject's dilated pupil and reflecting off the blood vessels at the back of the eye. Red-eye reduction works by firing a pre-flash (or several pre-flashes) before the main flash, which causes your subject's pupils to contract before you take the shot.

In some modes your camera will set a fairly fast shutter speed when you use flash, and while this will expose your subject correctly, it may not let enough light into your camera to expose the background, especially at night. Slow sync tells the camera to use a slower shutter speed to capture ambient light, in addition to firing the flash. Slow sync is linked directly to 1st and 2nd curtain sync (see right), so activating one of these modes automatically initiates slow sync too.

WHEN TO USE IT

- For taking pictures of people in low-light situations
- For low-light pet portraits
- When photographing wildlife at night

WHEN TO USE IT

- For recording background ambient light
- When you want to record background movement blur while keeping your main subject sharp

FLASH COMPENSATION

Just as you can use exposure compensation (see pp.80–83) on your camera to make an image brighter or darker, so you can compensate for your flash exposure too. This increases or decreases the power of the flash, either to balance it with the ambient light, or simply to change the intensity of the flash for creative effect. Flash exposure compensation is usually activated via a button on the camera body and is adjusted in ½- or 1-stop increments.

1ST/2ND CURTAIN SYNC

With a regular shot, the flash fires as soon as the shutter is fully open. This is known as 1st curtain sync (see p.153). It works well for static subjects, but if you're using slow sync flash (see left), any movement after the flash has fired will be recorded as a blur, with the trails in front so that moving elements appear to be going backward (above left). Switching to 2nd curtain sync fires the flash at the end of the exposure, creating a more natural look, with movement trails behind the subject (above right).

WHEN TO USE IT

■ For static subjects, 1st curtain sync is ideal

■ Use 2nd curtain sync to record movement blur in your subject, while keeping the subject itself sharp

HI-SPEED FLASH

Hi-speed flash, or high-speed sync, is typically found on high-end external flashes. It enables you to use shutter speeds that are faster than the camera's sync speed (see p.152), so you can use flash at 1/1000 sec, 1/2000 sec, or even faster. It achieves this by firing a series of very rapid flashes. The flashes are so close together that they effectively create a continuous light source that guarantees the entire frame is exposed, despite the very fast shutter speed.

WHEN TO USE IT

■ On bright days, to provide fill-flash

■ When you're using very fast shutter speeds

■ When you're using a wide aperture and/or a high ISO

WHAT ARE **SYNC SPEEDS** AND **GUIDE NUMBERS?**

Perhaps the most important concept to understand when it comes to using flash is sync speed (short for synchronization speed). Your camera's flash sync speed is the fastest shutter speed at which the sensor is exposed to light in its entirety. This is the point at which a flash can be fired, and that brief burst of light will expose the whole frame. If you use a faster shutter speed, then the sensor is only being exposed to a slit of light, so you end up with a partial image. The sync speed on most cameras is around 1/200 sec.

▼ Flash synchronization is based on the way in which camera shutters work. With fast shutter speeds (usually faster than 1/200 sec), the sensor is exposed to a traveling slit of light, rather than being exposed in its entirety, so the resulting image is cut off.

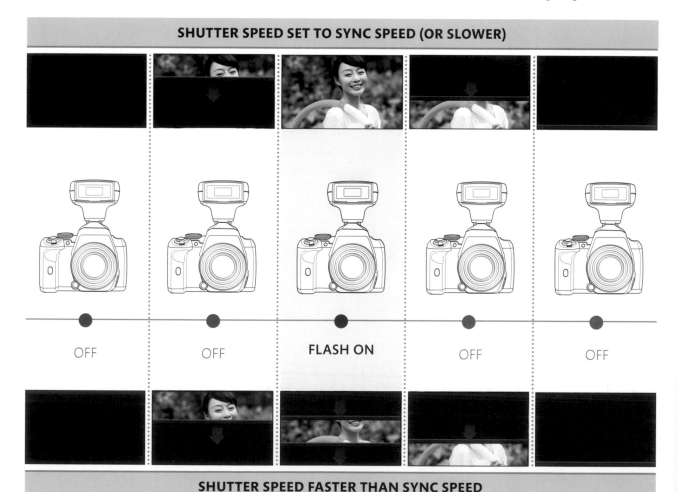

SHUTTER SPEED SET TO SYNC SPEED (OR SLOWER)

OFF OFF FLASH ON OFF OFF

SHUTTER SPEED FASTER THAN SYNC SPEED

How a shutter works

To understand flash sync speeds you need to know how a camera's shutter works. A shutter is comprised of two curtains. When you press the shutter release, the first curtain opens, exposing the sensor to light. After a predetermined amount of time (which is the shutter speed), the second curtain closes to end the exposure. Your flash needs to be triggered when the first curtain is fully open and the second curtain has yet to start closing. However, with fast shutter speeds this moment doesn't actually happen: the second curtain starts to close before the first is fully open. So, if you fire a flash, you'll record the closing shutter, as shown below.

GUIDE NUMBERS

The flash guide number is an indication of its power. In the past, knowing the guide number was essential, since you needed to use it in conjunction with the flash-to-subject distance and the aperture setting to determine the correct exposure. However, it's no longer quite as necessary. Through-the-lens (TTL) flash control means that the camera can now make the exposure calculations for you, and you may view your image immediately, so you know whether you need to tweak your settings. The guide number is no longer an accurate indication of a flash's power, either. In an attempt to make their flashes appear more powerful (at least on paper), some manufacturers have taken to measuring flash power at longer telephoto lengths and/or high ISO settings: both of which inflate the guide number.

1/200 SEC

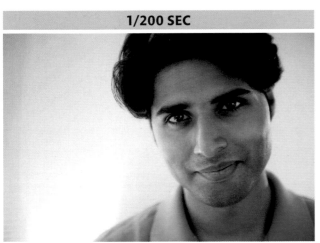

1/250 SEC

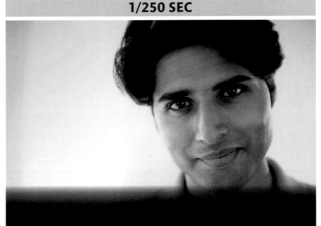

1/320 SEC

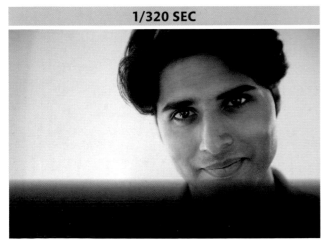

1/500 SEC

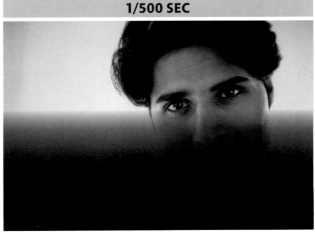

USING **FILL-FLASH**

Your camera's built-in flash can be both a blessing and a curse, especially when it comes to portraits. On the one hand it can be invaluable when you're shooting in low-light conditions, but it can just as easily ruin your shots since its direct light creates deep shadows and can result in red-eye. However, it doesn't have to be this way. Often, it is not so much the flash itself, but the way in which it's used that's the problem, and making a few basic changes to your flash settings can transform your results.

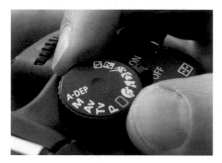

1 SELECT APERTURE PRIORITY
Aperture Priority will give you control over the depth of field, so you can throw the background out of focus if you want to.

2 ACTIVATE FLASH
Press your camera's flash button to pop it up or lift it manually—it depends on your camera model (but don't force it).

3 ACTIVATE RED-EYE REDUCTION
The default setting for red-eye reduction is usually Off, but you can change this on most cameras by using the flash button and control wheel.

INDOOR PORTRAITS

The simplest option for indoor portraits is to activate red-eye reduction as described above and use your camera's built-in flash in Program mode. You'll be able to adjust the exposure pairing to use a wider or smaller aperture (to change the depth of field), although the shutter speed won't go past the camera's maximum sync speed (usually around 1/200 sec). The aperture range will also be limited by the power of the flash, but don't forget that you can change the ISO if you need to. Increasing the ISO will allow you to use a smaller aperture setting and/or increase the effective range of the flash.

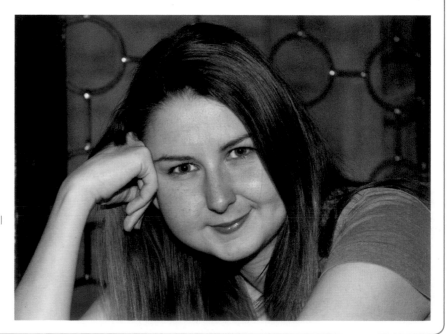

4 TAKE A TEST SHOT

Take a photo and check the result on your camera's LCD screen. If you need to, you can fine-tune the flash compensation to make the flash more or less obvious (see p.151).

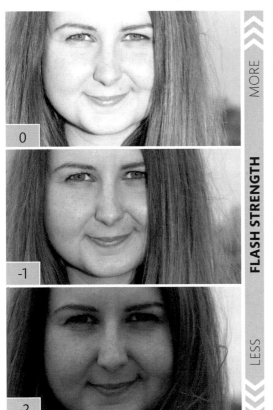

0

-1

-2

MORE

FLASH STRENGTH

LESS

5 ALTER THE FLASH STRENGTH

Decreasing the flash power by 1–2 stops will let the flash act as a fill light, rather than the main light source. On most cameras this is achieved by pressing the flash compensation button and turning the control wheel.

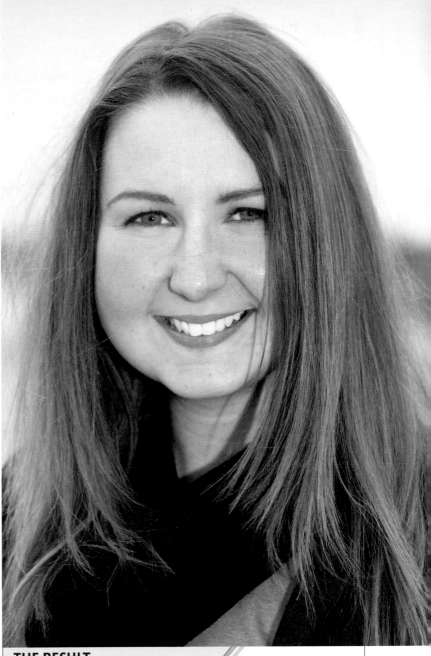

THE RESULT

Fill-flash has prevented any hard shadows being cast across our subject's face, which not only lifts the shot as a whole, but also adds sparkle to her eyes.

CAMERA **SETTINGS**

 1/200 SEC ISO 100

BOUNCING THE FLASH

In addition to offering you more in the way of power, a key difference between your camera's built-in flash and a good external, hot shoe-mounted unit is the ability to tilt and possibly rotate the flash head. Not all external flashes offer this, but it's worth investing in a model that does have this feature, even if it means spending a little more. This is because a hot shoe flash allows you to bounce the light off a ceiling or wall, which spreads it and makes it much "softer." As a result, your photographs won't suffer so heavily from the hard, unattractive shadows associated with direct flash.

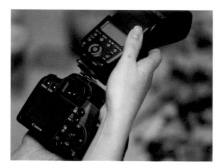

1 ATTACH YOUR FLASH
Fit your flash and lock it. Switch it on and set the flash to TTL (through the lens) so the camera will be controlling the flash output.

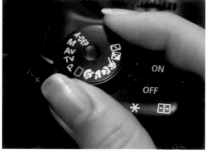

2 SELECT A MODE
Set your camera to Program, Aperture Priority, or Shutter Priority. Here Aperture Priority was selected to allow control over depth of field.

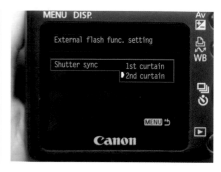

3 ACTIVATE FLASH SETTINGS
To balance the flash with the ambient light you may need a slow shutter speed, so use slow sync, setting either 1st or 2nd curtain sync (see pp.151).

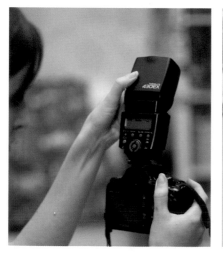

4 TILT THE FLASH HEAD
To bounce the flash, you need to tilt the flash head upward: the flash will probably have a lock that stops you doing this accidentally, so don't force it if it doesn't tilt easily.

5 TAKE A TEST SHOT
Since your camera and flash are set to TTL metering, the camera will automatically try to compensate for the added distance the flash has to travel (to the ceiling and back again, rather than simply straight), but it is worth firing a test shot, just to be sure the exposure is adequate.

6 ADJUST THE FLASH
If the lighting in your test shot isn't quite how you want it, adjust the flash compensation to make the flash appear more or less obvious, and shoot again.

HOT SHOE ACCESSORIES

There are many accessories designed to soften flash light. Diffusers fit over the flash, while others use an angled white card to bounce the light (so you lose less power, and it can be used outdoors). Other gadgets "split" the flash, so some light is directed upward, and some at your subject.

THE RESULT

Direct flash resulted in very harsh, artificial-looking illumination, but by bouncing the flash off the ceiling—effectively creating a much larger light source—we were able to produce a more natural-looking light.

CAMERA **SETTINGS**

S | 1/60 SEC | ISO 200 | AWB

▼ DIRECT FLASH

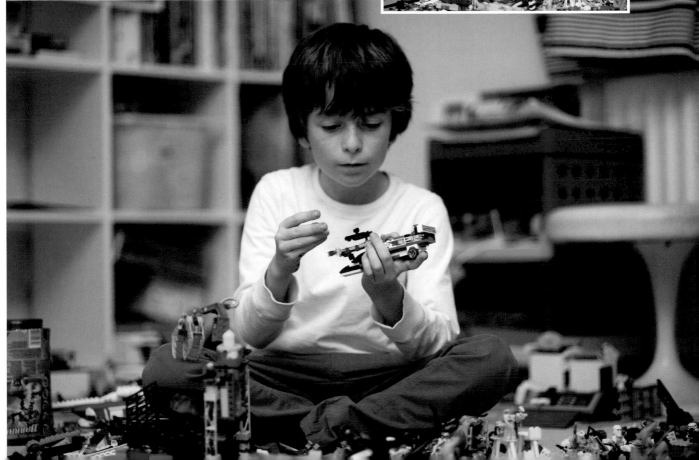

USING **FLASH AT NIGHT**

When you're photographing at night, or under any low-light conditions, you have several options when it comes to getting the exposure right. You could use a slow shutter speed, which might result in blur; set a wide aperture, which will restrict your depth of field; or you can increase the ISO, which will make your images more noisy. None of these approaches is necessarily wrong, but using a hot shoe flash may be the best solution because it will give you much more control over the exposure. This, in turn, will give you a greater level of control over the overall look of your photograph.

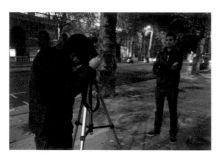

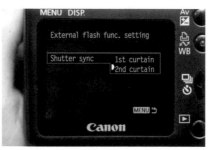

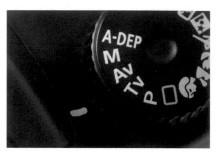

1 SET UP YOUR TRIPOD
If you want to retain some of the ambient light, you'll need to use a slow shutter speed, so a tripod is essential—unless you have a solid surface that you can sit the camera on.

2 SET SHUTTER SYNC
Once you're set up, set the sync mode on your camera. For static subjects, use either 1st or 2nd curtain sync. If your subject is moving 2nd curtain sync is the better option (see pp.151).

3 SELECT APERTURE PRIORITY
To use a slow shutter speed while keeping control over the depth of field, select Aperture Priority and set the aperture to f/8, which will keep the background fairly sharp.

NORMAL FLASH

NO FLASH

4 LET THE CAMERA DECIDE
The camera will set a fairly slow shutter speed because of the low light and relatively small aperture setting. With normal flash, your subject is well-exposed, but the background is barely visible (above left). If you use a slow shutter speed without flash, you see the background but the ambient lighting isn't enough to light your subject properly (above right). Setting the camera to slow-sync gives you the best of both worlds; the slower shutter speed captures ambient background light, while the aperture controls depth of field and flash power to ensure your subject is well-lit.

IMPROVING FLASH

Using a hot shoe-mounted flash (or built-in flash) in low-light conditions is almost certain to produce red-eye if your subject is looking directly at the camera. Avoid this by activating Red-eye reduction (see p.150). Direct flash is a hard light source, so invest in a diffuser that slides over the flash head (see p.157). Alternatively, you'll find instructions for making various ingenious DIY flash diffusers online.

ALSO WORKS FOR...

Slow-sync flash also works indoors, when you want to light your main subject but retain a sense of place. You need to be aware, however, that although the flash will freeze your subject at the moment the flash fires, the slow shutter speed can cause movement blur trails. This effect can work well for some shots, but act as a distraction in others.

THE RESULT

The final shot combines a well-lit subject with a background exposure that gives a sense of place. The warm colors from the streetlights and light trails from the moving traffic impart an urban edge.

CAMERA **SETTINGS**

A f/8 1 SEC ISO 200 AWB

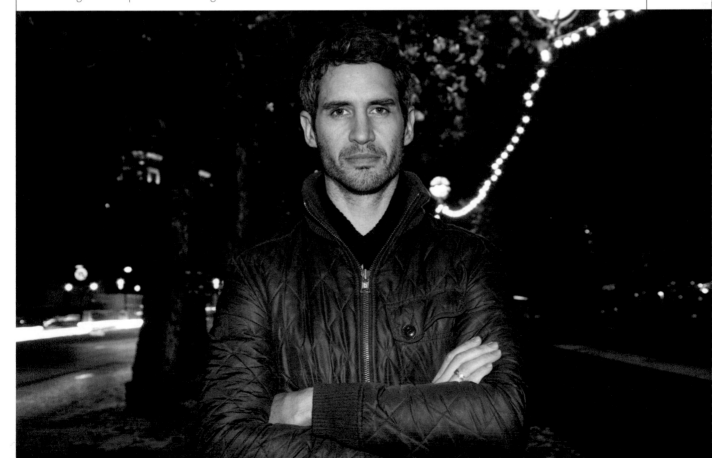

USING A **SIMPLE LIGHTING SET-UP**

Wireless flash control is an increasingly common feature on hot shoe-mounted flashes and dSLR cameras and CSCs, and one that allows you to start exploring professional lighting set-ups with minimal fuss. Even if you don't have wireless flash, you may be able to take your flash away from the camera using a dedicated through-the-lens (TTL) lead or remote triggering system. The main benefit of off-camera flash is simple: you're no longer limited to flat, frontal lighting. These opens up a whole world of creative options, starting with this simple one-flash setup that's perfect for portraits.

1 SET UP YOUR FLASH
Because you'll be using the flash away from the camera, you need something to hold it in place. Lightweight stands like the one shown here are inexpensive and perfect for the job, but you could use a tripod with a suitable hot shoe adaptor.

REMOTE CONTROL

Remote triggering systems are available for a wide range of cameras that don't have wireless control as standard. These triggers consist of a transmitter that sits in the camera's hot shoe, and a receiver under the flash that together provide you with full TTL wireless flash control.

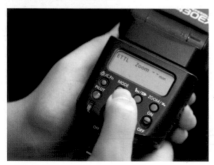

2 SWITCH TO TTL
Set your hot shoe flash to its TTL mode, so the camera can control how powerful the flash is, depending on the exposure settings you're using. That way, if you change the aperture, the flash will compensate.

3 POSITION A REFLECTOR
Adding a reflector (see pp.130–31) opposite the flash will help fill in any potentially hard shadows created by the flash. For portraits this softer light is almost always preferable.

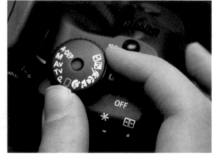

4 SELECT A MODE
Your camera will be controlling the flash output automatically, so you can set the shooting mode to Program, Aperture Priority, or Shutter Priority. But be sure not to exceed the camera's flash sync speed (see pp.152–53).

FLASH TOO BRIGHT

BACKGROUND SHADOWS

SHADOWS FILLED

5 **TAKE A TEST SHOT AND EXPERIMENT**
Until you take a test shot, you won't know for sure what effect your flash will have. Make sure that you don't have any exposure warnings indicated in the viewfinder (if you do it's probably because the aperture's too wide), and be prepared to move the reflector around to fill any hard shadows.

THE RESULT

Getting your flash away from the camera avoids the harsh, front-lit look you'd get from a built-in or direct hot shoe flash. This instantly produces more professional-looking results.

CAMERA **SETTINGS**

A f/4 1/100 SEC ISO 100 AWB

PAINTING WITH LIGHT

With off-camera flash you can create truly unique night-time images by "painting with light." The basic technique is fairly easy to grasp: set a long exposure time on your camera and fire your hot shoe flash multiple times to illuminate your subject. Assuming your exposure time is long enough, it's possible to light an entire building in this way (if you wish to), but there are a couple of things to be aware of. First, you need to work in total darkness and wear dark clothes so that the long exposure doesn't record you as a "ghost." Second, you have to be patient; it takes practice to get consistently stunning results.

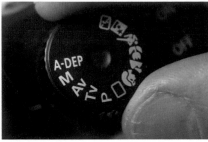

1 **SET UP A TRIPOD**
A tripod is essential for light painting: you'll be holding the shutter open for a while, so your camera must be steady.

2 **SELECT MANUAL MODE**
Set your camera to Manual mode and dial in a shutter speed of 30 seconds (usually the camera's maximum automatic setting). As a starting point, choose the lowest ISO, an aperture of f/8, and set the White Balance to Flash or Daylight for neutral colors.

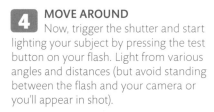

3 **SET YOUR FLASH TO MANUAL**
Set your flash to manual and zoom it to its widest zoom position so you get the greatest spread of light. Start with the power set at 1/16.

4 **MOVE AROUND**
Now, trigger the shutter and start lighting your subject by pressing the test button on your flash. Light from various angles and distances (but avoid standing between the flash and your camera or you'll appear in shot).

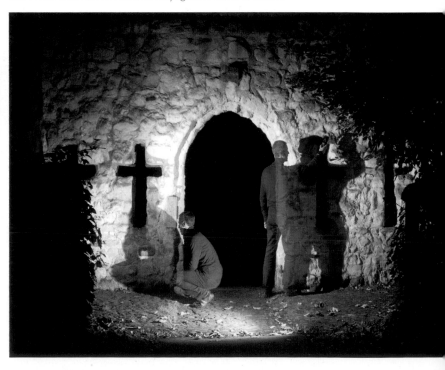

5 **ASSESS THE SHOT**
Check the exposure. If it's too bright, try reducing the flash power, firing fewer flashes, and/or make the aperture smaller. If it's too dark then the opposite applies: increase the flash power, fire more flashes, and/or use a wider aperture setting until you get the result you're after.

COLORED LIGHT

You don't have to restrict yourself to "straight" daylight balanced flash. Colored lighting gels can be used to transform the light from your flash, simply by holding them in front of the flash as you fire it.

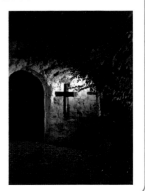

THE RESULT

The long exposure has lightened the residual orange glow in the sky, but it's a single flash fired from multiple angles that has illuminated the facade of this ruined gatehouse.

CAMERA **SETTINGS**

 30 SEC

IMAGE
ENHANCEMENT

IMAGE ENHANCEMENT

Although it's by no means essential, the majority of digital photographs will benefit from a certain level of post-production work, or image enhancement, whether that means simply tweaking the exposure or completely deconstructing and reassembling an image. Between these two extremes are the steps that will ensure that every photograph you take looks as good as possible, and in this chapter you'll discover just how easy and effective these adjustments can be.

Working with layers

When it comes to choosing editing software, layers should be considered an essential feature. In the simplest sense, layers can be thought of as clear sheets of acetate that you place over your image. You can then make any changes you wish on that layer, and your underlying digital image will be protected. If things go wrong at any time, you can simply get rid of the layer, rather than the original photograph. Using multiple layers enables you to make complex groups of changes, which can then be blended together, giving you even greater control over your images.

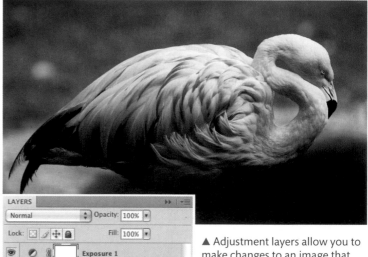

▲ Adjustment layers allow you to make changes to an image that can be reversed and fine-tuned without degrading the original.

SUGGESTED WORKFLOW

DOWNLOAD

The first step is to get your images onto your computer, either by connecting your camera to your computer, or by putting your memory card into a card reader.

OPEN IMAGES

All editing software will allow you to open your images individually, but some will also let you apply changes to multiple images at the same time.

CROP & STRAIGHTEN

Rogue elements creeping into the edges of frame and sloping horizons are very common problems and should be fixed before you do anything else (see pp.168–69).

SET EXPOSURE

Even if you get the exposure right with your camera, it's worth tweaking it on screen to see if there's any room for improvement (see pp.170–71). Before you start, create an adjustment layer.

ANATOMY OF A TOOLBAR

All image-editing software differs to a greater or lesser degree (the anatomy here shows Photoshop Elements), but certain features are shared by most: selection tools, brush tools, the ability to add text, and one or more retouching tools that will help you edit out unwanted blemishes, for example. These tools are generally found in a toolbar at the top or side of the screen. Additional features that call up a separate window or dialog box are usually accessed from the main menu bar.

KEY

1 Move tool For moving selected parts of an image from one place to another

2 Hand tool For dragging your image around the screen to see different areas

3 Selection tool A variety of regularly shaped selection tools

4 Magic wand tool Uses color to select areas of an image

5 Type tool Allows you to add text to your digital images

6 Cookie cutter tool Creates quirky cutouts from your image

7 Red-eye removal tool Corrects red-eye in portraits taken with flash

8 Clone stamp tool For removing dust and scratches manually

9 Brush tool Used to "paint" onto your digital images

10 Paint bucket tool For filling large, flat areas with a single color

11 Custom shape tool Adds predefined shapes to your pictures

12 Sponge tool Lets you selectively increase or decrease saturation

13 Magnifier tool Used to zoom in and out of your image

14 Eye dropper tool Allows you to sample (pick) colors from anywhere on the screen

15 Lasso tool Selection tools for choosing irregularly shaped parts of an image

16 Quick Selection tool Uses edge contrast to quickly select parts of an image

17 Crop tool A quick and efficient way to trim your images

18 Straighten tool Helps correct sloping horizons and converging parallel lines

19 Healing brush tool Removes defects and blemishes with a single click

20 Eraser tool Allows you to delete areas from a layer

21 Smart brush tool Allows you to paint creative effects onto your image

22 Gradient tool Allows you to add a gradient effect to your image

23 Blur tool Used to selectively blur parts of an image

24 Color swatch Used to set the current foreground and background color

ADJUST CONTRAST

If your image is looking a little flat and lackluster, you can boost the contrast between light and dark to make it appear more vibrant and "3D" (see pp.172–73).

COLOR

From highly saturated colors to subtle tints to black-and-white, color—or the lack of it—has a huge impact on how we perceive an image (see pp.174–79).

SHARPEN

Once you've made any other adjustments, ensure that small details and edges in your image are crisply defined (see pp.180–81).

OUTPUT

The final stage in your digital image workflow is to save and output your adjusted image, whether to print or the web.

CROPPING FOR IMPACT

In an ideal world it would be possible to have your camera locked on a tripod and carefully leveled for every shot you take, with a full range of focal lengths at your disposal so you can get as close to your subject as you wish. However, this is hardly practical.

Often you will be shooting handheld, rather than with a tripod, and sometimes you simply won't have a lens that's long enough. In these situations, take the shot and use your editing software's crop and rotate tools to improve the image in post-production.

1 ADD A GUIDE
Most editing software allows you to add guidelines, which are horizontal or vertical lines superimposed over the image. Drag a horizontal line to the horizon to determine whether it's straight; if not, this gives you a target for alignment.

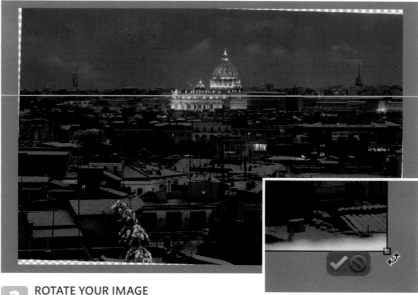

2 ROTATE YOUR IMAGE
The Rotate feature is most commonly a menu option, and when activated it will select the entire image area. Use the "handles" at the corners of the image to rotate the image by clicking and dragging them.

3 SELECT THE CROP TOOL
The Crop tool usually sits as an option on the main toolbar of your editing software. The icon, as shown here, often depicts a pair of traditional "cropping Ls."

4 SELECT THE WHOLE IMAGE
With the Crop tool activated, click and drag from one corner of your image to its diagonal opposite (top left to bottom right, for example). This will select the entire image area.

5 RESIZE THE CROP AREA
As with the Rotate tool, handles will appear at the corners of the area selected. Drag these inward to set the crop area. Here, the area that will be cropped out is shown in red: the full-color area is the new crop.

ALSO WORKS FOR...

There are two main reasons why you might crop an image. The first is to make your subject appear bigger in the frame; the second is to remove distracting elements, such as someone stealing the limelight in the background.

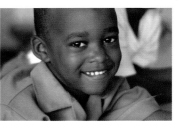

THE RESULT

Rotating the image has leveled the horizon, but it's the fairly severe crop that's had the most effect by focusing attention on the floodlit building and removing several unnecessary elements from the foreground.

CAMERA **SETTINGS**

▼ BEFORE CROP AND ROTATE

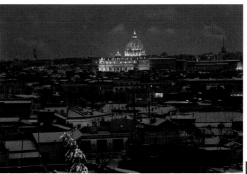

CORRECTING **EXPOSURE**

With so many different exposure modes and exposure metering patterns built into your camera, you may wonder why you'd ever need to adjust the exposure of a shot in your editing software. But sometimes you may feel that an image would look better a little lighter or darker than shot, or your camera will have been "fooled" by tricky lighting conditions. Whatever the reason, your editing software will have tools to help you, ranging from simple exposure sliders through to the more advanced Levels, a histogram-based tool which gives you greater control.

◀◀◀ LESS LIGHT **EXPOSURE** MORE LIGHT ▶▶▶

1 APPLY EXPOSURE COMPENSATION
The Exposure tool is the simplest way to correct exposure, and it works in a similar way to the exposure compensation found in your camera (see pp.80–81).

Increase the exposure level (+) to brighten an image, or decrease the exposure level (-) to darken it. As with in-camera exposure compensation, adjustments are usually made in "stop" increments, although editing software is usually more precise.

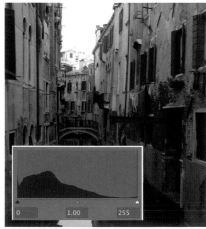 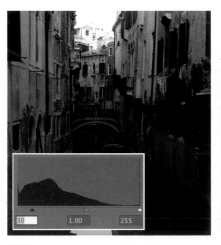 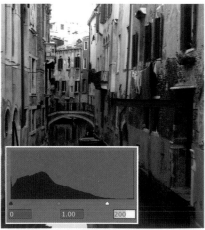

2 USE LEVELS
While Exposure allows you to make universal changes to your images, Levels lets you control the shadows, highlights, and midtones independently. It does this by using an editable histogram (see pp.78–79).

3 SET THE BLACK POINT
At the left end of the histogram (the shadows) is a black slider control. Move this to the right to darken the shadows in your image without affecting the highlights.

4 SET THE WHITE POINT
At the right end of the histogram (the highlights) is a white slider that controls the brightness of highlights. Move the slider to the left to brighten light areas without affecting the shadows.

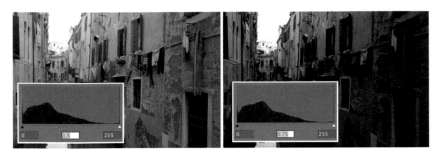

5 SET THE MIDPOINT
At the center of the Levels histogram is a gray, midtone slider (known as the "gamma" slider). This controls the overall brightness of the image and can be used to make universal exposure changes. Slide it to the right to brighten your image, and move it to the left to darken it.

THE RESULT

Adjusting the midtone and highlight areas with Levels quickly corrected the exposure in this shot. A subsequent color boost (see pp.174–175) and some sharpening (see pp.180–81) improved the shot further.

CAMERA **SETTINGS**

 1/30 SEC ISO 1600

▼ BEFORE EXPOSURE CORRECTION

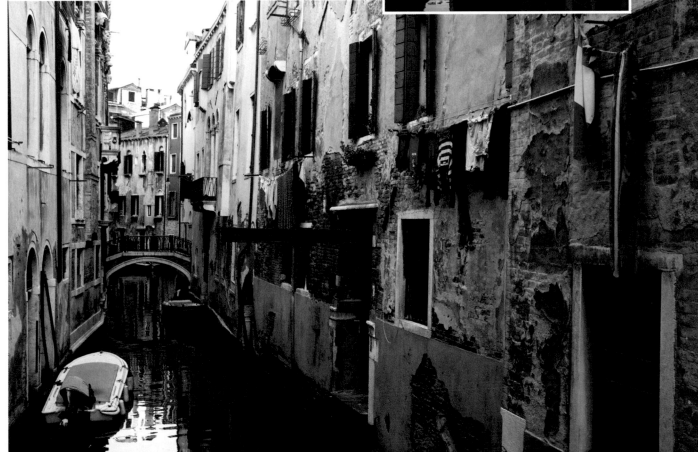

ADJUSTING **CONTRAST**

When photographers talk about contrast they're usually referring to two extremes: low contrast and high contrast. Neither of these is necessarily bad or wrong, but sometimes a shot feels a little flat or too contrasty. It's generally much better to deal with high contrast when you're actually taking the picture (see box, below), but your editing software is the perfect solution to the problem of flat-looking, low contrast images. The best tool for adjusting contrast is Curves, thanks to the high level of control it offers: shadows, highlights, and midtones can all be locked and manipulated independently.

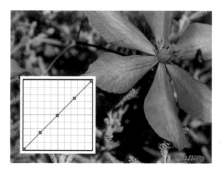

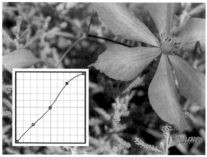

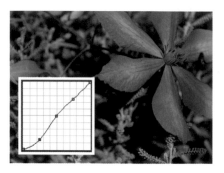

1 OPEN CURVES
When you open a Curves dialog box, you'll see a straight line running across a box from bottom left (shadows) to top right (highlights). The aim is to change the line into a curve to modify the shadows and highlights.

2 ADJUST THE HIGHLIGHTS
In its simplest sense, adding a control point to the top right end of the curve allows you to adjust the highlights in an image. When you move the curve upward, they brighten; when you move the curve downward, they darken.

3 ADJUST THE SHADOWS
The same process applies when adjusting shadows, except this time you need to add a control point to the lower left end of the curve. Drag the point downward to darken the shadows, or drag it upward to lighten them.

HIGH CONTRAST

While low-contrast images can often be improved in your editing software, the same isn't true with high contrast. Many programs have a Shadow/Highlight Recovery tool (or similar), but this won't help when the shadows or highlights in an image are clipped (see pp.78–79), as is the case here. In the original image (left), the highlights on the child's face are pure white, and they remain so after adjustment (right). You simply can't recover what isn't there to begin with, which is why high contrast is best tackled in-camera, either by using a reflector (see pp.130–31) or diffuser (see pp.132–33), or by shooting for HDR (see pp.84–85).

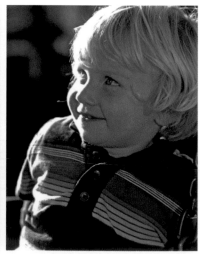

4 APPLY AN "S" CURVE
The simplest way to boost contrast is to create a shallow "S" shape, as shown here. This deepens the shadows and brightens the highlights without losing detail, which can occur with other contrast adjustment tools.

LEVELS VS. CURVES

You can use Levels (see pp.174–75) to adjust contrast: moving the black slider to the right and the white slider to the left to darken shadows and lighten highlights. However, with Curves you can usually add multiple control points, allowing you to finesse your results, should you need to.

THE RESULT

The original image felt a little washed out. Applying an "S" curve has made a significant difference—the increased contrast has made the colors appear more vibrant, and the flower now leaps from the picture.

▼ BEFORE CURVES ADJUSTMENT

CAMERA **SETTINGS**

A | ● | f/4 | 1/1000 SEC | ISO 100 | ☀

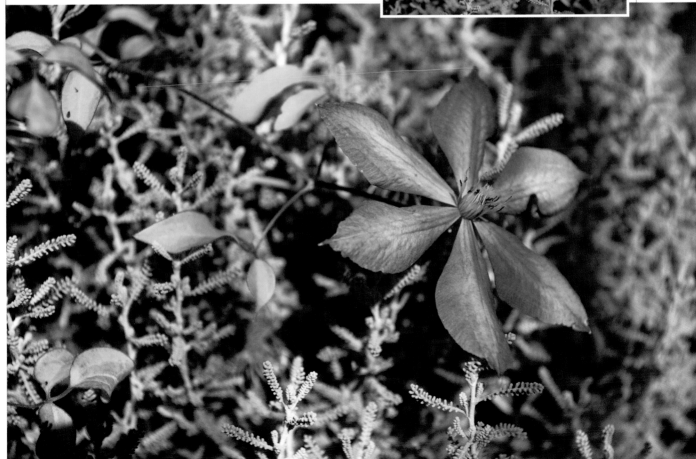

BOOSTING **COLOR**

The meaning of color in photography doesn't just relate to the color temperature of the light (see pp.124–25) or the white balance (see pp.126–29)—it can also refer to the intensity and level of color in an image. In this sense, color can be subjective, with no "right" or "wrong" result. For instance, by boosting color you can rescue photos taken on overcast days, when colors tend to appear drab and uninspiring. In abstract photography, color and shape are often more important than the ostensible subject—and improvements in post-production can lift this effect to a whole new level.

1 SET LEVELS
Before you make color adjustments, use Levels (see pp.170–71) to get the exposure right: overexposed images appear washed out, while underexposed images may look oversaturated.

2 ADJUST CONTRAST
Contrast can also have an impact on color: low-contrast images appear flat, while colors tend to stand out when the contrast is higher. Use Curves (see pp.172–73) to fine-tune the contrast.

CORRECTING COLOR CASTS

If your image has an overall color cast (that is, it appears overly cool or blue, or it has an orange tint), then you need to make an equal and opposite color adjustment. Look for a Color Balance or Color Variations tool in your editing software, since these are usually a little more refined than Hue/Saturation in this instance. However, set the exposure and contrast before you make any adjustments.

3 ADJUST HUE
Once the exposure and contrast have been set, you can make changes to the color. A Hue/Saturation tool can be found in most editing software, and the first step is to see whether changing the Hue will improve your image. Adjusting the Hue slider shifts the overall color bias of an image, from green through blue, red, yellow, and all colors in between. A small adjustment usually creates a significant overall visual effect.

4 ADJUST SATURATION
While Hue alters the color itself, Saturation determines its intensity, usually from a scale of 0 (fully desaturated/shades of gray) to 100 (heavily saturated color). Even small shifts in the Saturation slider can have a major impact on the image.

ALSO WORKS FOR...

Hue and Saturation adjustments can be used to transform your pictures, either by changing one of the parameters or changing them both together. A popular method is to brighten up shots containing people—this instantly makes this type of photograph more appealing: warmer tones suggest a happier mood.

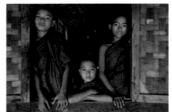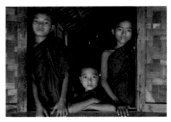

THE RESULT

A combination of exposure, contrast, and color adjustments has transformed this dreary, nondescript shot of a rain-spattered window into a pleasingly vibrant and eye-catching abstract.

▼ BEFORE COLOR BOOST

CAMERA **SETTINGS**

A | 1/100 SEC | ISO 400

CONVERTING TO **BLACK AND WHITE**

All image-editing software offers a simple Desaturate or Grayscale option (or similar), which will remove the color from your photograph at the click of a button. However, this won't give you any control over the appearance of the final image. It's the same as if you were to set your camera to capture in black and white: a straight conversion can result in a flat-looking image, without contrast or dynamic range. So, unless it's your only option, it's not the most effective route to take. Instead, check to see whether your software has a more sophisticated black-and-white conversion tool.

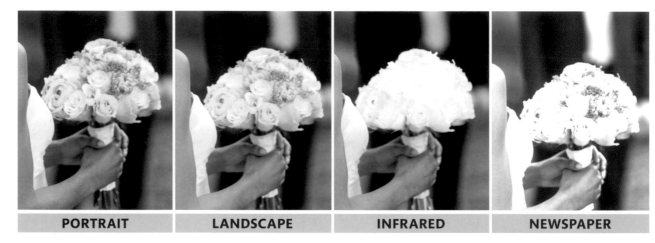

| PORTRAIT | LANDSCAPE | INFRARED | NEWSPAPER |

1 **EXPERIMENT WITH PRESETS**
To begin with, try each of the available presets to see their effects. The images above show a variety of presets available in Photoshop Elements, demonstrating how the notion of "black and white" isn't as straightforward as it seems.

| INCREASED RED | INCREASED GREEN | INCREASED BLUE |

2 **EXPLORE COLOR FILTERS**
Some software offer color adjustment in addition to (or instead of) preset styles. Through the use of sliders for red, green, and blue (and possibly more colors), these can also control how different colors appear in black and white. Increasing one slider generally means reducing the strength of other colors to compensate.

3 **FINE-TUNE THE RESULT**
If appropriate, you can apply an S curve to finesse the image (see pp.172–73). In this case, a boost in contrast has accentuated the modern feel.

USING DIGITAL COLOR FILTERS

Digital color filters replicate the effect of lens filters traditionally used in black-and-white photography. This can create dramatic, high-contrast skies in landscape images, for example. The way they work can seem confusing at first, but there's a simple way to remember the effect they'll have on your image. A color filter will lighten areas of the subject that are the same color (or similar), and darken opposite colors. For example, when you convert to black and white, a red filter will lighten red areas (and, to a lesser extent, orange and yellow areas) of the image, while at the same time darkening blue-green areas.

THE RESULT

Converting portrait and wedding pictures to black and white is a great way of giving them a timeless yet contemporary look. Removing the color can often enhance the romantic mood of an image like this.

CAMERA **SETTINGS**

▲ BEFORE BLACK AND WHITE CONVERSION

TONING THE IMAGE

Before color photography was invented, toned black-and-white prints were relatively common. Initially, this wasn't as much of a creative decision as a technical one—various photographic pioneers experimented with different chemicals in an attempt to extend the life of their delicate prints. However, even after it became possible to produce a stable black-and-white print, toned images remained a popular means of adding color and atmosphere to an otherwise grayscale image. The practice is still used today, although now the tones are more often applied using software, rather than toxic chemicals.

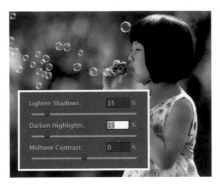

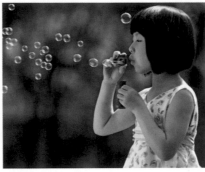

1 **REDUCE CONTRAST**
Toning works best when it's applied to a slightly flat (low contrast) image, so rather than boosting the contrast, consider reducing it using Shadows/Highlights (or similar) before you begin (see pp.172–73).

2 **REMOVE COLOR**
The basis for any toned image is a black-and-white original, so you need to remove the color. Convert the image to black and white (see pp.176–77) without increasing the contrast.

3 **ADJUST TONE**
Using the Color Variations (or just Variations) tool allows you to tone the shadows, midtones, or highlights, and you can also set the adjustment intensity from a mild tint through to a strong tone.

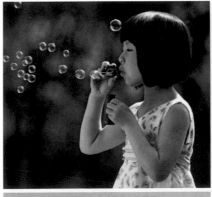

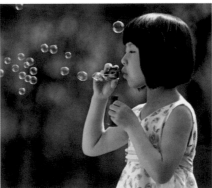

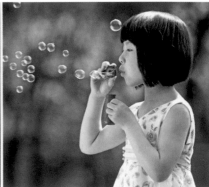

INCREASED RED

DECREASED BLUE

LIGHTENED

4 **EXPERIMENT**
The adjustment buttons give a live preview, so it's simply a case of clicking on an adjustment button, and the After image will be updated to show how your picture is looking. For a straight toned image, it is a good idea to leave the area set to Midtones, but you can change the intensity of the color adjustment, if you wish. Clicking on Increase Red, Decrease Blue, and Lighten results in a subtle, sepia-toned look.

5 MAKE FINAL ADJUSTMENTS

When you're happy with the tone you've created, click on OK to apply it to your image. Then, if necessary, tweak the brightness and contrast (see pp.170–73) and sharpen (see pp.180–81), ready for printing or sharing online.

SPLIT TONE

You can add a split tone to your images by toning the shadows with a different color than the one you've used for the highlights. This is usually done with opposite colors—adding a blue tone to the shadows and making the highlights more yellow is a classic combination.

THE RESULT

This was an incredibly straightforward process, yet the picture has been completely transformed: the warm sepia tone gives it an antique appearance that enhances the quiet, contemplative nature of the image.

CAMERA **SETTINGS**

A | | f/5.6 | 1/60 SEC | ISO 200 | ☀

▼ BEFORE TONING

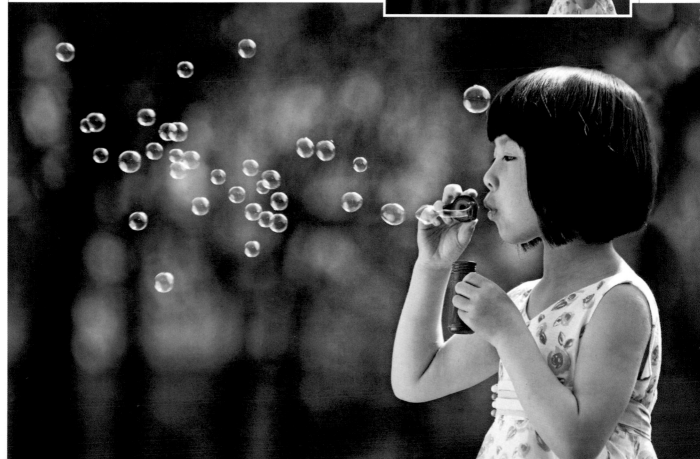

ACHIEVING **CRISP DETAILS**

If you've spent a fair amount of money on a camera and an accompanying lens (or lenses), you might wonder why you'd ever need to sharpen your photographs with editing software: surely your camera will deliver a sharp image? Well, yes and no. Your lenses have a significant impact on how sharp your pictures will be, but all digital photographs can benefit from extra digital sharpening. This is essentially because of the way in which digital camera sensors work—it's unavoidable, and not a camera fault—but your editing software is more than capable of making things right.

1 DUPLICATE THE IMAGE LAYER
You'll need software with Layers for this technique (see p.166). First, duplicate your image so you have a copy of it on a second layer (the "adjustment layer"). This will be at the top of the Layers palette, with your "master" layer beneath.

2 SET THE BLENDING MODE
Using the drop-down menu in the Layers palette, change the Blending mode for your duplicate layer from Normal to Overlay. Don't worry if the image looks overly saturated and contrasty at this point.

SHARPENING FILTERS

Most editing software incorporates several sharpening filters, ranging from simple Sharpen options that don't give you any control at all, through to advanced sharpening tools such as Unsharp Mask (USM). USM is an incredibly powerful (and complex) sharpening tool, but should be used with caution: it's easy to overdo it and end up with an unattractive, over-sharpened result (see detail below, right).

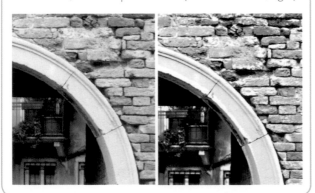

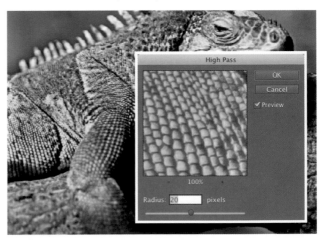

3 APPLY THE HIGH PASS FILTER
Although you want to sharpen the image, you won't be using one of your editing software's sharpening filters. This may seem strange, but these filters tend to be either rather crude or overcomplicated in their approach (see box, left). Instead, apply the High Pass filter to your duplicate layer. Adjust the filter amount so that the details in the image appear crisp.

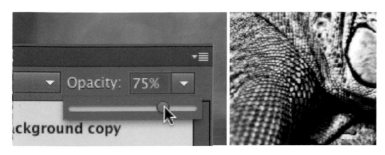

4 ADJUST OPACITY

Fine-tune the effect of the High Pass filter by adjusting the Opacity of your adjustment layer. Decreasing the opacity allows the master layer below to show through. Although this effectively reduces the sharpening effect slightly, you should be able to keep the edges nice and crisp, without any halos appearing along them: this would be a sure sign that the image is over-sharpened.

THE RESULT

With a subject that contains a lot of fine detail, such as this scaly iguana, sharpening is essential, especially if you plan to print your image. It also boosts color and contrast slightly, which further enhances the shot.

CAMERA **SETTINGS**

▼ BEFORE SHARPENING

GLOSSARY

*(words that appear **bolder** in the entries also have their own entry)*

aberration Unwanted defect in an image, typically caused by the camera lens.

AE-L (Automatic Exposure Lock) A camera feature that allows you to lock the **exposure** set by the camera, usually so you can reframe a shot.

AF-L (Automatic Focus Lock) A camera feature that holds the **focus** at a set distance.

ambient light Existing light in a scene, such as daylight.

angle of view The amount of a scene imaged by the camera. Usually given as a diagonal measurement.

aperture A variable opening in the lens that allows light to pass through to the sensor. The main control over **depth of field**.

Aperture Priority A semi-automated **exposure** mode: the photographer sets the **aperture** (and **ISO**), and the camera selects a shutter speed that will give the optimal **exposure**.

APS-C A discontinued film format, measuring 25.1mm x 16.7mm. The size closely matches that of the **sensor** found in many dSLR cameras and CSCs and results in a 1.5x or 1.6x **focal length magnification**.

artifact An unwanted defect in a digital image, such as sharpening halos or **noise**.

Auto (exposure) Exposure mode in which the camera sets the **aperture**, shutter speed, and **ISO**, in addition to the **white balance**, and most other camera settings.

autofocus A system that uses sensors to assess the subject and focus the camera lens automatically.

AWB (Automatic White Balance) A camera feature where the camera assesses the scene and sets the correct **white balance**.

backlighting Lighting situation where the primary light source is behind the subject, pointed toward the camera.

blending mode A feature in digital image editing software that enables you to change the way one **layer** interacts with other layers.

bracketing Taking a number of exposures of the same scene at different **EV** settings to ensure that one is correctly exposed, or to create an HDR image.

brightness The intensity of light in an image.

center-weighted metering An exposure metering pattern with a bias towards the center of the image.

clipping When detail is lost in either the **highlight** and/or shadow areas of an image.

CMYK (Cyan, Magenta, Yellow, Key) The primary colors used in printing, where Key is black.

color cast An overall color shift in an image, typically caused when the incorrect **white balance** is set.

color temperature A measure of the temperature of light, given in degrees Kelvin (K).

compression Typically used in reference to image files and the way in which they are saved. JPEG files use lossy compression to produce small file sizes, with some data loss. Some **Raw** files are uncompressed.

Continuous Autofocus (AF) Mode that allows the camera to constantly adjust the **focus** of the lens to compensate for a moving subject.

contrast The range between the brightest and darkest parts in an image. Contrast can be low or high.

crop To remove unwanted areas from an image, usually using image-editing software.

depth of field The area of an image in front of and behind the point of focus that appears acceptably sharp.

diffusion The scattering of light particles, which softens the light and shadows cast by it.

digital manipulation To make changes to a digital image using image-editing software.

display Part of a device that can show a digital photograph on a screen, such as a computer monitor, rear LCD screen on a camera, tablet, or smartphone.

distortion Commonly refers to a lens **aberration**, where straight lines appear curved, especially toward the edges of the frame.

dpi (dots per inch) Used as a measure of print **resolution**: the greater the number of dots (of ink) per linear inch in a print, the higher the resolution.

dynamic range The difference between the brightest and darkest parts of a scene that a camera can record information in. Usually given as a range of **stops**.

EFL (Effective Focal Length)
Used to describe the **angle of view** shown by a lens when it is used on a camera with a sub-**full-frame** sensor (see **focal length magnification**).

EV (exposure value) A single number given to the permutations of **aperture**, shutter speed, and ISO that all produce the same overall **exposure**. A change of one EV is the same as a change of one **stop**.

evaluative metering A metering pattern that assesses the scene as a whole, sometimes by dividing it into zones. Also known as Matrix, Multi-area, and Multi-segment metering.

EVF (electronic viewfinder)
A viewing system common to bridge cameras and CSCs that uses a small, eye-level LCD screen to provide the photographer with a through-the-lens view of a scene.

exposure The fundamental process of allowing a specific amount of light to reach the camera's **sensor** for a specific amount of time to create a digital photograph.

exposure compensation
Camera feature that allows you to adjust the **exposure** from that given by the camera, usually in 1/3, 1/2, or 1 **EV** increments.

f/number (f/stop) Term used to refer to the size of the **aperture** in a lens. Expressed as a fraction of the **focal length**; f/4, f/11, f/22, etc.

fill-in Using flash or a reflector to lighten (fill) any shadows falling across your subject. Commonly used in portrait photographs.

filter (1) A piece of glass or resin, often colored, that is put in front of the lens to modify the light entering the lens. (2) A software feature that changes an image (or part of an image), sometimes to emulate a lens filter.

flare An **aberration** that manifests as either distinct colored polygons, or as an overall haze that reduces **contrast**. Caused by non-image-forming light reaching the sensor.

focal length The distance between the optical center of a lens and a sharp image of an object at infinity projected by it. Usually measured in millimeters.

focal length magnification
Magnification factor applied to a lens used on a sub-**full-frame** camera to give its full-frame equivalent focal length. With **APS-C** sized sensors this is 1.5x or 1.6x; with **Micro Four Thirds** cameras it is 2x.

focus The point at which the light rays are brought together to produce the sharpest image.

full-frame A sensor size that matches the traditional size of a 35mm film frame; approximately 36mm x 24mm.

grayscale A monochrome digital image made up of shades of gray.

highlight The brightest or lightest parts of an image.

histogram Graph showing the distribution of tones in an image, from pure black to pure white. Can be used to determine **exposure** accuracy and clipping.

hot shoe A fitting found on the top of most digital SLR cameras and some CSCs that allows a flash to be attached to the camera.

ISO An international standard film rating, denoting a film's sensitivity to light. Now used in digital cameras, although changing ISO boosts the signal amplification, not sensitivity.

image stabilization Lens-based or **sensor**-based technology that typically uses sensors to sense and counter camera shake.

JPEG (Joint Photographic Expert Group) One of the most popular file formats for recording and saving digital photographs. It uses **compression** to reduce file sizes, although the compression process loses some of the information. This data loss is cumulative, so more data is lost every time a JPEG file is resaved as a JPEG.

Kelvin (K) Scale used for measuring color temperature.

landscape (format) When used to refer to an image format, signifies that the longest side of the rectangular frame is horizontal (as opposed to **portrait** format).

layer A feature of image-editing software that allows some elements of an image to float above others, thereby allowing adjustments to be made selectively.

LED (Light Emitting Diode)
The display technology behind the vast majority of camera screens and flat-screen televisions.

Levels A feature of image-editing software that is based around a **histogram**. Allows you to adjust the black and white points (shadows and **highlights**), as well as the **midtones**.

light meter A tool used to measure light and produce an **exposure** reading. All cameras feature a built-in light meter that takes reflected light readings, but you can buy handheld light meters that take both reflected and incident light readings.

macro Specifically refers to close-up photography at a magnification ratio of 1:1 or greater, so the subject appears at least life size on the **sensor**.

macro lens A lens designed specifically for **macro** photography.

manual exposure An exposure mode that gives you full control over the **aperture**, shutter speed, and **ISO** settings.

memory card The solid-state storage device used by virtually all digital cameras and smartphones. The most common type in current use is SD (Secure Digital). Some cameras use CF (Compact Flash).

metadata Information about an image that forms part of the image file itself. Metadata can record the location, time, and creator of an image, among other things, as well as camera, lens, and **exposure** details. Some metadata can be edited, allowing you to add copyright information and keywords to your images.

Micro Four Thirds A digital standard developed jointly by Panasonic and Olympus and popularized by their G-series and PEN compact system cameras respectively. Based around a **sensor** size of 17.3mm x 13mm, giving a **focal length magnification** of 2x.

midtone A tonal area in an image that is equidistant between pure black and pure white.

monochrome Any image made up of a single color, typically black.

multiple exposure A camera feature that allows you to take several shots and combine them into a single image. The effect can be created with image-editing software using **Layers**.

noise Random variations in digital images. There are two types of noise—chroma noise and luminosity noise. The former exhibits as colored patches or speckles; the latter as an underlying texture. Noise has two main causes: heat (as a result of long exposures) and high **ISO** settings. Most cameras and image-editing software offer some form of noise reduction system.

opacity Used in digital imaging as a measure of how transparent a **layer** is. Typically shown as a percentage value where 0% is entirely transparent and 100% represents total opacity.

optical viewfinder A camera feature that uses an optical system to view a scene, rather than relying on the camera's LCD screen or an electronic viewfinder (**EVF**). All dSLRs use an optical viewfinder.

overexposure When too much light is received by the **sensor**, resulting in an overly bright image, most often with a loss of detail in the **highlight** areas.

panoramic (format) Used to describe a picture format where the image is long and narrow.

partial metering Metering pattern used by Canon. Measures at the center of the frame, using an area that is larger than a **spot meter** pattern, but smaller than **center-weighted metering**.

pixel Short for picture element; the smallest unit of digital imaging.

pixellated Appearance of a digital image in which the individual pixels are clearly discernible.

portrait (format) When used to refer to an image format, signifies that the longest side of the rectangular frame is vertical (as opposed to **landscape** format).

ppi (pixels per inch) A measure of a digital image's **resolution** based on the number of **pixels** per linear inch.

prefocusing A technique where the focus is set (usually manually) in anticipation of the subject arriving. Suitable for fast-moving subjects.

prime lens A lens with a single, fixed **focal length**.

Program An exposure mode where the camera sets both the **aperture** and shutter speed. Differs from **Auto** in that the photographer can set the **ISO**, and can also shift the exposure pairing to prioritize **depth of field** or shutter speed.

Raw Image file format that records the data from the camera as shot, with little or no processing. Processing is then carried out on the computer.

red-eye An effect created when light (usually from an on-camera flash) reflects off the blood vessels at the back of the subject's eye, making their pupil appear red in an image.

red-eye reduction A feature of a camera flash that attempts to prevent red-eye by firing a series of pre-flashes to dilate the subject's pupil.

resizing Changing the size of a digital photograph, either making it smaller to use online, for example, or increasing the size to produce an enlarged print. Increasing the size of an image reduces its quality.

resolution (1) Of a lens, is a measure of its ability to record fine detail clearly. (2) Of a digital image, refers to the number of pixels per inch (ppi) or, in the case of a print, the dots per inch (dpi).

rim lighting Lighting technique where the subject is lit in such a way that it is outlined with light. Usually results in the subject falling into silhouette unless fill-in is used.

RGB (Red, Green, Blue) The primary colors used in the recording and viewing of digital images.

rule of thirds A traditional composition rule, based on the idea of dividing the frame into three equal segments, both horizontally and vertically, using imagined lines. Key elements of the image should be placed along these lines, or at their intersection, for greatest effect.

saturation The intensity of color.

scanning The process of digitizing a printed image, film frame, or document using a scanner.

Scene mode A set of pre-programmed exposure modes optimized for use with specific subjects—for example, Landscape, Portrait, and Sports.

sensor The light-sensitive imaging chip inside a digital camera.

sepia Traditional color tone applied to monochrome images to give them an antique look.

shutter The mechanism inside a camera that determines how long the sensor is exposed to light. The time the shutter stays open is the shutter speed.

Shutter Priority A semi-automated exposure mode in which the photographer sets the shutter speed (and ISO), and the camera chooses an aperture that will give the optimal exposure.

silhouette Effect in which the subject appears as a black shape, usually against a brighter background. Can be caused by or created with strong backlighting, and avoided through the use of fill-in lighting.

Single-shot Autofocus (AF) Mode where the lens is focused and the focus distance will not change until an exposure is taken or the shutter release button is released. Ideal for static subjects.

SLR (single-lens reflex) A viewing system that uses a prism and mirrors to transmit the light passing through the lens to an optical viewfinder. Now used to describe a type of camera that uses that viewing system: for example, a digital SLR.

spot meter Very precise metering pattern that reads the light in a very small area of the frame.

stop A change in exposure equal to a halving or doubling of the amount of light. Can be used to refer to exposure in general, or any one of the exposure controls: aperture, shutter speed, and ISO.

sync speed The fastest shutter speed at which the camera's sensor is exposed to light in its entirety. At faster speeds the sensor is exposed to a traveling slit of light.

telephoto A focal length with a narrow viewing angle, typically 35° or smaller.

TIFF (Tagged Image File Format) Widely used image file format for saving processed Raw files. Produces high quality files that are either uncompressed, or use lossless compression algorithms.

TTL (through-the-lens) Any camera system that receives information via the lens, such as a viewfinder, exposure meter, or autofocus system.

underexposure When not enough light is received by the sensor, resulting in an overly dark image, most often with a loss of detail in the shadow areas.

white balance A camera feature used to adjust the color of an image to match the prevalent color temperature of the light.

wide-angle A focal length giving a wide angle of view, usually at least 50°.

zoom lens A lens covering a range of focal lengths.

INDEX

ACKNOWLEDGMENTS

DK would like to thank:

Gerard Brown and John Munro for the photography and Thomas Morse for retouching. Many thanks also to our models: Rhiannon Carroll, Hannah Clark, Satu Fox, Joe Munro, Priscilla Nelson-Cole, John Owen, Farmer Sharp, Duncan Turner, and Angela Wilkes (also Lotus the pug and Piper the pointer).
For their kind permission to photograph we're very grateful to: Borough Market, Brands Hatch Racing Circuit; The British Museum; Drusilla's Animal Park; and Earnley Butterflies, Birds and Beasts.

The publisher would like to thank the following for their kind permission to reproduce their photographs:

(Key: a-above; b-below/bottom; c-center; f-far; l-left; r-right; t-top)

2 Corbis: Staffan Andersson / Johnér Images. 3 Corbis: (cl). 4-5 Corbis: Guido Cozzi / Atlantide Phototravel. 6 Corbis: Nabiha Dahhan / Westend61 (tl); Yves Marcoux / First Light (tc). Getty Images: The Image Bank / Peter Adams (tr). 7 Corbis: Imaginechina (tl). 8 Corbis: Chris Collins (tl); Frank Lukasseck (tr); Tim Fitzharris / Minden Pictures (cra); Tabor Gus (cb); Tim Graham (fcr). Getty Images: Blend Images / JGI / Jamie Grill (c); Ricardo Cappellaro / Flickr Open (cl). 12-13 Getty Images: E+ / kgfoto. 16 Courtesy of Nikon. 17 Courtesy of Canon (UK) Ltd: (b). Pentax UK Ltd: (ca). Sony Corporation: (tc). 18 Courtesy of Canon (UK) Ltd: (tr). Courtesy of Nikon: (b). 19 Courtesy of Canon (UK) Ltd. 20 Courtesy of Canon (UK) Ltd: (br). Courtesy of Nikon: (bl). 21 Courtesy of Canon (UK) Ltd: (bl, br). Courtesy of Nikon: (cl, cr). 24 Olympus.co.uk: (cl, cr). Panasonic: (bl, br). 25 Olympus.co.uk: (cl). Panasonic: (bl). 26 Courtesy of Canon (UK) Ltd: (bl, br). Courtesy of Nikon: (cla, cra). 27 Courtesy of Canon (UK) Ltd: (bl). Courtesy of Nikon: (cla). 32 Tamron Co. Ltd. 34 Manfrotto: (r). 35 Manfrotto: (tr, bl). 36 Courtesy of Canon (UK) Ltd: (cl, cr). 37 LumiQuest®: (bl, bc, br). Manfrotto: Lastolite (cr). Courtesy of Nikon: (tr). Image Courtesy of Sigma Imaging (UK) Ltd: (tc). 38 Crumpler: (cla). Hoya Filters: (clb, bl). LowePro / DayMen International Limited: (fcla). Manfrotto: Manfrotto Bags / KATA (cra). Peli Cases: (fcra). 39 Courtesy of Canon (UK) Ltd: (fcr). Courtesy of Nikon: (cr). SanDisk Corporation: (tc, tr). Sony Corporation: (ftr). 40 Getty Images: Taxi Japan / Ryuichi Sato (c). 42-43 Getty Images: Photodisc / Arthur S. Aubry. 48 Corbis: Nabiha Dahhan / Westend61 (macro/close-up / l); Photosindia (portrait / l); Bruno Morandi / Hemis (portrait / r); (landscape / l, landscape / r); Randy Faris (child / l); Isaac Lane Koval (sports / l); Patrick Seeger / EPA (sports / r); Frank Lukasseck (macro/close-up / r). Getty Images: Riser / Sean Justice (child / r). 50 Corbis: Guido Cozzi / Atlantide Phototravel (auto / l); Hero (program / l); Rob Taylor / Loop Images (program / r); Frank Lukasseck (shutter priority / l); Henrik Trygg (shutter priority / r); Martin Puddy (aperture priority); Martin Sundberg (aperture priority / r); Kenji Hata (manual / l); Bruno Ehrs (manual / r). Getty Images: Monkey Business Images / the Agency Collection (auto / r). 57 Getty Images: Arctic-Images / The Image Bank (tr); Daniel Osterkamp / Flickr (tc). 59 Getty Images: blue jean images (cra); Imagemore Co, Ltd. (crb). 62 Corbis: Michael Durham / Minden Pictures (water); Michael Truelove / Cultura (sports); Helen King (night lights); James Hager / Robert Harding World Imagery (wildlife). 63 Corbis: Tim Fitzharris / Minden Pictures (wildlife); Paul Souders (tr); Image Source (sports); Lawrence Manning (night lights); Frank Krahmer (water). 67 Corbis: Tim Davis (tc); Radius Images (tr). 73 Getty Images: Martin Harvey (tc). 76 Corbis: Tim Graham (bl); Reed Kaestner (br). 77 Corbis: Kent & Charlene Krone / SuperStock (br); Hugh Sitton (cr). Getty Images: Photodisc / Dennis Flaherty (tr). 78 Corbis: Rudy Sulgan (cl, c, cr). 79 Corbis: Roy Hsu (cl); Frank Lukasseck (cr). Getty Images: Photonica / Geir Pettersen (c). 84–85 Chris Gatcum. 86-87 Getty Images: Ricardo Cappellaro / Flickr Open. 88 Corbis. 89 Corbis: Guido Cozzi / Atlantide Phototravel (ca); Odilon Dimier / PhotoAlto (cla); Jon Hicks (cra). Getty Images: Blend Images / JGI / Jamie Grill (clb); Digital Vision (cb); BLOOMimage (crb). 95 Corbis: Ted Levine (tr); Andrew Parkinson (tc). 99 Jurek Biegus: (b). Corbis: Koji Aoki / Aflo (tr). 100-101 Corbis: Frank Lukasseck. 102 Corbis: Frank Krahmer (cr). Courtesy of Nikon: (crb). Tamron Co. Ltd: (fclb). 103 Corbis: John E. Marriott / All Canada Photos (cl). Getty Images: The Image Bank / Darrell Gulin (cr). Courtesy of Nikon: (cla, ca, cra, fcra). Olympus.co.uk: (fcla, fclb). Tamron Co. Ltd: (cb). 105 Corbis: Leslie Richard Jacobs (tr); Oanh / Image Source (tc). 106 Getty Images: The Image Bank / Peter Adams. 107 Corbis: Tim Graham (bc, br). Getty Images: Photodisc / Ursula Alter (cb, crb). Tamron Co. Ltd: (tr). 113 Getty Images: Taxi Japan / ICHIRO (tr). 115 Corbis: George Hammerstein (bl). 117 Corbis: Staffan Andersson / Johnér Images (tr). Getty Images: Digital Vision / Frank Krahmer (tc). 120-121 Corbis: Chris Collins. 123 Corbis: Peter Dressel / Blend Images (crb); Yves Marcoux / First Light (cr); Jim Zuckerman (br). Getty Images: Iconica / Stephen Simpson (cra). 124 Corbis: Blaine Harrington III (candlelight); Radius Images (clear skylight); Sara Wight (overcast sky); Myopia (midday). Getty Images: OJO Images / Le Club Symphonie (sunset). 127 Corbis: Julian Calverley (tr); Jeremy Woodhouse / Blend Images (tc). 139 Getty Images: Photographer's Choice / Richard Boll (tr). 143 Corbis: Daniel Smith (bl). 145 Getty Images: Photonica / EschCollection (tr); Visuals Unlimited, Inc. / Adam Jones (tl). 147 Corbis: Tabor Gus (cr); Gerolf Kalt (clb); Matt Mawson (br). 150-151 Getty Images: Tom Merton / OJO Images. 150 Corbis: Caterina Bernardi (cr, fcr); Tim Hall / Cultura (fcl, cl). 151 Corbis: Awilli (cr). 152 Getty Images: Lane Oatey / Blue Jean Images (c, cl, cr, bl, bc, br). 153 Getty Images: Blend Images / JGI / Jamie Grill (cl, cr, bl, br). 159 Getty Images: Stockbyte / George Doyle (tr). 164-165 Getty Images: Photodisc / David De Lossy. 169 Corbis: Anthony Asael / Art in All of Us (tc, tr). 176 Getty Images: The Image Bank / Byba Sepit (fcl, cl, cr, fcr, fclb, clb, crb, fcrb). 177 Getty Images: The Image Bank / Byba Sepit (cla, br). 178 Corbis: Imaginechina (cla, ca, cra, clb, cb, crb). 179 Corbis: Imaginechina (b, cra, tl).

All other images © Dorling Kindersley
For further information see: www.dkimages.com